The Female Chef

The Female Chef

Stories and recipes
from 31 women redefining
the British food scene

Written by
Clare Finney

Photographed by
Liz Seabrook

Edited by
Florence Filose

HOXTON MINI PRESS

Contents

Foreword

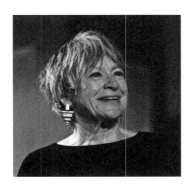

Sheila Dillon, food journalist and presenter of BBC Radio 4's The Food Programme

In 2021, you could gather up a collection of interviews with women in finance or medicine or architecture or journalism, and you'd have powerful stories of struggle to overcome discrimination and inbuilt prejudices against women. Stories of the glass ceiling. What Clare Finney has gathered here is more than that, because the stories of women who work in the food business are at the heart of understanding the maelstrom of feelings that women's rise to equality has set off in society. The hate, the anger, the resentment, the trolling. More than in many other careers, society's perception of women's and men's roles is inherent in food, and women's move from domestic cooking to positions of power in the hospitality business calls these widely accepted roles into question.

As Clare Finney and her interviewees show, the military organisation of professional kitchens – a brigade with a chef or chief, organised in a top-down, do-as-you're-told-and-fast, 'yes Chef!' way, which made the 'soft' domestic art of transforming nature's ingredients into delicious dishes a profession acceptable to men and to society – is now fractured. The rigid divide I grew up with, between restaurants run by men and the domestic kitchen of the wife and mother obliged by every social norm to nurture the family every day, gets less rigid all the time. We live in revolutionary times and food is at the heart of that revolution – how we produce it, shop for it, cook it and eat it is all changing. In reading these stories from 31 extraordinary women, you begin to understand what that means.

Cooks or Chefs?

In March 2010, Waitrose proudly unveiled the faces of their new 'food ambassadors': Delia Smith and Heston Blumenthal. The image, captioned 'Britain's best-loved cook' and 'Britain's top chef', featured Blumenthal in chef's whites, arms crossed, looking knowingly at the camera while Smith smiled over his shoulder in a pretty white shirt. Of course, Blumenthal is by any measure a chef; Smith – having only ever briefly worked in a restaurant, let alone run one – is not; yet for reasons I couldn't have articulated at the time, the ad irked me. Why was Smith standing behind Blumenthal? Why was her success defined by how beloved she was, while his was purely about talent? Why did it leave me with – or rather reinforce – the impression that 'cook' and 'chef' were inherently gendered words?

Fast forward ten years, and Britain's food landscape is so changed as to be almost unrecognisable. The number of ways in which one can be, or become, a chef have proliferated, and where once the division between dining out and dining in seemed absolute, now the boundaries feel increasingly blurred. The advent of supper clubs have made restaurants out of people's homes; residencies, takeovers and collaborations have seen so-called cooks brought into restaurant kitchens. Yet while female chefs certainly have more of a profile than they did a decade ago, and the media and the *Michelin Guide* are making a more concerted effort to platform them, there's no sugar-coating the statistics: in 2010, 22 percent of chefs in the UK were women; by 2018 that figure had dropped to 17 percent. Right now, only 11 of the places on the World's 50 Best Restaurants list are run by women.

When I began working on this book, that Waitrose advert sprung to mind – encapsulating as it did the various preconceptions around cooking, cheffing and gender. After all, when as recently as 2019 you have Blumenthal himself saying women aren't represented at the top of the

industry because 'ultimately the body clock starts working' and 'it is one thing to have a nine-to-five job [with kids] and quite another to be a chef with kids,' it's hard to deny the existence of these biases, or their ramifications in the world. That same year Marco Pierre White – the original *enfant terrible* of the kitchen – claimed that while women 'are more consistent [...] because they respect the house more', men are more qualified for working in restaurant kitchens because 'they are not as emotional and don't take things personally.' The thinly veiled implication in both of these statements is that a woman's biology and culinary skills are indivisible.

So what is the difference between a cook and chef? And why is that even relevant to a book celebrating female chefs in Britain? Come to that, why is the fact that these chefs are female even of interest anymore, when the feminist agenda of the last decade has largely been to remove gender from professional identity; to do away with terms like 'actress' and 'comedienne' and consider women in the same meritocratic light as their male peers? These are the questions I sought to answer while putting together this book – the vast majority of which was conceived of, written and compiled during one of the worst periods in the history of hospitality; when British pubs, restaurants and catering companies closed to the public for the best part of 18 months on account of the Covid pandemic. If I was going to take up these chefs' time and headspace, it needed to be for something far more interesting and nuanced than (yet another) women-in-food listicle.

The *Oxford English Dictionary* sheds little light on the matter. It states that a chef is 'a person whose job is to cook, especially the most senior person in a restaurant, hotel, etc.'; a cook is 'a person who prepares and cooks food, especially as a job or in a specified way'. Calm, clean definitions that fail to account for the messy layers of association and inference these words have acquired over the years. Though in its mother language, French, the word *chef* simply means 'leader', 130-odd years of English usage has muddied its original meaning – not least because in the UK the term is used exclusively in restaurant kitchens. The sense of hierarchy, already embedded in the word, has been compounded by decades of the *Brigade de Cuisine*, a pyramidal system of kitchen organisation pioneered in the 1890s by French chef Auguste Escoffier at London's Savoy hotel.

It was under Escoffier that certain tasks – the preparation of sauces, vegetables or pastry for example – were codified and ranked; under him that the working culture of kitchens came to resemble that of the military. The *Brigade de Cuisine* was in fact modelled on the seven years Escoffier spent in the army, where he was struck by how a chain of command could result in ruthless efficiency, even under intense stress. Being a chef in the Savoy's kitchen – and in the thousands of kitchens which were subsequently modelled on it – was as much about giving and receiving orders in a high-pressured environment as it was cooking a delicious dinner. Unless one was a head chef, creativity, passion and even talent all came secondary to being quick, precise and obedient.

Though I am loath to deploy such terms as 'typically male' or 'typically female', there's no denying the maleness – and whiteness – of Escoffier's system, conceived as it was by a Frenchman in a grand hotel in late 19th-century England. A hyper-masculine, military approach to management leaves little room for women to juggle work with childcare or soldier through the first nauseated trimester; issues that remain very much alive in the industry, and are often cited as the reason relatively few woman are elevated to leadership, for all their determination, training and talent. Add to this the fact the *Michelin Guide* was born around the same time, before women even had the vote in either Britain or France, and you can begin to understand why several women in this book have chosen to reject the label 'chef'.

For Asma Khan of Darjeeling Express (p.32), the word is too closely bound up with the inequalities she considers systemic within hospitality, where 'success is seen in male terms' and one person takes the credit of the work of a dozen others. 'The *Brigade* system, the *Michelin Guide* – it makes you think there needs to be a hierarchical structure to create fabulous food. In my [all-female] kitchen everyone gets paid the same,' she told me passionately. Yet some women I spoke to found it insulting when they weren't referred to as chefs, or simply considered the title to be self-evident. 'Anyone who goes to work every day and has to cook the same thing over and over again is a chef. I don't know why people get so funny about it,' shrugged Margot Henderson of Rochelle Canteen (p.124).

Nevertheless, the question 'Do you consider yourself a chef or a cook?' continued to prompt an extraordinary array of discussions. Indeed, two women actually changed their minds during the course of my conversation with them: Saiphin Moore, founder of Rosa's Thai Café (p.158), began as an avowed 'cook' – but after an hour spent reflecting on all the restaurants she's opened, and all that she's done in transforming attitudes towards Thai cuisine in Britain, 'chef' seemed to her the more appropriate title. Award-winning cookbook author Olia Hercules (p.200) got her chef's diploma at Leiths School of Food and Wine, worked for several years in Yotam Ottolenghi's restaurants, and has been a 'chef' for as long as I've known her. Yet when we spoke about the emotional resonance of the words, she said she'd recently found it to be more nuanced. Using 'chef', Hercules said, was an attempt to earn respect from her male contemporaries: 'I wanted men to take me seriously, and not dismiss me as a domestic cook.' Yet 'cook' is more her style, being 'so much warmer'. Maybe by reclaiming and elevating the word, she could 'stick two fingers up at the macho chef situation,' she continued, and be evaluated on her own, unashamedly feminine terms.

It's a shift in attitude that seems to be gaining traction. Skye Gyngell (p.172) also now proudly describes her approach to cooking as 'female', having previously rebuffed the description. Indeed, if you'll forgive my pop-feminism here, it follows something of the same trajectory as the broader feminist movement: from seeking the same rights, privileges and honours as men and flattening femininity in the process – the Margaret Thatcher approach, if you will – to encompassing and celebrating the experience of womanhood across a spectrum of backgrounds, identities and cultures.

After all, women around the globe have been cooking in the home for millennia. With exceptions, the first mouthful of food we have upon entering this world comes from our mother. Though times are – mercifully – changing, for most of us our mother or another female relative continues to be the primary feeder throughout the course of our childhood and, in the West at least, much of our cookery canon consists of books written by women: Elizabeth David, Mrs Beeton, Eliza Acton, Hannah Glasse and, of course, Delia herself. Though the rarefied world of gastronomy has been – and continues to be – male dominated, the work of nourishing and sustaining families and communities has historically and biologically been 'women's work' – rendering womanhood and the act of feeding inextricably bound together. Now that the sands are shifting and food as 'industry' is moving from something male and white to something more balanced, the question of whether female industry leaders want to incorporate femininity into their professional identity seems more pertinent than ever before.

It was through this varifocal lens that I set out to consider who should be in this book, and what I might ask them. It goes without saying that this list is not definitive, and that not every chef I asked was available: 2020–21 was not the best year to be asking chefs to spare an hour. Anxious to avoid the path most travelled, I did my best to bypass

the more 'male' metrics of success – fame, money and Michelin stars – and instead interviewed the changemakers: the women transforming kitchen culture, campaigning for more diverse representation, infiltrating previously male-dominated areas or introducing new techniques and cuisines. Reading through, you will see we have chosen to photograph women both at home and at work; playing on the ambiguity of a woman's 'place' in the kitchen. In these spaces, I asked about their childhoods, their experiences of and ambitions for Britain's food and restaurant culture, and to what extent they felt they represented the woefully unrecognised women of previous generations in their food.

As they spoke and I wrote, the spectre of Smith the cook and Blumenthal the chef appeared again; like a board-game spinner oscillating between 'Chef-Cook-Chef-Cook' in my mind's eye. Yet while interviewing 31 individuals from a variety of backgrounds brings few conclusions, if there are any it is that chef and cook is something of a false dichotomy: like women and men, or nature and nurture, chef and cook are on a spectrum, and most people who cook for a living sit somewhere between the two extremes. We might associate Heston the chef with 'genius' and Delia the cook with 'love' – but as avowed chef Angela Hartnett (p.62) points out in these pages, 'a good chef brings all of what they know to the kitchen: knowledge, experiences, history – and passion. The moment a chef cooks without feeling, they're out of a job.'

With these words in mind, I will leave it to you to decide how much a fixed definition is of use as you read the passionate, personal, pioneering stories in this book. For my own part, these conversations left me feeling that it is the increasing fluidity of these identities that has enabled women in hospitality to carve out their own space in the kitchen, whether that be in a restaurant or in the home. If the urgent and ongoing drive to make the industry kinder and more inclusive is to continue to win ground, we need these boundaries to be broken down, or at the very least redrawn; for the women and men who feed us to have the right to call themselves cook, chef, both or neither. In these women and their contemporaries, I believe the future to be in very capable hands.

Clare Finney, June 2021

Anna Jones

Vegetarian cookbook author and food writer,
and graduate of Jamie Oliver's Fifteen

'Growing up in Britain in the 1980s, the food I wanted to eat and read about didn't exist.'

'I've been cooking family dinner since I was 11; I was doing dinner parties for my parents and parents' friends. But no one ever said, "This could be your job" – at school or at home,' says Anna Jones. 'It just wasn't part of the conversation.'

In fact, it wasn't something Jones herself considered, until she picked up an abandoned *Times Educational Supplement* on the bus to work. 'I was working in Financial PR – which didn't feel right or fun – and I read this article on the way in that said, you should determine your calling by which part of the Sunday paper you first turn to. And I thought, it has to be food.' 15 years later – after a chef's apprenticeship at Jamie Oliver's Fifteen, seven years at Jamie Oliver HQ, a *Guardian* recipe column, and four cookbooks – Jones wishes she'd

kept that article, 'because that piece of writing changed the entire trajectory of my career.'

Jones epitomises the Modern Cook – a phrase which both titled her *Guardian* column and informed her first three cookbooks. Her fresh, seasonal fare sits squarely in the centre of the Venn diagram between healthy and satisfying. *One*, her latest book, unites that rare balance with her mounting concern for the environment, and her newfound love of meals that use only one pot or pan. 'It was a natural evolution,' she explains – both of her recipes, which have always been plant based, and of her style since becoming a mother to her son Dylan, now aged five. 'I used to spend two hours on dinner. That is not the case anymore,' she laughs. Motherhood has simplified her

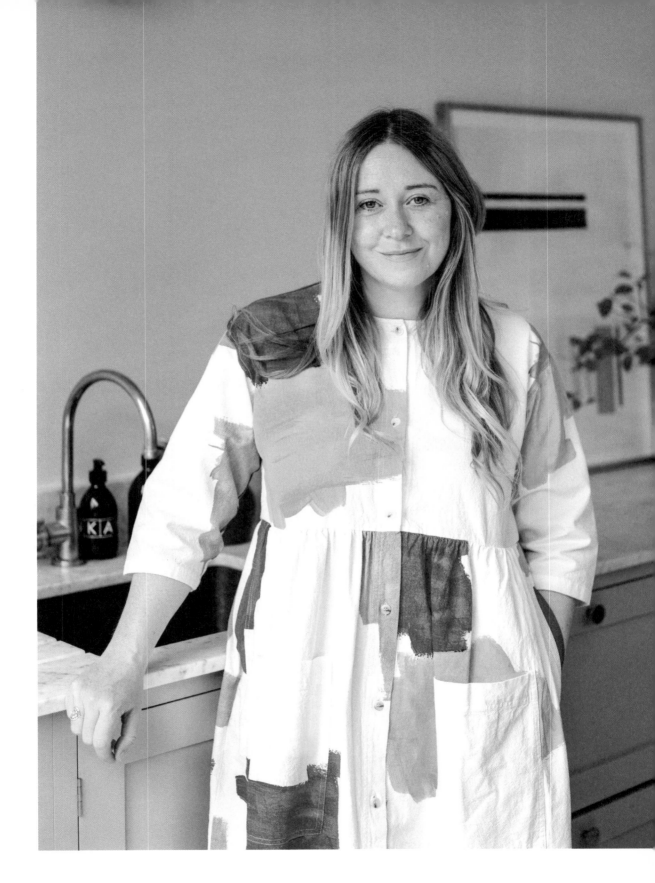

Anna Jones

Jones at home in Hackney, preparing the recipe people tell her they cook most often: red lentil dhal with crispy sweet potatoes and coconut chutney (see overleaf).

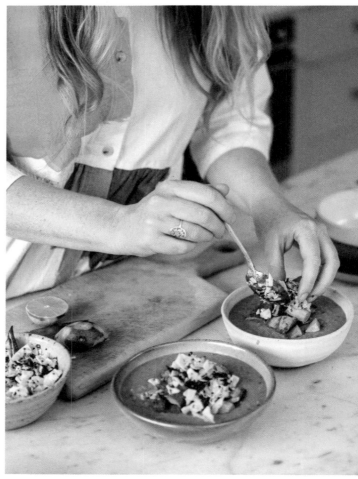

cooking process, but it has also removed any trace of pretension she may have had in the kitchen. From being the sort of person who was, she admits, 'quite disparaging of people who said they didn't have time to make a béchamel or a tomato sauce,' she is now 'over the moon if I can do everything in one or two pans'.

'As a chef and a cookbook writer you really want your more complicated recipes to rise to the surface – but it is the pastas, the dhals, the simple soups that get cooked most often by readers. That's what I've focused on,' she continues. Her recipes aren't 'cheffy' in the conventional sense of the word, nor does she really consider herself a chef – 'if you put me in the middle of busy service now, I might struggle!' – yet 20 years on from the days when a career in food 'meant either a restaurant kitchen or a catering company', Jones feels the delineation between cheffing and cooking is no longer so stark.

'There are people who clearly occupy either the "cook" territory or the "chef" territory, but increasingly there are people who bring both sides together – like Jamie', Jones says, referencing the famously hybrid cook and chef who helped launch her career. While there is what she calls 'feminine energy' to being a cook – 'it's that heart-led way of cooking that's about nurture and love' – it is by no means exclusive to women, any more than the 'masculine energy' of being a chef is exclusive to men.

'Going back to my childhood around 30 years ago, we had Nigella and Delia as "cooks", and Marco Pierre White and so on as "chefs". Now I think there's more of a middle ground,' Jones continues. 'I can think of dozens of male and female chefs right now cooking in restaurant kitchens who have more of a feminine, "cook" energy: Asma Khan (p.32), the Honeys (p.184), Ruthie at River Cottage for example. It's different, but not seen as a lesser.' As for herself, 'I feel like I have masculine and feminine sides – most of us do! – but on balance I feel like I'm more drawn towards the "cook".' Might she have gone into restaurants, had such restaurants existed when she graduated from Fifteen's kitchen in 2003? 'I think if I had worked in women-led kitchens like Darjeeling Express or Honey & Co, or in kitchens run by forward-thinking men like Lyle's, then it could have been a different story. But the industry hadn't changed in the way it has now.'

The industry's loss has been our gain. With her bestselling debut, *A Modern Way to Eat*, Jones persuaded countless cooks that less meat didn't mean less taste – at a time when that myth was still at large in Britain. Given that eating less meat is one of the most effective ways we can reduce our carbon footprint, this is no small coup. 'I am not saying I've reinvented the wheel: vegetarianism is ancient,' she points out. 'But growing up in Britain in the 1980s, the food I wanted to eat and read about didn't exist – I wanted to create vegetarian food that was modern and inclusive.' And, as so many of us with a go-to Anna Jones recipe can attest, that's exactly what she did.

'I feel like I have masculine and feminine sides – most of us do!'

Anna Jones' Dhal with Crispy Sweet Potato and Quick Coconut Chutney

'This dhal has become my most cooked recipe. It's hard to know when you are writing recipes what will resonate with people. But after a few thousand I think I've worked out the formula. Something that takes under 40 minutes, uses easy-to-find ingredients, doesn't require a lot of prep and can be adapted and switched as the seasons change. And, of course, is unreasonably delicious for the amount of work put into it. This dhal is all of those things and, ten years or so after first making it, it is still something that's cooked every other week in my house.'

Serves 4

2 sweet potatoes, skins on, washed and
 roughly chopped into 1½cm/½in cubes
1 tsp cumin seeds
½ tsp fennel seeds
olive oil, for drizzling
sea salt and freshly ground black pepper

For the dhal
2 garlic cloves, peeled and chopped
thumb-sized piece of fresh ginger, peeled
 and roughly chopped
1 green chilli, finely chopped
1 red onion, peeled and roughly chopped
1 tsp cumin seeds
1 tsp coriander seeds

1 tsp ground turmeric
1 tsp ground cinnamon
200g/7oz red lentils
400ml/13½fl oz tin of coconut milk
400ml/13½fl oz vegetable stock
2 large handfuls of spinach
bunch of fresh coriander, roughly chopped
 (stalks and all)
1 lemon, juiced

For the coconut chutney
50g/2oz unsweetened flaked or desiccated coconut
1 tsp black mustard seeds
10 curry leaves
20g/¾oz fresh ginger, grated
1 red chilli, finely chopped
vegetable or coconut oil, for frying

Preheat the oven to 220°C/425°F (200°C/400°F fan).

Start preparing the coconut chutney by pouring 150ml/5fl oz boiling water over the coconut, then leave to soak.

Put your sweet potatoes on a roasting tray and add a good pinch of salt and pepper, the cumin and fennel seeds and a drizzle of olive oil. Roast in the oven for 20–25 minutes, until soft and sweet in the middle and crispy brown on the outside.

Now make the dhal. In a large saucepan, sizzle the garlic, ginger, chilli and red onion in a little oil for about 10 minutes, until soft and sweet. Grind the cumin and coriander seeds in a pestle and mortar, then add to the pan with the other spices and cook for a couple of minutes to toast and release the oils. Add the lentils, coconut milk and stock to the pan and bring to a simmer, then turn the heat down and bubble away for 25–30 minutes.

While that is cooking, finish making your chutney. Drain the coconut and put it into a bowl. Fry the mustard seeds and curry leaves in a little oil until they begin to crackle, then pour the mixture over the coconut. Season with salt and pepper, then stir in the ginger and chilli and give it a good mix.

To finish your dhal, take it off the heat, then stir in the spinach and allow it to wilt a little, stirring in half the chopped coriander and the lemon juice too. Pile into bowls and top with the crispy sweet potatoes, spoonfuls of the coconut chutney and the remaining coriander.

Andi Oliver

Former punk singer turned chef, broadcaster, and founder of Andi's Wadadli Kitchen

'All food should be soul food, because all food should make you feel connected and happy.'

'I came at it like a punk – like an old punk saying "Yeah! Let's do some food!"' Andi Oliver quips, laughing infectiously. It is just one part of her answer to my question of why she started cooking professionally alongside her stellar career in TV and radio; yet when I return to it, while writing up our interview weeks later, it reads less like a throwaway line, more an encapsulation of Oliver's culinary approach.

There's the enthusiasm; the seamless fusion of food and her past life in punk music (she was a singer in the 80s band Rip Rig + Panic); and the boundless energy that has made her the go-to host of such diverse shows as *BBC Glastonbury* and *Great British Menu*. Yet there is also, contained within that remark, a sense of the rebellious spirit

that has made her one of the country's leading ambassadors for Caribbean cuisine.

'This notion of "soul food", or what people call soul food,' she says – 'they are referring to cooking of the African diaspora.' Though the word is positive, it is invariably used to define this style of food in opposition to European ideas of refined 'gastronomy' – in much the same way the word 'craft' has been used by Europe's artistic community to describe African artworks of 'great value, history and cultural weight'.

'All food should be soul food,' Oliver points out, 'because all food should make you feel connected and happy' – and by the same logic, any technique that takes skill and experience to master is worthy of elevation. 'I have the utmost respect for those

Andi Oliver

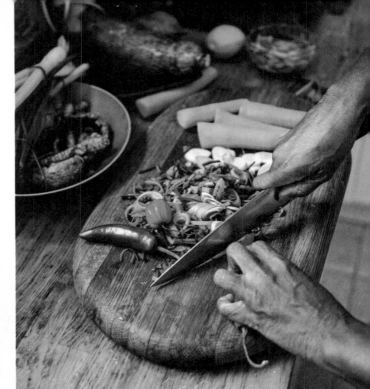

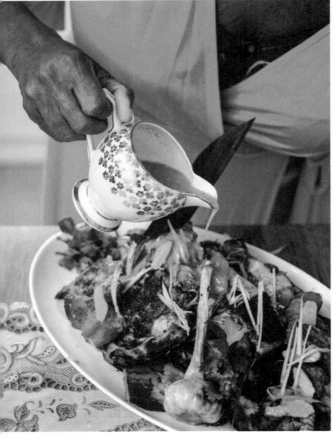

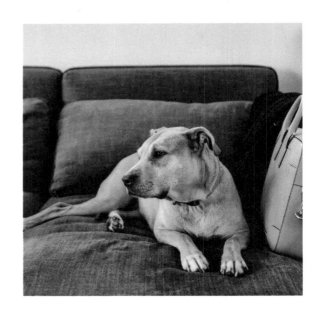

Oliver at home, preparing a roast chicken rubbed with Wadadli spices and served with coconut gravy (see recipe overleaf).

who have gone through classic French training. It is gruelling and exacting. But I am equally awe-struck by what the lady just up the road from my house in Antigua, Sister Hector, can do with just one cassava root.

'To make cassava flour and bambolla [sweet, coconut-stuffed cassava cake] from cassava root takes years of finesse. It is just as impressive as a perfect consommé – yet culturally they are viewed differently.' Bound up with the sheer joy she exudes when broadcasting and cooking is a determination to break down this divide between perceptions, and the people behind them. 'These Eurocentric ideas of value are just completely out of date.'

On *Great British Menu* – the televised chefs' competition on which she sat as judge for three years – she tells me, 'I forensically examine a plate of food. I apply a set of standards. What impresses me – what thrills me, is when contestants are cook-ing with their whole heart; when they are cooking with meaning.' Adding gratuitous shavings of fresh truffle 'is not cooking, it's shopping. 95 percent of *Great British Menu* is about the intent of the chef.'

'It's about connection,' she continues, now talking about food more generally, 'connection and communication', which is why music and food are so intertwined – and why opening her first restaurant in London's Stoke Newington in 2017 'felt like a homecoming. Cooking the recipes I had been dreaming up for years and those plates going out to a full restaurant – you feel like people can hear and see you, just like I felt when I was on stage.'

With her pop-up restaurant and home delivery service, Wadadli Kitchen, which opened in June 2020 to serve 'real Caribbean cooking', Oliver feels like she has found her voice – 'my kitchen voice, and I'm really excited about what I am doing.' Roaming between influences from Antigua to Saint Lucia, Martinique to Guyana, she is using 'the ingredients and flavours I grew up with to make traditional dishes, but also to create some-thing new.'

Again, the idea is to challenge assumptions about Caribbean cuisine – in itself something of a misnomer. 'The Caribbean is an enormous region and a major crossroad of cultures. People forget the Latin American influence, the Indian influ-ences.' The idea of innovation – of melding her British and Antiguan heritage and the cuisines of other islands – challenges both those who assume 'Caribbean food is jerk chicken', and those who are part of the diasporic culture, who 'cling to the old ways of doing things and don't like change.'

If anyone can persuade them, it is Oliver: a multicultural, mainstream figure whose punk mentality has never left her; an artist for whom food, like music, is first and foremost a means of communication. 'It's taken me years to say I am a chef, because I've no formal training. But I think, if I had gone down that route, that wouldn't have worked out for me. I'm a singer,' she says again – 'and for me, food is always more than ingredients on a plate.'

'These Eurocentric ideas of value are just completely out of date.'

Andi Oliver's Wadadli Spiced Roast Chicken and Coconut Gravy

'Three things of beauty that will perk up any day: a spice-rubbed chicken, a roast and coconut gravy! This recipe is to me the perfect equation for comfort, but not as we know it. There is quantifiably not much better in life than a roast dinner; this recipe brings together all sides of my life in some very simple steps, it's a great example of what being British and of Caribbean heritage means to me. Serve it with roasted roots and buttery, garlicky greens and you're on to a winner.'

Serves 3–4 people

1 whole free-range organic chicken
 (around 1½–2kg/3lb 5oz–4lb 7oz)
1 medium yellow onion, cut in half
1 medium-sized head of garlic (about 6–7 cloves)
sprig of fresh thyme
salt and pepper

For the Wadadli spice oil
7g/¼oz ground turmeric
7g/¼oz ground cumin
7g/¼oz ground coriander
5g/⅛oz fresh ginger, peeled and finely grated

80ml/2¾fl oz cold-pressed rapeseed oil
1 large spring onion (or two small ones),
 roughly chopped
2g (a few sprigs) flat-leaf parsley
2g (a few sprigs) fresh coriander
6g/¼oz mixed red and green bird's eye chillies,
 roughly chopped
4g/⅔ tsp sea salt
crack of black pepper (or a good big pinch
 of coarse ground black pepper)

For the coconut gravy
25g/1oz block of coconut cream
400ml/13½fl oz coconut milk

Preheat your oven to 150°C/300°F (130°C/270°F fan). Lay the chicken on a board and push both halves of the onion, 3 cloves of garlic and the sprig of thyme into the cavity.

Add the rest of the garlic and all of the Wadadli spice oil ingredients to a blender or food processor and blitz to make a paste.

Transfer the chicken to a deep roasting tray then pour the spiced oil all over, turning it around a couple of times to make sure it's well coated. Give the bird a good sprinkle of salt, cover the whole tray and chicken with aluminium foil and slip it into the preheated oven for 1 hour.

Remove the tray from the oven, take off the foil and, using a big spoon, baste the chicken with all the lovely cooking juices, then pour off the majority of the juices into a saucepan.

Now to crisp up the lovely spiced skin. Pop the tray back into the oven and turn the heat up to 200°C/400°F (180°C/360°F fan). After about 15–20 minutes the skin will be crispy and it'll be ready to take out – if it needs a little longer, then just slip it back in for a further 5–10 minutes more and it'll be right where you need it.

Meanwhile, add the coconut cream to the juices in the saucepan and melt it over a low-

medium heat, then add the coconut milk and give it a stir. Bring the gravy to a gentle simmer, tip any remaining juices from the chicken tray in, and reduce over a medium heat for 7–10 minutes – and hey presto! Coconut gravy! Season with salt and pepper to taste.

Transfer the chicken to a serving platter and enjoy with crunchy, golden roast potatoes (I often use white sweet potatoes as a side) and all the other usual roast accompaniments – Yorkshires, greens, carrots, peas, roast parsnips or whatever takes your fancy!

Elizabeth Haigh

*Former head chef of Michelin-starred Pidgin in
east London, now with her own restaurant*

'I made something that matters to me: a restaurant that could do justice to Singaporean food culture.'

The first time I encountered Elizabeth Haigh was in Pidgin: the Hackney restaurant that has made its name for never repeating a dish on its weekly changing menu. She was head chef at the time, and a month off winning the Michelin star that would catapult her into fame. I say encountered; in truth, she was only just visible beyond the pass – head down and entirely focused on preparing a dazzling series of seasonal small plates. Yet I felt like I'd met her, through eating her innovative, intelligent, deeply satisfying modern European food.

Except it wasn't Haigh's food. Haigh is innovative and intelligent – but Pidgin wasn't her concept; nor weekly changing modern European a menu she felt any particular affinity with. 'I wanted to put 10,000 hours in', she says – a theory origi-nally conceived by journalist Malcolm Gladwell, which states the key to achieving world-class expertise in any skill is a matter of practicing it correctly for that length of time – 'and you cannot put 10,000 hours into a constantly changing menu,' she says. The food of her heart, the food she'd go on to serve in Mei Mei, her first solo restaurant, was that of her Singaporean mother and grand-mother: food that took not just hours, but years – lifetimes, even – to perfect and master. After an interstellar career that saw her rise through the ranks of some of London's most pioneering kitch-ens – Neil Rankin's Smokehouse, Kitchen Table by James Knappett, The Royal Oak in Paley Street – before winning her own star at Pidgin, Haigh decided she no longer had something to prove.

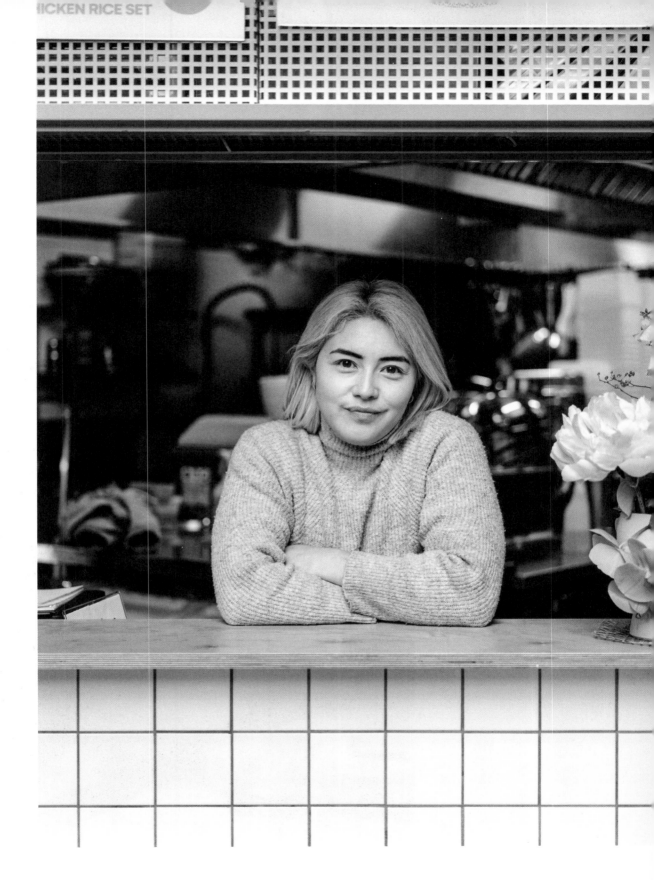

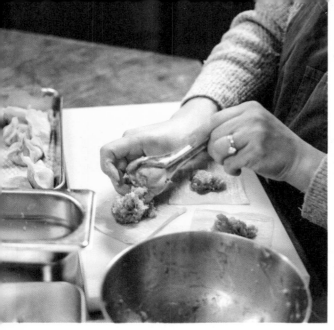

Haigh at Mei Mei, her restaurant in London's Borough Market, making wontons (see recipe on p.30).

'I think at first I was drawn to that Michelin-star, detailed approach to cooking because I wanted to catch up on the experience I lost by doing another degree' – Haigh studied Architecture – 'then I went to Smokehouse because I wanted to learn more about cooking with fire and meat, and because I was fed up of being put on pastry because I was female.' Rankin taught her a lot, and she progressed to head chef at lightning speed; yet after Pidgin, 'which was a feat, but not really a learning curve,' she was done trying to make a point. 'My ego didn't need pushing any more or challenging any more. I had a profile, a name for myself. The joy for me lay in reconnecting with my love of food.'

So she went back to her heritage; to the mantou buns, chilli crab and Hainanese chicken rice she grew up on, and made 'something that matters to me. A restaurant that could do justice to Singaporean food culture.' Though London's understanding of the range and scale of cuisines across Southeast Asia has grown more nuanced in recent years, Singaporean cuisine – being a cuisine of many cultural influences – remains 'under-represented or misunderstood.'

What matters at Mei Mei is that guests feel a sense of connection – whether or not they are from Singapore. 'We love that Singaporeans who come here say it reminds them of being back home. That is the power of food and cooking,' Haigh says. 'But it is also in creating new memories and love.' Recipes are from her mother – 'going back to her was important. She's learnt a great deal from her ancestors' – yet her British father was also an influence. 'I am technically influenced by Mum, but my passion for food, the idea that you feed to show love, also comes from my dad. He is the happiest guy around the table with some beers and steamed crab.'

In 2017, Haigh's young son Riley was born; and the experience of becoming a mum herself had as much to do with her establishing Mei Mei as her fatigue with weekly changing menus and Michelin stars. 'It changed what we do. It had to – partly because it would be impossible for me to work those hours, partly because I think, as a mother, there is a sense of nurture that naturally comes out.' That she has succeeded in becoming a mum at the same time as establishing and running her own restaurant is testament to her determination, as well as the support of her husband (and business partner) Steele Haigh. She has in the past talked about the challenges of being pregnant in a professional kitchen: 'I worked until I was seven months pregnant, and I felt so faint and ill after working 12-hour days,' she told *Stylist* magazine in 2018.

When we speak, Haigh has just finished her first cookbook *Makan: Recipes from the Heart of Singapore*, described as 'a love letter to family cooking and traditions.' It feels – and indeed reads – like a culmination of the journey she began after leaving Pidgin. 'What I love about what I do now is that I literally put in 10,000 hours: into dishes that have been passed down through generations of aunties, mothers, nonyas; into food and people I admire, respect and want to do justice to.'

'I was fed up of being put on pastry because I was female.'

Elizabeth Haigh

'We love that Singaporeans who come here say it reminds them of being back home. That is the power of food and cooking.'

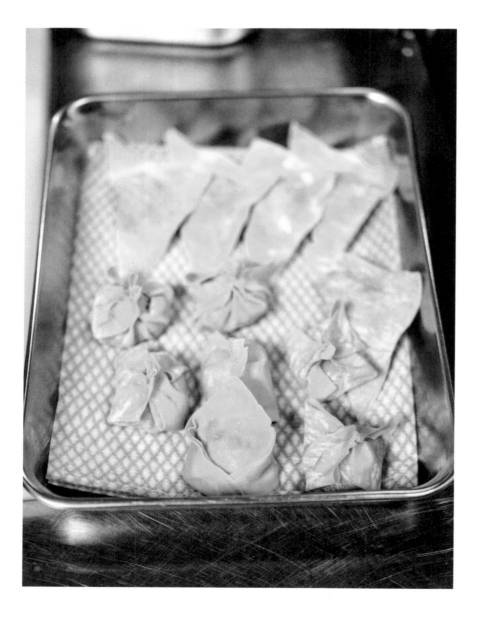

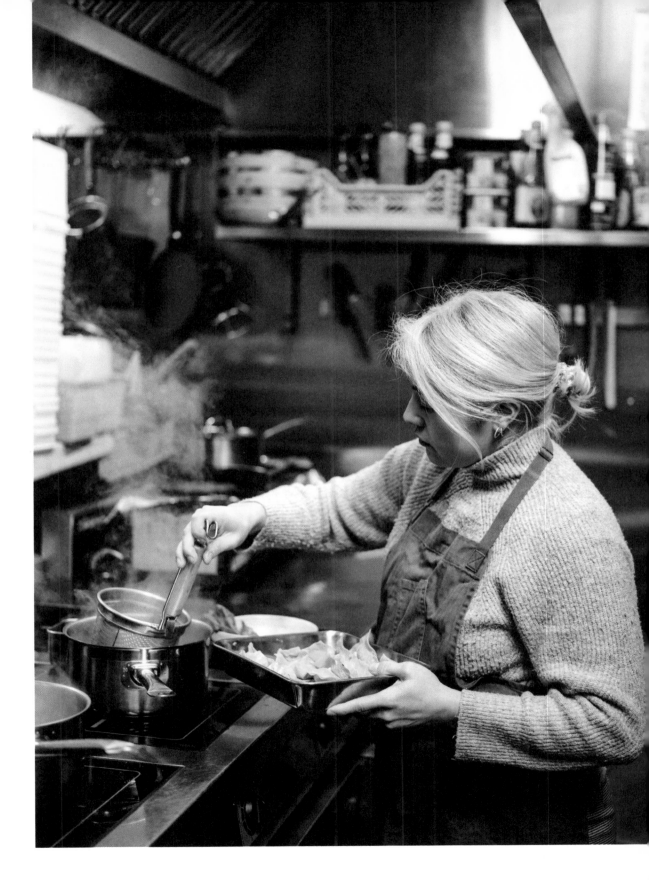

Elizabeth Haigh

Elizabeth Haigh's Wonton Soup

'There's something incredibly comforting about wontons. You can make them vegetarian or meat, or a fish filling is so versatile as well. My favourite part about this dish is getting Riley, my son, involved in making the wontons with me, which he loves. This is the reason I wanted to write *Makan*. To get him excited about this cuisine like I have been brought up to be. I love this version of wonton soup because adding the gai lan (Chinese broccoli) and egg noodles to the dish makes it feel very wholesome.'

Serves 2

½ pack of wonton skins (readily available
 in Chinese supermarkets)
cornstarch, for dusting
2 nests of egg noodles
2 litres/3½ pints good-quality chicken stock
 (you can use chicken stock powder
 mixed with boiling water)
soy sauce, to taste
gai lan, blanched (or lettuce, washed)
spring onions, chopped, to serve
coriander, chopped, to serve
sesame oil, to serve
salt and freshly ground white pepper

For the wonton filling

200g/7oz pork mince (use one with a
 10% fat content, i.e. not too lean)
¾ tsp salt, plus more to taste
½ tsp sugar
½ tsp sesame oil
⅛ tsp white pepper
1 tsp Shaoxing wine or rice wine
2 tsp rapeseed oil or sunflower oil
1 tbsp water
1 tbsp peeled and finely grated fresh ginger
50g/2oz water chestnuts,
 roughly chopped
½ tsp cornstarch
200g/7oz peeled raw prawns, chopped

Start by making the wonton filling. Add all the filling ingredients except the prawns to a bowl and mix everything together by hand for 5 minutes. You want to make sure that the pork and the seasoning are well mixed and the pork well seasoned. Mix in the chopped prawns and stir very well. You can test the mixture by blanching ½ a teaspoon of it in seasoned boiling water until cooked, then taste it to check the seasoning.

To make the wontons, take a wrapper and add only about a teaspoon of filling. Wet the edges with water and bring the corners together to form a triangle, trying to remove as much air from the wonton as possible to prevent it from bursting open later on. Dust the bottoms with a tiny bit of cornstarch to prevent them sticking together, then fold the two ends together to form the wonton shape.

Repeat until you have made about three dozen (or less, depending on how generous you are with the fillings).

Put 2 litres/3½ pints water in a saucepan over a medium–high heat and bring to the boil. When it's boiling, turn the heat down to medium and add 2 teaspoons of salt. Add the wontons slowly, one by one, into the pot; don't overcrowd the pot, it's best to cook them in a few batches if you need to. Once the wontons are done, they will float.

Remove the cooked wontons from the pot with a slotted spoon and place them in cold water for 10 seconds, then set aside. Repeat the process until all your wontons are cooked. Cook the egg noodles according to packet instructions, then run them under cold water to prevent them sticking together.

To complete the soup, put the chicken stock in a pan over a medium–high heat and bring to the boil. When you have a rolling boil, turn the heat down to medium. Season with salt, pepper and soy sauce to taste. Add the blanched gai lan (or lettuce), the egg noodles and the cooked wontons to the soup, dropping them in slowly.

Serve in deep noodle bowls and garnish with chopped spring onions, coriander, a drop of sesame oil and a pinch of ground white pepper.

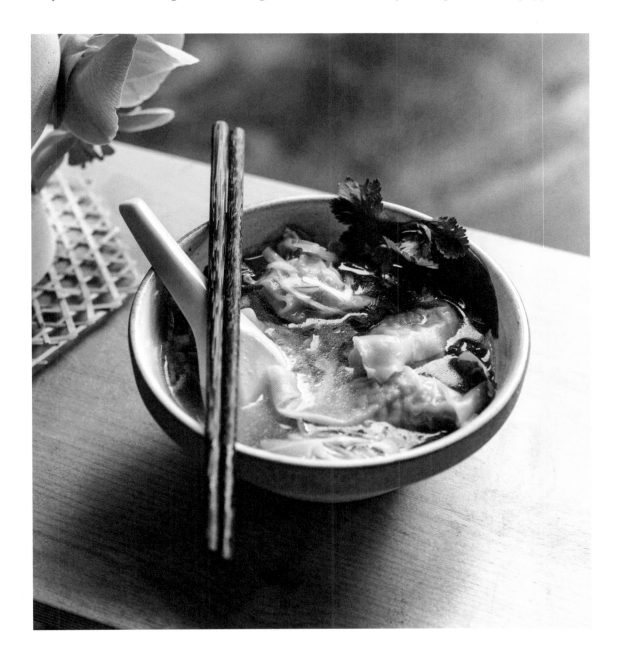

Asma Khan

Restaurateur, cookbook author, and the first
British chef to feature on Netflix's Chef's Table

'I do it for every woman who cooked and
received nothing; I am the face of these great
home cooks.'

There are no women on the walls of the palace Asma Khan grew up in in Calcutta, India. There are portraits of men – princes, politicians, officers – but 'no women have been given that honour,' she tells me. 'These dishes that I serve in my restaurant, the recipes everyone talks about – the women who handed them down died believing they were "unskilled".'

It's why, when Khan appears on TV; when she's interviewed in magazines and newspapers; and when she cooks her fragrant, jewelled biryanis and soulful tamarind dal, she does so not just for her all-female kitchen team but 'for every woman who cooked and received nothing; for every woman who felt their dishes didn't warrant recognition. I am the face of these great home cooks.'

Her brigade of chefs is famously made up of women who, like her, immigrated to Britain from Southeast Asia. 'That's not because I really wanted an all-female team. I just needed people who understood this style of cooking.' In India, restaurant kitchens are the preserve of men 'who have been to culinary school, but who cannot tell their grandmother's story.' In its dishes, drawn from Khan's rich heritage, her Covent Garden restaurant Darjeeling Express celebrates generations of female experience. Her ethos lies in 'the delicate layering of spices, the balance of flavours, that we can measure just by running our hand through the steam and breathing in the aroma' – and the patience to make the same dish for the same loved ones again and again.

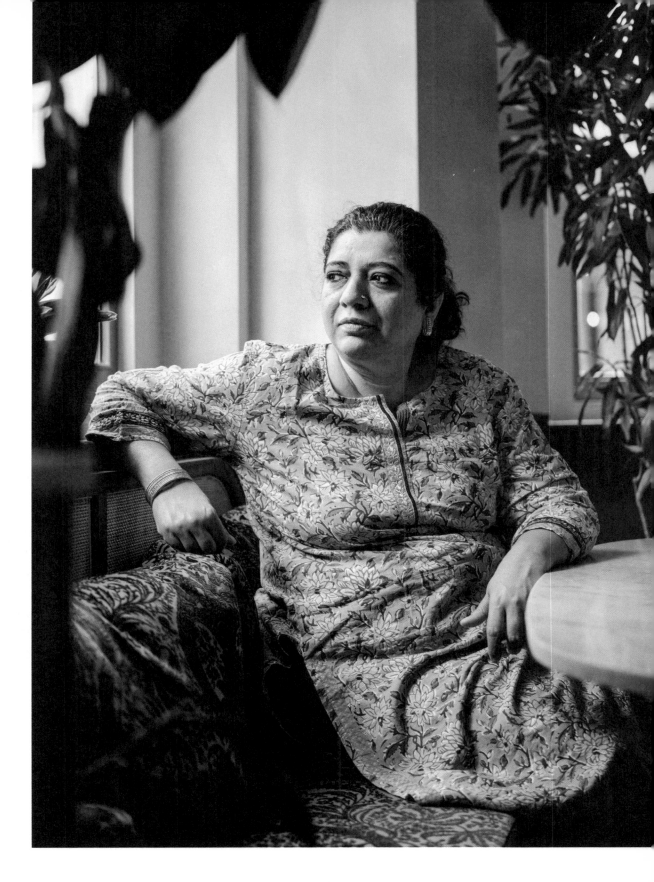

Asma Khan

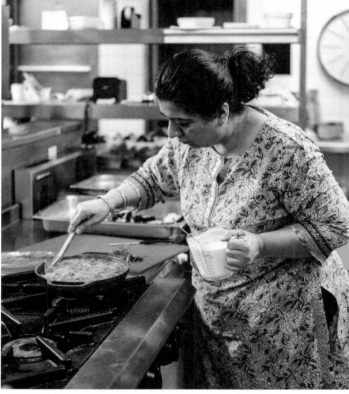

Khan making beef kofta (see recipe overleaf) at her Covent Garden restaurant, Darjeeling Express, which serves Indian dishes lovingly cooked from family recipes.

'You can re-buy ingredients, but the time spent making a dish can never come back. You pour yourself into it.' Her food brings many Indian guests to tears; tears of recognition for 'the twists and the touches that come with this style of cooking. They taste the memories of their childhood.'

Khan's own culinary journey is well known, thanks to Netflix's *Chef's Table* series on which, in 2019, Khan was the first British chef to be featured. The second daughter of a royal Indian family – which itself comes with a stigma – she grew up immersed in food thanks to her mother's catering business. Yet while she would happily sample the fruits of her mother's labour, and that of her servants, 'I wasn't even vaguely interested in cooking. I had no need to be. I never visualised a scenario in which I'd need to cook.'

Fast forward a decade, a Law degree, an arranged marriage and a move to Britain in 1991, and that scenario had vividly materialised. Cold, homesick and alone most evenings while her new husband taught at a university, Khan craved her mother's food – so she went back to India to learn what it took.

She learnt quickly: 'I now realise that by hanging around the kitchens as a child, I'd seen the stages. I knew the balancing of chilli, salt and sugar; the careful preparation of onions for gravy.' Simply watching her mother, aunts and servants in the kitchen had given her an initiation no formal training could rival. 'I weigh with my hands. I measure with my eyes. I don't know what a teaspoon of anything looks like,' she smiles. In a world in which everything from centilitres of stock to social media followers and Michelin stars is meticulously monitored, Khan carves an alternative route.

This starts with the cooking, which is done, as she says, by hand, eye and instinct. 'My women have learnt to cook by watching. They don't have professional training.' Whereas in restaurants, food is normally batch-cooked and prepared in advance as far as possible, 'fridges weren't common in Indian homes. My women don't cook with them. So what you order in my restaurant is made fresh, and you have to wait.'

At first people complained that they couldn't 'just get another rice' – 'but then it arrived, delicate and fresh – and they understood it.' Yet Khan's ambition to disrupt an industry she considers systemically patriarchal goes beyond her kitchen: 'there is femininity in my restaurant, which you sense not because the walls are pink, but because I am challenging the idea that success within hospitality be seen in these male terms: the French *Brigade* system, the aspiration to get a Michelin star, the veneration of the head chef at everyone else's expense.'

This system can produce fabulous food, Khan continues – 'but it is not food that has been created with love or justice.' She is not a chef, she explains, because she is not in that system, and hasn't trained, or risen through any ranks to get there: 'Everyone at Darjeeling Express is paid the same hourly rate.' The reason she wears colourful clothes, rather than chef's whites, the reason she remains outspoken, is because she is 'on the fringes of the closed club of hospitality. But I will keep disrupting. I will call out racism and misogyny. I owe it to generations of women. I owe it to my team.'

'I weigh with my hands. I measure with my eyes. I don't know what a teaspoon of anything looks like.'

Asma Khan's Beef Kofta

'Certain dishes made in Calcutta by the Anglo-Indian community bear a similarity to other dishes. This meatball curry looks like a classic kofta dish but has something distinctive about it – the inclusion of parsley. My friend's mother grew parsley especially for this recipe, even though it was not a herb commonly used by the locals. I presume this was a legacy of the *memsahibs* of the Raj, who probably grew parsley in their gardens. The meatballs are not fried before being added to the gravy, instead they are cooked directly in it. As long as you roll the meatballs tightly and do not stir the contents of the pan too much, they should not break up in the gravy.'

Serves 8

For the meatballs
1 kg/2lb 3oz finely minced beef
2 tbsp parsley, finely chopped
3 green chillies, finely chopped
1 tsp salt

For the gravy
4 tbsp vegetable oil

3 onions, ground to a paste
1 tbsp garlic paste
2 tbsp fresh ginger paste
1 tbsp ground coriander
¼ tsp chilli powder
1 tsp salt
2 tbsp tomato purée
500ml/1 pint thick coconut milk
1 tsp ground garam masala
handful of parsley leaves, chopped (optional)

To make the gravy, in a deep saucepan, heat the oil over a medium–high heat. Add the ground onions and fry for 4–5 minutes. Add the garlic and ginger pastes to the pan and cook for a further 5 minutes. If the contents are sticking to the base of the pan, add a splash of water.

Add the ground coriander, chilli powder and salt to the pan, then cook, stirring, for 2 minutes.

Add 500ml/1 pint water, increase the heat and bring to a boil. Add the tomato purée, then stir until the gravy is smooth. Turn the heat down to low.

Next, make the meatballs. Place all the ingredients in a bowl, mix together and knead gently. Divide the mixture and make 20 golf-ball-sized meatballs, 4 cm/1½in in diameter. Roll each meatball between your hands to make sure there are no open cracks or seams that will make the balls break up in the gravy.

Once you have made the meatballs, increase the heat under the gravy pan to medium. Add the meatballs one at a time. Shake the pan to roll the balls in the gravy. Do not use a spoon to turn the meatballs as they may break. Continue to cook, uncovered, over a low–medium heat for 20–30 minutes. Add the coconut milk to the pan and cook, stirring, for a further 5 minutes.

Before serving, taste to check the seasoning and adjust as necessary. (The only accurate way to assess the seasoning is to taste a meatball with the gravy. I prefer not to season this dish.) To serve, sprinkle the ground garam masala over the curry and mix through. Garnish with more chopped parsley leaves, if you like.

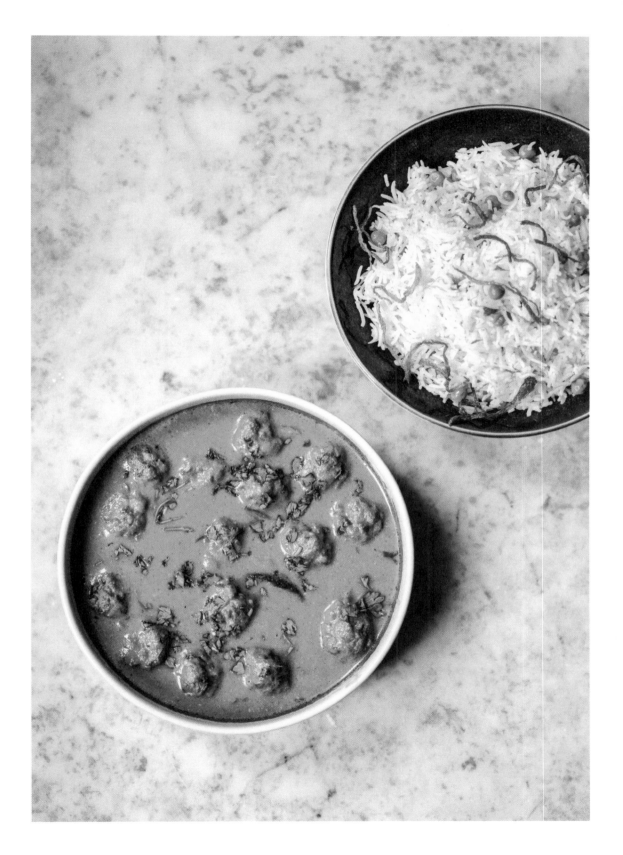

Ixta Belfrage

*Recipe developer and chef who co-authored
a cookbook with Yotam Ottolenghi in 2020*

*'Balancing flavours is one of the few things
that has always come naturally. I don't know
the rules, so I can't follow them.'*

Tucked at the back of Ixta Belfrage and Yotam Ottolenghi's collaborative cookbook, *Flavour*, is an unassuming section entitled 'Flavour Bombs'. Here, an intriguing 'arsenal of flavour-packed condiments, sauces, pickles, salsas and so on' promises to enliven even the simplest of meals. It's an apt description not just for the likes of smoked cascabel oil, blood orange nam jin and curry leaf mayonnaise listed, but more widely for the potency of Belfrage's cooking: informed by the master of fusion, Ottolenghi himself, her cosmopolitan parents and a somewhat nomadic childhood.

'My mum is Brazilian. My dad's father lived in Mexico – and when I was three, we moved to Italy,' Belfrage tells me. 'Wherever we were, I've always found myself in the kitchen – so when I started cooking it was like muscle memory.' That her mother was not an inventive cook stood her in good stead. 'Mum insisted on very healthy, plain food – brown rice and vegetables – and as a child I was so angry at how boring it was, having been exposed to amazing Italian, Brazilian and Mexican food,' she laughs. 'So Mum said, "If you want all these things you keep talking about, you're going to have to learn to cook yourself."'

And learn to cook she did – but Belfrage's instinctual and uninhibited style, perfect for what she does now, was not a natural fit for the restaurant kitchen. 'I hated the idea of being taught how to cook,' she says; yet when she left school the options for careers in cooking seemed limited. After a few unhappy years exploring alternative

Ixta Belfrage

Belfrage at home in London making a plantain omelette with Scotch bonnet salsa (see recipe overleaf).

jobs in travel and design, she began running her own catering business – and eventually ended up at NOPI in 2015.

'I was working such long hours catering, and I didn't know what I was doing really – so I applied for 30 commis chef roles and NOPI invited me in the next day.' In many ways NOPI confirmed Belfrage's suspicions about restaurant culture: 'The hours were crazy, I had no social life and I was really unhealthy.' The kitchen was male dominated, and that inevitably influenced the dynamic. 'Lots of guys were lovely, but the way some spoke about women was problematic. I think the less women there are, the less women apply, the less balanced a kitchen can be.'

Moreover, she was doing 'a terrible job,' she laughs – so much so that when Cornelia Staeubli, one of the founding partners at Ottolenghi, approached her in the kitchen one day, she thought she'd fire her. Instead, Staeubli offered her the life-changing opportunity of a trial in the test kitchen. 'I'd never heard of it before, but Cornelia explained and I thought, "Holy hell! There's a job in food that's Monday to Friday, nine to five? Where do I sign?"'

Belfrage soon found she had an instinctual knack for developing recipes: 'Balancing flavours is one of the few things that has always come naturally. I don't know the rules, so I can't follow them. I don't have a sense of pride that means I have to do something the "right way"' – and where, in the wrong hands, such liberalism might lead to accusations of appropriation, Belfrage's background,

age and mentoring from Ottolenghi makes her as sensitive to culinary heritage as she is to the balance of acidity and heat.

'It's important to be aware of the history of your ingredients; to make sure you are citing your inspiration so readers can educate themselves if they choose to.' Of course, there's a limit: 'Sometimes it's impossible to say the original source of something because every recipe is inspired by another recipe which is inspired by another recipe and so on.' But in so far as it's possible to credit her sources of inspiration, she does so.

It is refreshing in fusion – a genre so loaded even the name is controversial – to hear a chef explain the politics of cooking from different cuisines this simply. 'I'm not an expert. I am inspired by experts, but I would never try to claim expertise or authenticity,' she says – dispelling the myth that fusion is a minefield. 'Fusion is really one of the safest spaces to be.'

The next few years will see Belfrage build on the foundation bequeathed her by Ottolenghi – 'an incredibly kind, intelligent soul, who really expanded my knowledge' – solidifying her profile not just as a recipe writer and chef in her own right, but as a force for good in the industry. 'I want to do what I can to help people from other backgrounds, through mentorship and supporting organisations such as Be Inclusive Hospitality.' Her potential seems boundless: to shake things up, and to simplify; to make complex flavours accessible; to break the rules, respectfully.

'It's important to be aware of the history of ingredients; to make sure you are citing your inspiration.'

Ixta Belfrage's Upside-Down Plantain Omelette with Scotch Bonnet Salsa

'My mother, a Brazilian who grew up in Cuba, is obsessed with plantains. She grew up eating them alongside pretty much every meal and brought my sister and me up in the same way, so now my fruit bowl is never without a pile of blackening plantains. There is a plantain recipe for every stage of ripeness, from hard and green to soft and black. This recipe calls for plantains that are ripe and sweet, preferably nearly all black, with only some yellow marks. In truth, I only ever use plantains at this stage of ripeness. Unripe plantain is no substitute here because you won't achieve the sweet, caramelised layer we're looking for.'

Serves 2 as a main or 4 as part of a spread

For the omelette
120g/4¼oz full-fat coconut milk, from a tin not a carton (at least 75% coconut extract)
6 eggs
½ tsp fresh ginger, peeled and finely grated (or ¼ tsp ground ginger)
1 small garlic clove, finely grated or crushed
1 tsp lime zest
¾ tsp fine salt
5g/¼oz chives, finely chopped
5g/¼oz coriander, finely chopped
40g/1½oz spring greens (or spinach or kale), very thinly sliced
100g/3½oz feta, broken into medium chunks

2 very ripe medium-sized plantains (460g/1lb) – they should be nearly all black and quite soft, with only some yellow marks
30g/1oz ghee or unsalted butter
1 tbsp olive oil, plus extra for drizzling
flaked salt, to serve
lime wedges, to serve

For the salsa
200g/7oz extra-ripe sweet cherry tomatoes
1 tsp lime zest
1 tbsp lime juice
1½ tbsp olive oil
½ tsp flaked salt
1–2 Scotch bonnet chillies (or a milder chilli if you prefer), to taste

Preheat the oven to 200°C/390°F (180°C/360°F fan).

Before measuring out your coconut milk, take all the contents out of the tin and whisk well to combine the solid and the liquid then weigh out the 120g/4¼oz.

Add the coconut milk to a large bowl with the eggs, ginger, garlic, lime zest and fine salt and whisk together. Stir in the chives, coriander, spring greens and feta, then set aside.

Peel the plantains and slice into ¾cm/¼in rounds. You need about 320g/11¼oz peeled slices.

Place a 28cm/11in ovenproof, non-stick frying pan on a medium-high heat and add the ghee (or butter) and the oil. Once the ghee has melted, layer the plantain slices to cover the bottom of the pan, then set a timer for 3 minutes, and cook without stirring or flipping the plantain, to create a caramelised, golden layer on the bottom of the pan. Lower the heat, then pour over the egg mixture to evenly cover the base, and leave to fry for another minute undisturbed. The omelette should be set around the edges but still liquid in the middle.

Transfer the pan to the oven and bake for 8–9 minutes, until the omelette is just set on top, with a good wobble in the centre. Don't be afraid of this wobble, the omelette will set a little as it cools, but also we (or at least I) want the omelette to have a soft, oozing centre! Leave to cool for 5 minutes, then use a spatula to release the sides of the omelette from the pan.

While the omelette is in the oven, make the salsa. Finely chop the cherry tomatoes into very small pieces. Transfer to a medium bowl, using your hands as a natural sieve so you don't take all the liquid and seeds with you (otherwise the salsa will be quite soggy). Stir in the lime zest, lime juice, oil and flaked salt. Very finely chop the Scotch bonnet; they vary substantially in heat level so start with ½ a chilli, removing the seeds and pith if you prefer milder heat. Add to the salsa, stir and taste, then add up to 1½ more finely chopped chillies, to taste.

Place a large plate on top of the pan, then quickly flip the whole thing over so the omelette ends up on the plate. Hopefully all the plantain pieces will end up on the omelette, but if not just peel them from the pan and place them back on top.

Drizzle with a little oil and sprinkle with more flaked salt. Serve with the salsa on the side, and some extra lime wedges for squeezing.

Erchen Chang

*Taiwanese co-founder and head chef
of London's six BAO restaurants*

'Food is my means of expression. So being an artist makes sense.'

'I don't think of myself as a chef or a cook. I think of myself an artist,' says Erchen Chang; and indeed, the fleet of Taiwanese-inspired restaurants Chang has co-created – BAO (in Soho, Borough and Fitzrovia), Café BAO, BAO BAR and BAO Noodle Shop, as well as an online store, Convni, and delivery service Rice Error – build upon a concept dating right back to her final year at the Slade.

'The logo of a lonely man eating a bao is a continuation from my final show – and in BAO restaurants we always draw back to that central image: of a place you can come on your own in the middle of a busy, cosmopolitan world to enjoy a warm bao and a quiet moment.' Of course, at the time of creating that show in 2011, Chang wasn't thinking about restaurants. 'I was interested in art and design, in all its forms, and learning about the processes behind them.' Yet as her interest in cooking grew and the idea of establishing a bao-based pop-up took shape, she found herself applying her artistic training and experience to the kitchen.

'The bao started simply as something fun to try and make, because we grew up eating it,' recalls Chang, who spent her childhood in Taiwan before attending boarding school in the UK. 'Our first one was mediocre – so we played with the recipe, researching and breaking down all the details. Even then, we weren't settling for mediocre. We wanted it to be the best.' Though in practice this seems a long way off from establishing, at first, a successful street food stall, now a mini restaurant

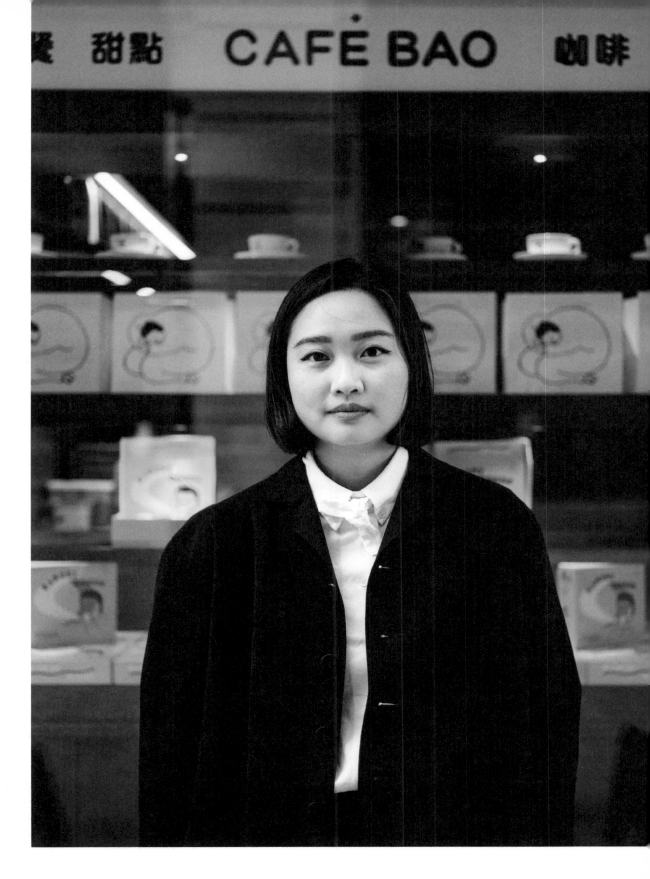

Erchen Chang

Chang making braised pork gua bao with
fermented mustard greens (see recipe on p.50)
at Café BAO in King's Cross.

empire, 'in our minds, there was never much shift. Whether we were doing art, cooking dinner, developing branding or recipes – the way we thought about it and approached it was the same.'

It is thanks to Chang, her husband and business partner Shing Tat Chung, and her sister-in-law Wai Ting Chung that we know what bao is. Indeed, the style of bao they serve has become the definitive bao in Britain. It combines two styles, Chang explains: 'the classic gua bao, which is more bouncy; and a light, fluffy bun we had in the mountains just north of Taipei. It was there that we had our epiphany moment,' Chang recalls. There in the mountains, they realised that if they combined the best of both baos, a British bao-based restaurant 'could really work'.

Understand this, and you'll understand their approach to authenticity, which is informed not by what's most traditional to Taiwan but by 'what works in the context of who we are and what we're doing. I've lived here longer than I have Taiwan; there is part of me that has a British palate,' says Chang. 'I can't separate that, but I'm not afraid to educate people. I'm working on a tripe dish at the moment that is inspired by a Taiwanese recipe – but I'm changing it into something crispy rather than chewy and soft.'

Does this count as catering for 'Western tastes'? 'I don't think about it like that,' she says, 'I am cooking it like that because it tastes good, and makes sense in our context. Like the Western-style cafés in Taiwan that serve burgers heavily influenced by Taiwanese flavours – we have our own genre.'

There is, however, one way in which the BAO group is unequivocally Taiwanese: Chang's grandmother, her greatest culinary influence and, crucially, their soy sauce supplier. 'The aged white soy sauce we use is from a family in the village where she lives. They produce in such small quantities – and they don't ship overseas, so she is the only reason we can get it. But it makes our food taste so good.' Her grandma's influence on Chang's recipe development is more indirect. Laughing, she says 'I do ask my grandma for tips – but she is so vague! She can't say what they do exactly because she's so intuitive in the kitchen.' In the restaurants Chang needs precision: 'We talk about why a cut of meat is cooked this way; we write down quantities. We encourage our chefs to taste, and taste again, even if they've cooked that dish hundreds of times.'

Perhaps the reason the idea of artistry is so important to Chang is because it transcends the dichotomy between her professional rigour, and the more instinctive, more 'feminine' cooking of her grandma, I wonder. While Chang and her colleagues might not follow or even know her grandma's recipes, 'we do want to deliver her memories and sense of care.' When Chang develops new recipes, designs new menus or cooks, 'I am not just creating food,' she says. 'Food is my means of expression. So being an artist makes sense.'

'I cook like this because it tastes good, and makes sense in our context. We have our own genre.'

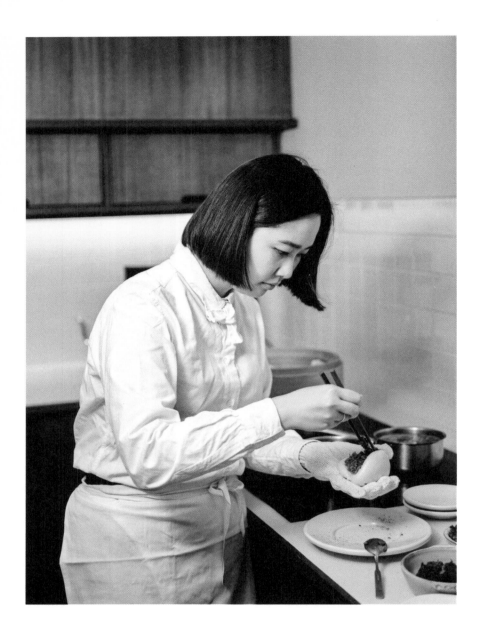

'I've lived here longer than I have Taiwan; there is part of me that has a British palate. But I'm not afraid to educate people.'

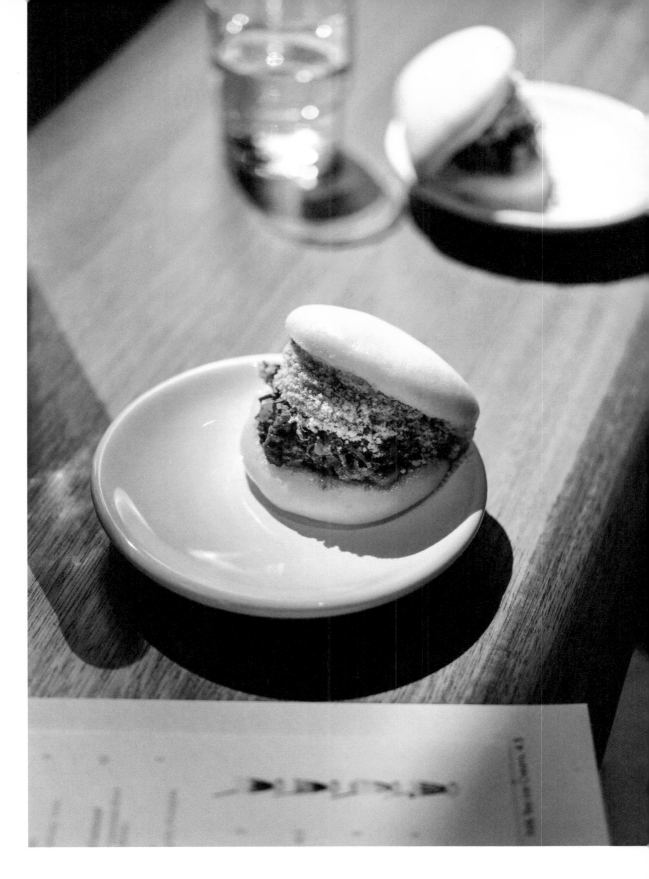

Erchen Chang's Braised Pork Gua Bao

'Back in 2012, when we'd just graduated from university, Shing, Wai Ting and I went on a road trip together to where I'm from in Taiwan. We love cooking and making things with our hands and when we were travelling, we talked about ideas to perfect the bao and search for the perfect balance of this classic. Our braised pork bao features in all of our restaurants, it's the beginning and the core of BAO. It's a great example of taking something with heritage and examining, researching and testing over a period of time to achieve the art of perfection.' Recipe pictured on p.46–49.

Makes around 20

For the gua bao
500g/1lb 2oz plain flour
2 tsp yeast
145ml/5fl oz warm water
2 pinches of salt
50g/2oz sugar
1 tbsp vegetable oil, plus extra for brushing
145ml/5fl oz milk

For the soy-braised pork belly
1kg/2lb 3oz pork belly
50ml/1¾fl oz light soy sauce
40ml/1¼fl oz dark soy sauce
60ml/2fl oz Shaoxing wine
2 spring onions
1 garlic clove, crushed
20g/¾oz fresh ginger,
 sliced and crushed

1 whole star anise
20g/¾oz rock sugar
pinch of garlic powder
4 whole dried red chillies
6g/¼oz cinnamon bark

For the fermented mustard greens
1kg/2lb 3oz Chinese mustard greens
20g/¾oz salt (or 2% salt of the weight of the veg)
2 tbsp vegetable oil
2 tsp doubanjiang (a fermented broad bean paste
 that you can easily find in Chinese supermarkets)
rice wine vinegar, to season

For the peanut powder
200g/7oz deshelled peanuts
2 tbsp caster sugar

To serve
handful of coriander

Prepare the fermented mustard greens preferably 2 weeks in advance. First, wash the mustard greens thoroughly, then chop them into 3cm/1in pieces. Sprinkle the salt evenly over the greens and work your hands through them to ensure the salt is properly mixed in. Sterilise a glass jar and fill it with the salted greens, packed as tightly as possible. After a time, the salt will draw out the liquid from the greens. This liquid should cover the greens – if it doesn't, place something heavy on top to submerge the greens in their own brine. Leave to ferment for at least 7 days, but the longer the better.

On the day, start with the soy-braised pork belly. Cut the pork belly into manageable blocks so that it will easily fit into your pot, around

5x5cm/2x2in. Blanch the pieces first by dropping them into a pot of boiling water for a moment or two, this will get rid of any impurities. Then place the pork in a casserole dish or large saucepan.

Add the rest of the pork belly ingredients to the dish or pan, then pour over cold water until everything is just covered. Bring to the boil, then turn the heat down low. Let it simmer for 2 hours – the simmer should be very low with small bubbles on the surface.

Meanwhile, make the peanut powder. Heat the oven to 175°C/350°F (155°C/310°F fan), place the peanuts on a baking tray and roast until golden, roughly 20–25 minutes. Let them cool completely, then tip some into a food processor and blitz to a fine powder. It is best to do this in small batches, as peanuts have a high fat content and can turn into peanut butter in no time. Mix the powder with the caster sugar and set aside.

While the pork is simmering, start preparing the gua bao. First mix the flour, yeast and warm water together in a bowl. Cover and leave for at least 30 minutes in a warm place until doubled in size. Then add the remaining ingredients and mix until it comes together as one.

Turn the dough out onto a floured work surface and knead for 10 minutes – it will be sticky but gradually become more elastic. Divide the dough into around twenty 40g/1½oz pieces. Give each one of them a strong knead and roll them into tight balls. Place them on baking sheets and cover as you go, to prevent them drying out.

Dust the work surface with more flour and flatten the balled pieces of dough with your hand, then use a rolling pin to roll each one into an oval shape, around 5mm/¼in thick. Brush one side with vegetable oil. With the oiled side up, fold one edge of the dough over onto the other and press down gently so it forms an oyster shell shape.

Place the bao on baking parchment in a warm bamboo steamer (or in whatever you normally use to steam vegetables) and leave to rest for 15–20 minutes in a warm place to rise again.

Meanwhile, drain the fermenting mustard greens and finely chop them. Heat the 2 tablespoons of vegetable oil in a frying pan over a medium-high heat. Add the doubanjiang and let it fry. Once the doubanjiang starts to turn the oil red, add in the chopped, fermented greens and stir-fry for 5–10 minutes, until the greens are super fragrant and wilted. Season with a few drops of rice wine vinegar and set aside.

When the gua bao have risen, place the steamer over a medium-high heat and steam the gua bao for 15 minutes.

While they are steaming, and once the pork has had its 2 hours, remove the pork belly from your dish or pot and set it aside to cool, then discard the spices and vegetables and bring the braising liquid to a boil over a high heat. Reduce to a light, sticky consistency. Once the pork belly has cooled slightly, chop it into rough cubes around 1cm/½in. Add the chopped pork back into the reduced sauce and give it a good stir. Turn the heat down to low and cook for 10 minutes to let the pork mingle with the sauce. Wash and finely chop the coriander.

Check the gua bao are steamed all the way through by pressing one with your finger; if it bounces back nicely it is ready. (If not using straight away, the bao will keep in the fridge for 5–7 days, or in the freezer for up to a month.)

When ready to serve, use heat-resistant gloves to assemble each of the bao with some of the piping-hot silky pork, fried fermented mustard greens, a big pinch of chopped coriander and a dusting of golden, sweet peanut powder. Enjoy immediately.

Pamela Brunton

Chef and co-founder of Inver restaurant in west Scotland, who originally studied Philosophy

'121 years after the Michelin Guide was first printed, which was before women had the right to vote, the world is a different place.'

On 8 June 2020 *Vittles*, a food newsletter started during the pandemic, set out a dream for the future of British restaurants; a dream in which restaurants might be judged, not for the name on the door or the numbers on their menus, but for their contribution towards the environment and society. Its headline was 'Ditch the "Industry"; Save the Restaurant', its author was Pamela Brunton – a chef who, in her beloved restaurant Inver, offers a vision of what that might be.

Located on the shore of Loch Fyne in Scotland, Inver's primary ingredients – those that drive the restaurant's narrative and identity – come from the local area, from small-scale farmers, fishermen and growers who regularly dine and socialise at the restaurant. By ditching the 'industry' – a word

Brunton used as a byword for 'the excesses of capitalism, which are expressed commonly (but not exclusively) in the hospitality industry as the high-end of fine dining' – Brunton has succeeded in creating a restaurant that is truly local. 'The reciprocity in these close relationships build and bind community,' Brunton wrote in *Vittles*. 'Trust and wellbeing circulate with the small gifts of coffee and glasses of wine, the favours returned, the names on the menus reflecting who grew what, where, according to what season it is. These things are what our business gives us, our staff and community, in the ledger entry where profit should be.'

Ultimately it boils down to value systems, Brunton explains on the phone from Inver, two months before reopening after the third lockdown.

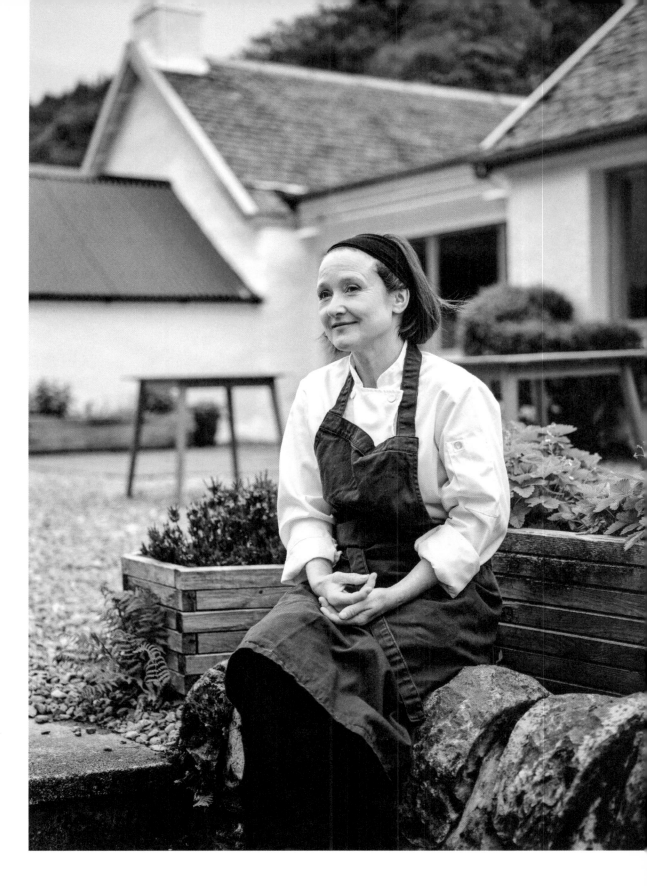

Pamela Brunton

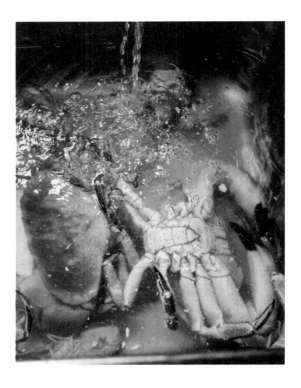

*Brunton preparing locally caught seafood
and foraged flowers at Inver, her restaurant
on the banks of Loch Fyne in Scotland.*

'We are all brought up within value systems, and it can be very difficult to step back from them. But at some point we are going to have to do that,' because as they stand, 'the values by which modern fine-dining restaurants have historically been run serve only to exacerbate the world's problems, rather than improve them.'

What discussions around gender and the kitchen need to focus on, says Brunton, is not women's entry into the professional sphere – 'women have been cooking professionally for millennia' – but the masculine, hierarchical lines along which modern restaurants, particularly fine-dining restaurants, were established 200-odd years ago. 'Typically when men take on a profession that has been traditionally reserved for women, it needs to be publicly lauded. It needs to be valuable.' The restaurant 'industry' – and the media and awards bodies that support it – does not represent the broad spectrum of creed, colour, gender and sexual orientation of the people it employs in this day and age. 'The criteria by which restaurants are judged need to include different ways of viewing the world; need to reflect the fact that, 121 years after the *Michelin Guide* was first printed, which was before women had the right to vote, the world is a different place.'

In fact, the world is first and foremost a place that needs urgent attention; from an environmental perspective and a societal one. Brunton and I speak in a year that has comprised record sea-level rises, the murder of George Floyd, the continued rumbling of the Me Too movement and a global pandemic exacerbated by industrialised food systems. 'At some point, environmental sustainability, racial equality and gender balance needs to be the baseline. Who cares about spurious notions of fine dining if you haven't addressed the state of the world?' she exclaims.

Needless to say, Brunton's a big-picture person; a Dundee-born lass who left a Philosophy degree to work as a chef for eight years, then completed a Master's in Food Policy at London's City University. After graduating, she spent three years putting her newfound knowledge and skills to work at Sustain and The Soil Association – charitable groups who campaign for more sustainable food systems – before returning to Scotland to establish Inver with her partner, Rob Latimer, in 2015. She discusses macro issues with ease – 'I think because of the process I went through,' she says: 'studying philosophy, which is intangible and challenges you to interact with the world using your imagination and intellect, then going into cooking, which is all about tangible outputs, but also means bringing your cultural, personal and historical references to the table.' Yet living and working in a tiny, remote hamlet like Strathlachlan means taking a micro approach, too.

'I live here. I am part of the community here. I want to work with individuals whose names and faces I know and care about, not a computer system.' Sometimes what she does is political, she continues – 'but sometimes it's simply personal. You shouldn't be able to score points for being carbon neutral when your staff are miserable. It needs to be complete.' In Inver, Brunton has found a place and people where philosophy and practicality can be reunited and reconciled; where they feed off each other to create tangible benefits for the area; and where she can explore the idea of a restaurant more in line with the original French derivation of the word: 'to restore'.

'I live here. I am part of the community here. I want to work with individuals whose names and faces I know and care about.'

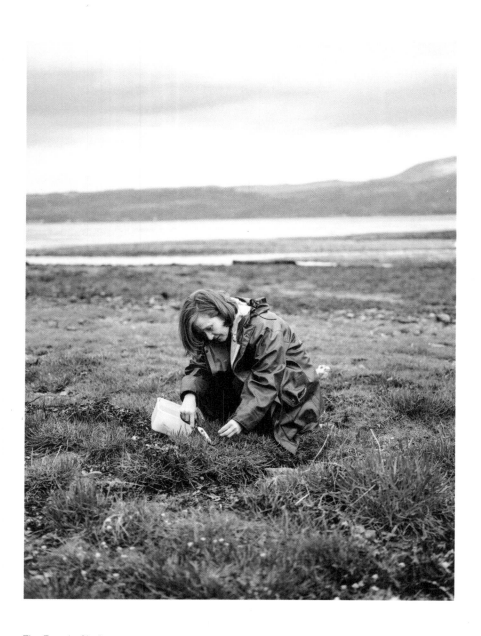

Pamela Brunton

Pamela Brunton's Gigha Halibut, Coastal Greens and Smoky Mussel Butter

'The menu at Inver rolls with the seasons, but the Gigha halibut and smoky mussel butter have been a fixed point in the kitchen landscape for the last couple of years. The halibut hatchery is a few miles from Inver, run by friends and neighbours, and I collect seaweed and sea greens from the lochside shore by the restaurant.'

Serves 1

1 Gigha halibut fillet (around 150g/5oz)
fine sea salt, to taste
vegetable oil, for frying
large handful of mixed seashore greens (e.g.
 samphire, sea blite, sandwort, sea aster,
 sea plantain or arrowgrass, or seaweeds like
 sea spaghetti and dulse), cleaned free of clay,
 shingle and sand, then washed well
butter, for frying

2–3 fresh mussels, cleaned
flaky sea salt, to taste
lemon juice, to taste

For the smoky mussel butter
1kg/2lb 3oz fresh mussels, cleaned
1 shallot, sliced
75ml/2½fl oz white wine (or the same of water)
275g/9½oz cold butter, diced
30ml/1fl oz lemon juice
pinch of sea salt

Start by making the smoky mussel butter. Add the mussels, shallot and wine (or water) to a deep pan, about twice the height of the level of the unopened mussels. Place over a medium–high heat and bring to a boil with a lid on the pan, then reduce the heat and simmer for 45 minutes. Turn off the heat and let the mussels infuse in their liquor for 45 minutes, then tip the lot into a colander set over a large bowl, mixing the mussels around to allow all the juice to drain out of the shells. Strain the liquor through a fine sieve lined with muslin cloth.

Now to hay-smoke the mussels. You can do this on either a covered barbecue or in a sturdy pan with a lid. If using the latter, line the base of the pan with aluminium foil, then place a large handful of hay on top and set it alight. Pick the meat from half of the spent mussels and add it to a colander or steel sieve;

place this over the smouldering hay and put on the lid. Smoke for 20 minutes, stirring and relighting the hay halfway through. Pour the mussel liquor back into the pot and bring to a simmer, then turn off the heat. Add the smoked mussel meat to the pot and leave to infuse for 30 minutes, then strain again.

Pour the mussel liquor back into the pot once more and bring to a simmer until reduced by a third and you have around 200ml/6¾fl oz of liquor. Add a piece of the diced butter to the liquor and, using a hand-held immersion blender, blend until emulsified. Repeat piece by piece with all of the butter, then stir in the lemon and salt. Set aside until needed – this makes enough for 10–12 servings (it's hard to make a smaller quantity), but it freezes well.

When ready to prepare your dish, first lightly season the halibut fillets with the fine sea salt. Place

a frying pan over a high heat and add a little vegetable oil. Once the oil is hot, place each piece of halibut skin-side down in the pan. Cook without moving the fillets for 1 minute, then turn the heat down to medium and continue to cook for another 2 minutes.

Meanwhile, lightly blanch the greens in boiling water and steam open the mussels.

Once the fish has had its 2 minutes, add a little butter to the pan, and when it melts and foams, spoon the hot butter over the fish to finish the cooking. A 150g/5oz fillet will rarely take longer than 4 minutes to cook through. Remove from the pan to a shallow bowl or plate and season with flaky sea salt and a squeeze of lemon juice.

Add the blanched greens and steamed mussels to the side of the fish, then spoon over the warm smoky mussel butter.

Angela Hartnett

Restaurateur, cookbook author and campaigner
with two Michelin stars and an MBE

'My aunt always says, women do run everything,
in a way. They just don't go on about it.'

In October 2020, midway through one of the worst years restaurants have ever known, famed chef and restaurateur Angela Hartnett stepped into the limelight once more: not to judge a competition, nor even to cook, but to join other chefs in campaigning for a Minister of Hospitality to represent the interests of the industry.

The campaign, dubbed 'Seat at the Table', was inspired by what many considered to be the inadequate handling of the tribulations faced by hospitality during the pandemic. Its potential to address the industry's more systemic problems, however, is far-reaching. 'If we want to continue to be world beating; for men and women to have the passion and skills for hospitality, then we need investment,' Hartnett points out – in education,

training and in public perception. 'If the government keep referring to us as unskilled workers, how are we going to persuade parents or kids to consider hospitality as a career?'

If successful, the campaign will be the latest leap of several huge strides Hartnett has made on behalf of women in hospitality, explicitly and implicitly. She was the first woman to run the kitchens at The Connaught Hotel; the first female chef to win the prestigious Catey Award; and has won two Michelin stars so far in the course of her career. Her work has given rise to extraordinary female talent: from the chefs she's trained, or judged on television, to the many she's inspired or advised – including Nieves Barragán Mohacho (p.96) and Gizzi Erskine (p.84). Yet Hartnett has

Angela Hartnett

Hartnett's Michelin-starred restaurant
Murano, in Mayfair, focuses on modern,
Italian plates inspired by her childhood
spent cooking alongside her Italian
grandmother and aunts.

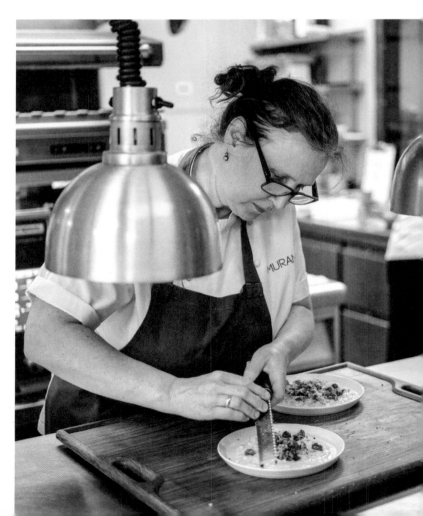

never given preferential treatment to women nor sought it herself, either in her own restaurants or when working for Gordon Ramsay – she reports ignoring Ramsay's suggestion that she cut short her night shifts to get home safely, insisting instead on doing the same hours as everyone else.

It is striking that, over a decade after she left Ramsay's restaurant group, journalists interviewing Hartnett continue to fish for gossip on the *Hell's Kitchen* host. Apart from detracting from her success since, this constant wheeling-out of what Hartnett calls 'the Gordon bandwagon' has the effect of painting his kitchens as uniquely aggressive when 'you'd have found that energy in any high-pressured environment in those days. I don't believe people weren't screamed at in journalism, for example, or TV. I think, as an industry, we give ourselves a harder time than we need to. Most employers with sense know that to recruit and retain good people, being a good employer is critical. We're in a recruitment crisis; no one is going to make it harder on themselves by creating a nightmare for employees.'

Unsurprisingly for a chef who has spent her life fielding questions around the issue, Hartnett is wary of any sweeping generalisations when it comes to men and women in professional kitchens. Even the suggestion that female chefs might be more inclined to draw on the cooking of their mothers and grandmothers does not go unscrutinised: 'I cook my Italian family's recipes now, but I only started that later in my career; I cooked far more French cuisine at first, which is how I'd been trained.' Meanwhile Raymond Blanc, Massimo Bottura, Nuno Mendes, 'so many male chefs, in fact, talk about the influences of their mums and grandmas. To claim otherwise is a disservice to cultural heritage. My aunt always says, women do run everything, in a way. They just don't go on about it.'

Of course, this is not to say there isn't a distinction between restaurant cooking and home cooking; indeed, it is a distinction Hartnett is acutely aware of, having judged both *Great British Menu* and *Britain's Best Home Cook*. Yet the romantic idea that there is somehow more 'love' in a dish your mum has cooked than there is one a chef has produced is, she says, somewhat misplaced. 'A stressed mum cooking for a family of five isn't going to cook with love every night,' she says, and she has a point: the pandemic's lockdowns saw even the foodiest among us reaching for the ready meal at times. 'A good chef brings all of what they know to the kitchen: knowledge, experiences, history – and passion. That's important. The moment a chef's cooking without feeling, they're out of a job.'

'A good chef brings all of what they know to the kitchen: knowledge, experiences, history – and passion.'

'So many male chefs talk about the influences
of their mums and grandmas. To claim
otherwise is a disservice to cultural heritage.'

Angela Hartnett's Anolini

'Making anolini at Christmas is a long-standing tradition in my family. In fact, these ravioli-type parcels, filled with a stuffing based on a veal and beef stew mixed with breadcrumbs and Parmesan, are made by everyone in Emilia-Romagna. I've been making them with the women in my family ever since I can remember, and I will probably continue to do so until the day I die. I use my grandmother's traditional anolini stamp to cut them out, but you could use a fluted cutter or a shot glass instead. The quantities given here are those we'd make at home, the idea being that you get at least two meals out of this recipe: the anolini in broth and then the cold, sliced meat to eat another day.' Recipe pictured on p.66–67.

Serves 8–10 as a starter

For the pasta dough
400g/14oz '00' pasta flour
½ tsp salt
4 eggs (plus 1 extra for an egg wash)
1 tbsp olive oil

For the pasta filling
100ml/3½fl oz olive oil
50g/2oz butter
1 onion, roughly chopped
1 carrot, roughly chopped
1 celery stick, roughly chopped
1 leek, roughly chopped
leaves from 2 sprigs of fresh thyme
1½kg/3lb 5oz chuck beef, in one piece
500g/1lb 2oz veal rump, in one piece
120g/4¼oz Italian sausage (I like Lugano, but use anything slightly spicy)
2 tbsp tomato purée
good splash of red or white wine

800ml–1 litre/1½–1¾ pints chicken stock
200g/7oz freshly grated Parmesan, plus extra to serve
100g/3½oz stale white breadcrumbs
salt and freshly ground black pepper

For the meat broth
200g/7oz beef brisket
100g/3½oz smoked bacon (Alsace if you can find it) or pancetta, in one piece
1 Toulouse sausage, about 50g/2oz
1 x 1½kg/3lb 5oz free-range chicken, jointed into 8–10 pieces
1 onion, chopped
1 celery stick, chopped
1 leek, chopped
1 carrot, chopped
1 head of garlic, cut in half horizontally
1 sprig of fresh thyme
1 bay leaf
salt and freshly ground black pepper

To make the pasta dough, mix the flour and salt together and tip onto a work surface or board. Make a well in the centre. Mix together the 4 eggs and the oil and pour two-thirds into the well, reserving the rest. Starting from the outside, work the flour into the liquid until a dough forms. The dough is conditioned by its environment, so depending on the warmth of your kitchen and hands, you may need to add the remaining egg mixture if the dough doesn't come together.

Knead until it is smooth, firm and elastic (this will take 5–10 minutes). Wrap in clingfilm, then in aluminium foil, and rest in the fridge until needed.

To make the filling, first heat the olive oil and butter in a large pan over a medium heat. Add the onion, carrot, celery, leek and thyme leaves and cook gently, stirring occasionally, until soft and caramelised, about 5–10 minutes. Remove the vegetables from the pan and set aside.

Add the beef and cook on all sides until browned, about 5 minutes. Add the veal and sausage and continue to brown for another 10 minutes. Return the vegetables to the pan, add the tomato purée and cook for a further 2 minutes. Add the wine and allow it to bubble and reduce completely. Stir, then pour over enough chicken stock to completely cover the meat. Place a cartouche (a circle of baking parchment) over the mixture, reduce the heat to as low as possible, and cook gently for 2½–3 hours, stirring occasionally. The meat should be soft enough to cut with a spoon. Remove the meat from the pan and set aside, reserving the juices. Allow to cool, then refrigerate until completely cold, before cutting half the meat into 5mm/¼in dice. Set aside for the anolini filling. You can slice the rest of the meat and serve it cold.

Put the Parmesan and breadcrumbs into a bowl and add enough of the reserved meat juices to form a soft paste. Add half the diced meat and mix well. Check the seasoning and refrigerate until ready to use.

Meanwhile, prepare the meat broth. Cut the brisket, bacon and sausage into large chunks about the same size as the chicken pieces. Put the chopped meat and the chicken into a large pan and cover with cold water. Bring to the boil, then reduce the heat and simmer for 1 hour, skimming off any scum as frequently as possible. When the meat has cooked for 1 hour, add the remaining broth ingredients, then simmer for a further 1–1½ hours. Continue to taste and season until you feel the flavour is right. Strain the liquid through a sieve into a clean pan and discard the meat.

While the broth is simmering, remove the pasta dough from the fridge and unwrap. Cut the dough into 3–4 pieces and use a rolling pin or the palm of your hand to flatten a piece to the width of your pasta machine. Make sure your pasta machine is on its widest setting, and run each piece of dough through it twice. Reduce the setting by one notch and run it through twice again. If the dough feels a bit sticky, add a little flour, but not too much, as this will dry it out. Run it through the machine twice on each notch until you get to the narrowest notch. Halfway through this process you will need to fold the dough in half before finishing rolling.

Finally run it twice through the narrowest notch, then cut into a long strip 10cm/4in wide.

Put two-thirds of a teaspoon of filling at intervals along the strip, about 2½cm/1in apart and two thirds of the way down the strip. Brush between and around each mound of filling with egg wash (a little beaten egg and water). Fold over the long side of the pasta nearest to you so that it completely covers the filling. Cup your hand and carefully press down around each mound to get all the air out. Using a 3–4cm/1¼–1½in cutter or shot glass, cut out individual rounds.

When ready to serve, bring the meat broth back to the boil. Tip in the anolini and cook until they rise to the surface, about 3–4 minutes. Serve the broth and anolini in shallow dishes, sprinkled with freshly grated Parmesan.

Chantelle Nicholson

New-Zealand born chef, cookbook author and owner of Tredwells restaurant in London

'Kitchens have changed so much in the past five years, and I'm excited to be in a position where I can help dictate where we go now.'

When I visit Chantelle Nicholson's pop-up restaurant in Hackney, All's Well, in early 2021, I find that the walls have been painted pink: a pale, dusty pink, the colour of June roses and strawberry milkshakes. The bar back is burnt orange. It is, Nicholson says, looking proudly around the first space she has opened under her own name, 'the complete opposite of Tredwells' – the restaurant in Covent Garden she opened under, and then inherited from, her former boss Marcus Wareing – 'because Tredwells was never me.'

'It was a very "masculine" environment,' she continues, referencing Tredwells' brass detailing, mahogany tables and dark green leather banquettes, 'so when I did All's Well I wanted to rebel against that. It's been interesting because a lot of people who have come here who know me have remarked, "This is the essence of you."'

That is not just on account of its pinkness. A hyper-seasonal, sustainable concept whose menu is shot through with humour and creativity, All's Well was Nicholson's lockdown baby, born in the autumn of 2020. 'The reason for doing it was partly because Covent Garden was so quiet, so I had double everything; partly because I coveted a community,' she explains. She signed a six-month lease on a site sandwiched between a laundromat and a fried chicken shop, after falling in love with east London during lockdown runs along the canal.

All's Well feels right: for the times, which are uncertain; and for her career, which has 'come full circle: I started out baking, and now I'm here, I am

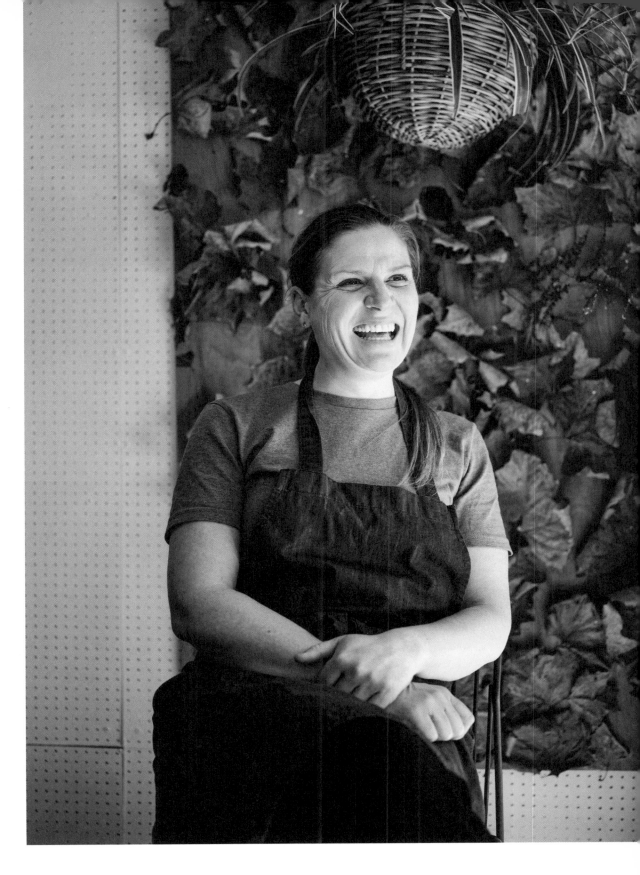

Chantelle Nicholson

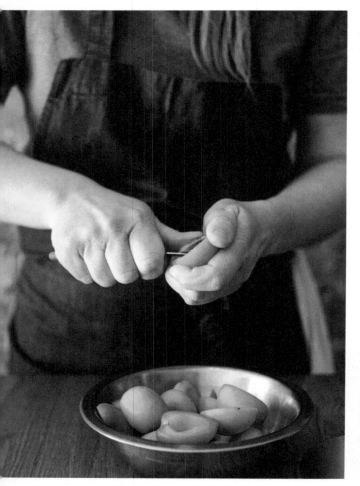

Nicholson at her Hackney pop-up,
All's Well, making apricot tarte tatin
(see recipe overleaf).

baking again.' That she is baking strawberry and thyme shortcake with almond créme at her own restaurant, as opposed to the breakfast muffins at someone else's, is just one marker of how far she's come.

Nicholson's career in food started when she took a Saturday job at a local café in New Zealand, her home country, to earn some money while studying Law. This turned into a full-time job, which turned into the Gordon Ramsay scholarship competition – and suddenly she was in London, in The Savoy Grill by Marcus Wareing. 'I remember walking into this huge, busy kitchen, asking myself, "Is this actually happening?" I had no idea what I was getting myself into, I think, when I reflect on it now.'

In fact, the Savoy was nothing in comparison to Pétrus, where Wareing moved her a few years later. 'That was horrific. I used to cycle there thinking, I wish I could be knocked off my bike so I don't arrive. If I'd started at Pétrus, I'd never have stayed in this industry.' In fact, Nicholson made moves to leave – and it was in doing so that she developed her renowned business relationship with Wareing. He enlisted her help in the operational side of the business, and they opened The Gilbert Scott in the newly developed St. Pancras Renaissance Hotel.

There, she was 'exposed to every little bit of running a restaurant': the reservation system, social media, rotas and finances. Now she has her own restaurants, she does all of that as well as the menu. 'When I think about the women-led restaurants I know, they do everything,' she reflects. 'If I ask a woman what reservation system she uses, she will be able to tell me which one and why. Many men wouldn't know the difference between them: they just do the kitchen. Same with social media

and emails. I can't think of many female chefs who have a PA.'

It's more a statement of fact than a criticism – but it's frustrating that female chefs are so rarely in the media, given how much more abreast they are of their businesses. 'It is always the same white male chefs the media turn to for comment. The media talk about trying to support [diversification in the industry], but they do the opposite' – something that was particularly evident during the pandemic, when Angela Hartnett (p.62) was notably the only woman given a platform to speak on hospitality's behalf.

Though Nicholson has never considered her gender a barrier, she is acutely aware of the need for change. 'Having children.' Her immediate answer when I ask if she's had to compromise anything to get to where she is today. 'There's a reason there aren't many female chefs with children; and that those who have, have found it challenging – because it's almost impossible to take a year out.'

Still, she remains optimistic. A few years ago she walked into Tredwells and realised the ratio of women to men was 70:30. 'I've never taken gender into account, but I think when you have a strong female presence in the kitchen, women feel more confident about applying to work with you. They know they can ask certain questions. Kitchens have changed so much in the past five years,' she continues, 'and I'm excited to be in a position where I can help dictate where we go now.' And, as she looks to develop All's Well beyond its brilliantly successful appearance in east London, I for one will be following along for the journey.

'I can't think of many female chefs who have a PA.'

Chantelle Nicholson's Apricot Tarte Tatin

'Making tarte tatin was one of the first jobs I had to do when I started at The Savoy Grill. I had never made, nor eaten, one before, so it was a wonderful discovery. And apricots have a special place in my heart – I am lucky enough to have eaten the best, grown by my family in Central Otago; gently plucked from the tree, sun-ripened and super sweet.'

Serves 2

160g/5¾oz all-butter puff pastry
50g/1¾oz butter (kept in the fridge)

8 apricots
50g/1¾oz caster sugar
½ a piece of star anise
créme fraîche, to serve

Roll out the puff pastry to 3mm/¼in thick, then pop it onto a piece of baking parchment and put it back in the fridge for 20 minutes so the pastry can rest. Meanwhile, preheat the oven to 195°C/380°F (175°C/350°F fan), remove the butter from the fridge and halve and destone the apricots.

Remove the pastry from the fridge and cut a circle to fit a small, ovenproof saucepan (approximately 12–14cm/5–5½in in diameter). Place the pastry circle back on the baking parchment and return to the fridge.

Cut the butter into 4 pieces then press it firmly into the saucepan, using the top part of a clenched hand, into an even layer. Sprinkle over the sugar and shake the pan to distribute it evenly.

Grate 2 petals of the star anise onto the sugar. Push the side of one apricot half, skin down, into the sugared butter then lay the rest around the outer part of the pan, covering each other like fallen dominoes and finish with two in the centre (see image on **p.72**).

Remove the pastry from the fridge and place on top of the apricots in the very centre of the pan. Cook over a medium-high heat until the butter and sugar begin to bubble and a golden caramel begins to form around the edges of the pastry. Put in the oven for 40–50 minutes, until the pastry is cooked through and golden. Allow to rest for 5–7 minutes before placing a plate on top of the pan, then flip the entire pan over so the tarte tatin slips gracefully onto the plate to be sliced. Serve with créme fraîche and anything else you fancy – ice cream, custard or cream.

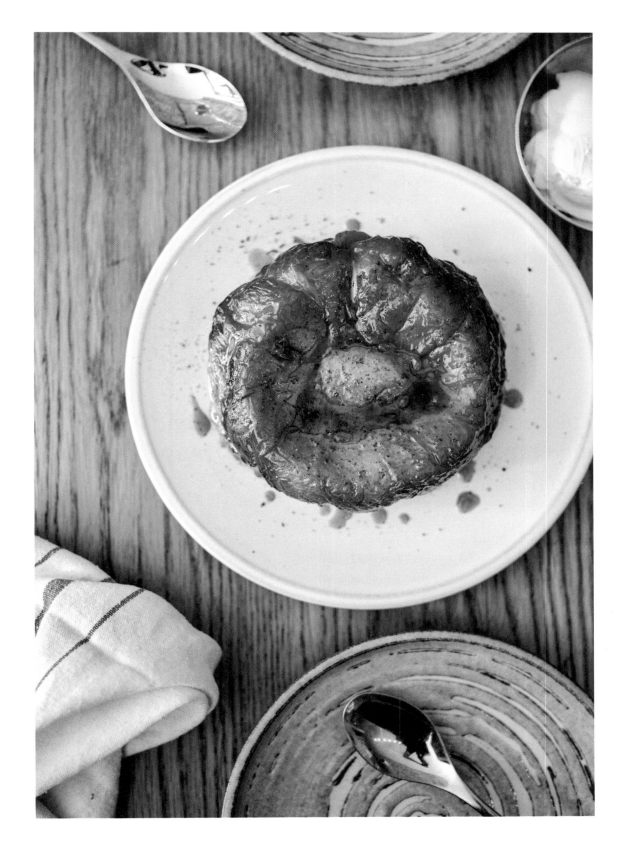

Emily Scott

*Cornish chef and restaurateur who opened
Emily Scott Food at Watergate Bay in 2021*

'I've been cooking quietly and consistently for a long time; now I am happy putting myself forward and feeling good about it.'

You could be forgiven for thinking Emily Scott was new to the British restaurant scene. Her first book, *Sea & Shore*, came out in 2021; her TV debut was in 2019, on *Great British Menu*. The year before that, she appeared as a 'new entry' on CODE's list of the 100 most influential women in hospitality. She is a new face – at least to those beyond Cornwall, for whom the county has historically been the stronghold of Rick Stein, Paul Ainsworth and Nathan Outlaw. Yet Scott has been a chef, and a successful one, for 20 years; only now does she feel 'more confident in what I've created, and in being in the limelight. Maybe it's being older,' she muses, 'but now I am 45, and I've been cooking quietly and consistently for a long time, I am happy putting myself forward and feeling good about it.'

When we speak, Scott is on the cusp of opening what will be, not her first restaurant by any means, but her first restaurant under her own name: Emily Scott Food at Watergate Bay. It's a big deal, she says – 'because I am ambitious, but as someone who has struggled with self-doubt, I have always preferred being behind the scenes.' Prior to this, she ran a pop-up in the old Jamie's Fifteen Cornwall building, next door, and previous ventures include heading the kitchen at St. Tudy Inn near Bodmin and founding The Harbour Restaurant in Port Isaac, which she opened when her youngest child was two years old. 'I didn't just have one child; I had three, in four years, so they've been on this brilliant journey with me,' she says – 'not because I had a huge ego, but because I needed

Emily Scott

Scott preparing a vanilla-seeded panna cotta and blackberry compote (see recipe on p.82) at her restaurant on the beach in Cornwall, Emily Scott Food at Watergate Bay.

to work. I'm quite capable, really,' she reflects quietly. 'I am quite brave.'

'Quite' is an understatement. Take St. Tudy Inn for example, a traditional boozer beloved by locals for its rustic charm and decent ale selection. It's not every woman that could rock up and take charge of running it, fresh from a divorce and with three young children in tow. 'With a pub, people feel like they own it. You're trying to please such a huge number of different people, and they must have looked at me, with my kids and my dog and thought, "What have we here?"' she laughs. 'I won't miss the criticism. But it was one of the best things I've ever done, even though it was one of the most challenging and difficult. It taught me that you can't be everything to everyone – and it gave me a platform.'

For Scott's many Cornish fans it has been rather amusing to see her catapulted into the national consciousness, after decades of local popularity. 'It's funny,' she says, 'because if you're thinking about well-known chefs in Cornwall, I am very much on that list.' She is beloved by patrons and peers alike: 'Nathan [Outlaw], Rick [Stein] and Mitch [Tonks] gave me lovely quotes for my book. They are always very supportive.' These names may be better known than Scott's outside of Cornwall – for now – but there's no sense of competition or jealousy. Her goals are quieter, more local and more community focused than fame and Michelin stars – as testified, perhaps, by her being chosen in spring 2021 to host the G7 Summit in Carbis Bay. 'I have a strong sense of what I am doing,' she says, 'and it's nice to get more recognition for that. But I am a humble chef, and I don't think that's a bad thing.'

Indeed, there is a part of Scott that feels she is not a chef, so much as a cook: 'I can't bear being boxed and I feel like a "chef" is this sort of butch, knife-wielding person. It comes with a sense of hierarchy, and I don't like the hierarchies in the kitchen. I don't need ranks.' The word 'cook', on the other hand, evokes 'a sense of wanting to nourish, and look after people, and bring them together. It is a nicer word,' she continues – and one, moreover, that needs reclaiming.

'It's not just about the food. It's about the feeling you generate: the style, the wine, the atmosphere, the setting.' To renounce the word 'chef' is not to downplay her training or experience, which are extensive, but to 'reclaim and elevate cooking', and all its connotations of care, generosity and self-sufficiency. 'I am not reliant on anyone. If my team left tomorrow, I could do it again; I have done that before, with the help of my children Oscar, Finn and Evie, my partner and my close friends,' says Scott. 'I am chef lead – but I am a cook at heart. And I think that is why my brand is slowly growing.'

'I don't like hierarchies in the kitchen. I don't need ranks.'

'It's not just about the food. It's about the feeling you generate: the style, the wine, the atmosphere, the setting.'

Emily Scott's Vanilla-Seeded Panna Cotta and Blackcurrant Compote

'A wonderful pudding to eat on a warm summer's day, I actually cook this throughout the year, changing the fruit that it is paired with depending on the season: candy pink forced rhubarb in January, raspberries and English strawberries in the summer, but my favourite is blackcurrant compote. The panna cotta is so delicious, cool and soft that I think the sweet, sharp blackcurrants are the perfect accompaniment.'

Serves 6

For the panna cotta
800ml/1½ pints double cream
150ml/5fl oz semi-skimmed milk
1 vanilla pod, split
2½ sheets of gelatine
150g/5oz icing sugar, sifted

For the blackcurrant compote
300g/10½oz blackcurrants, picked over and
* removed from the stems*
200g/7oz caster sugar

For the shortbread (makes about 12)
300g/10½oz unsalted butter, softened
135g/4½oz soft light brown sugar
420g/15oz plain flour, plus extra for dusting
caster sugar, for sprinkling

You can make the shortbread ahead of time. Preheat the oven to 170°C/340°F (150°C/300°F fan) and line a baking sheet with baking parchment.

In a large bowl, beat the softened butter and light brown sugar together until smooth. Sieve over the flour and mix until the mixture comes together into a smooth dough. Turn out onto a lightly floured work surface and use a rolling pin to gently roll the dough out to 1cm/½in thick. Cut into rounds – I usually like to use a pretty, star-shaped cutter – and place on the prepared baking sheet. Sprinkle with sugar and chill in the fridge for 15 minutes.

Transfer the sheet of shortbread to the oven and bake for 10–15 minutes until lightly golden. Transfer to a wire rack to cool, then sprinkle with more sugar.

For the compote, wash the blackcurrants in cool water and place in a saucepan. Add the sugar and bring to the boil over a medium heat, then reduce the heat and simmer for about 5 minutes, or until the blackcurrants have softened and split. Transfer to a bowl and allow to cool completely before chilling in the fridge.

To make the panna cotta, place half of the cream, all of the milk and the split vanilla pod into a heavy-based pan and slowly bring to a simmer. Once simmering, remove from the heat and leave to infuse for 10 minutes. Immerse the gelatine in a small bowl of cold water and leave to soak. In a separate bowl, combine the remaining cream with the icing sugar.

Return the infused cream mixture to the heat to warm through. Remove the gelatine from the

water, squeezing out any excess liquid, then add to the warmed cream and stir to dissolve. Pour the infused mixture through a fine sieve onto the cold cream and icing sugar and stir well. Pour into French glasses, then chill in the fridge for at least 3 hours. To serve, arrange the blackcurrant compote and crumble some shortbread on top of each panna cotta.

Gizzi Erskine

Cookbook author, food writer, restaurateur and
TV presenter who once worked as a body piercer

'I know being okay-looking has helped me in TV,
but I feel like that's bigger than my talent to some
people. You don't see the men getting that.'

'When I walked into St. JOHN Bread and Wine on my first day and was told we were going to break down a whole goat, I thought, "This is it. This is what I want",' Gizzi Erskine recalls animatedly. At first, it's hard to imagine, Erskine being – among many things – impossibly glamorous; yet nothing encapsulates the chef better than this image of her standing by head chef Fergus Henderson, with her signature eyeliner and beehive, geeking out over goat anatomy.

Erskine eludes categorisation. Classically trained at Leiths School of Food and Wine, her most recent venture sees her collaborating with the rapper Professor Green to sell stuffed-crust pizzas in Hammersmith. Prior to that, she opened The Nitery: a high-end, West End restaurant resi-dency that received five stars from the famously finickity critic Giles Coren. She's penned seven cookbooks and had a regular *Sunday Times* recipe column and two TV series, but spent her teens and early twenties as a body piercer in Camden. In short, the only through-line in Erskine's wide-ranging career is Erskine herself: her irre-pressible personality, and her obsessive passion for process.

'Grant [her boss at the body piercing studio] was as meticulous as anyone I've met in the food industry – more so, I think,' she enthuses. 'I learnt about anatomy, physiology, disease, different metals, first aid – it was never just about putting a hole in people. You can be creative' – and she is, extraordinarily so – 'but what Grant showed me

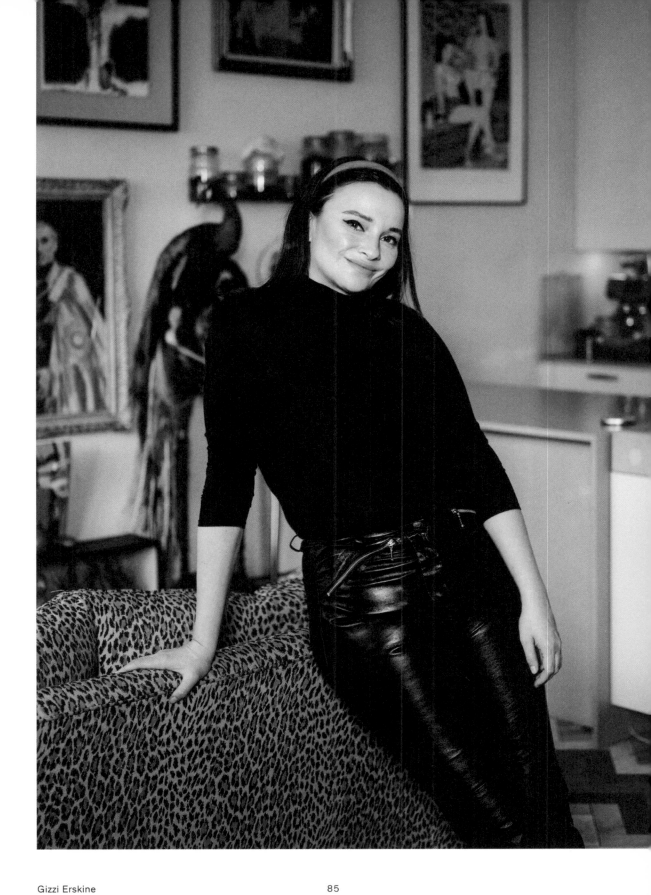

Gizzi Erskine

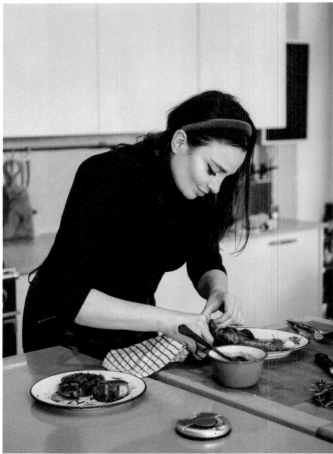

Erskine at home in London, making lamb chops, chargrilled spring onions and romesco sauce (see recipe overleaf).

was that to be really good you've got to be detail-orientated and understand the background of what you do.'

Hearing that, it is easy to see what drew Erskine to St. JOHN, with its nose-to-tail, produce-led approach. Yet what drew her to food in the first place was not technique so much as feeling. 'I remember Mum having dinner parties, and me and my sisters helping out as front-of-house staff. From a very young age, I knew that a sense of occasion came with good food.' She loved the science of it: 'building something, the process of making and creating' – but she also, thanks to her mum, understood food's emotional resonance. 'I remember cooking for my sister when we were at boarding school, because she wasn't well, and Mum talking me though her recipe for sweet-and-sour pork. It was so good to be able to feed someone, and I loved Mum passing the recipe on to me.'

By the time Erskine got to Leiths, age 22, she was hungry to succeed. 'I'd already had a career. I just wanted to learn and qualify – so I worked my arse off.' Unable to afford relinquishing her job at the body-piercing studio, she worked day and night, 'living in a squat,' she recalls. 'Everyone had partners or money to fall back on. I had nobody.' Halfway through, she had a breakdown. 'I was getting evicted. I was exhausted. And I passed out at school,' she says – at which point Leiths' principal, Caroline Waldegrave, stepped in and offered to support her. 'She refused to let me quit. She gave me confidence, invested in me – and I smashed it. I came top of the year, won all the prizes, and an internship at BBC Good Food,' Erskine recalls proudly.

The chef's work ethic is formidable. Though she's not proud of leaving school at 15 – 'I was a brat', she explains, simply – it was 'the best thing that could have happened professionally. I needed to prove myself afterwards.' The same goes for the prejudice she's experienced since, from cynics of both genders who chalk her success up to 'what they assume to be a "domestic goddess" appearance, when in fact what I wear is based around the music I love.'

'It's misogyny,' she says bluntly. 'I know being okay-looking and having a "vibe" has helped me in TV, but I feel like that's bigger than my talent to some people. You don't see the men getting that.' The fact that, as a 41-year-old author, television host and chef, 'I still have to battle with people who believe I've sucked someone off to get where I am is horrible – but in the end, I'm grateful for it, because it's 100 percent made me strive harder and achieve more.'

'From a very young age, I knew that a sense of occasion came with good food.'

Greenhouse Romesco Sauce with Chargrilled Spring Onions

'Classically, romesco sauce is made from red peppers, but I make it with whatever I can get my mitts on and while paler, this sauce is punchier. I'm a vinegar fiend. If you're a little less into acidic food then hold back a teaspoon or two of the vinegar. I serve this with overgrown spring onions as I'm not able to find British-grown calçots that easily.'

Serves 4

2 red, orange or yellow peppers
1–2 large vine-ripened tomatoes
30g/1oz blanched almonds
4 large, overgrown spring onions
1 garlic clove, finely grated

3 tbsp sherry vinegar
rounded ½ tsp smoked paprika
good pinch of cayenne pepper
1 tbsp tomato purée
3 tbsp olive oil, plus extra for drizzling
sea salt and black pepper

Whack the oven up as high as it goes, and once up to temperature, put the peppers and tomatoes on a baking tray. Roast for about 15 minutes until they are soft and the skins are beginning to char and peel away easily. Once they've got to this stage, remove from the oven and allow to cool enough to handle so you can pull away the skins from both and the seeds from the peppers.

Next put the almonds on a baking tray and place in the oven for a few minutes until nice and brown, being careful not to let them burn.

Now, classically the spring onions would be grilled on the barbecue, but for ease I can tell you that you can get a good result by roasting them, whole, in the hot oven for 10 minutes until they start to char. Alternatively cook them on a hot griddle pan. Set aside and once cool enough to handle, cut them in half lengthways.

At this stage, put the peppers, tomatoes, almonds, garlic, sherry vinegar, smoked paprika, cayenne, tomato purée and olive oil into a food processor with 1 teaspoon of salt. You don't want this super smooth, so I recommend pulsing in the processor until it's well blended, but there is still texture from the almonds.

To serve, check for seasoning and then spread the sauce onto four nice plates and lay two halved spring onions on top of each, with an extra drizzle of olive oil and a little sprinkle of sea salt. I like to serve this alongside some perfectly pink lamb chops (as pictured).

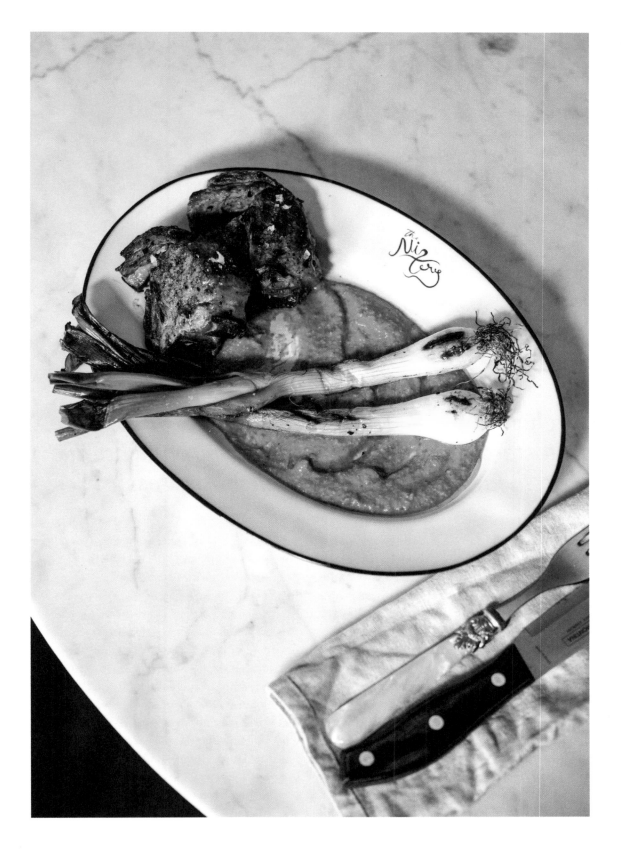

Judy Joo

*Korean-American TV chef, restaurateur and
food writer who started out as a banker*

*'Kitchens are like trading floors, full of male
testosterone, and I was used to environments like
that. In fact, I was used to even more pressure.'*

In May 2018, Judy Joo ascended the podium of
Columbia University, the institution from which
she holds a Bachelor of Science, and delivered the
keynote commencement speech. In a witty and
warm, yet spine-tinglingly wise address, the engi-
neer-turned-banker-turned-chef advised gradu-
ates not just to reach for the stars, as every com-
mencement speech inevitably must do, but to
push for equality in their chosen industry. 'I have
gone through three male-dominated arenas,' she
reflected. 'And I have succeeded by embracing the
challenge of living outside my comfort zone. But
as you can imagine, my work has given me first-
hand experience with harassment and discrim-
ination of age, race and gender. Your job, if it hap-
pens to you or to someone else, is to speak up.'

The speech was, she tells me three years later,
her proudest moment. 'It's such an honour that
people have found my story compelling.' It's a story
that takes in an early career spent on the trading
floor of a bank; quitting to work her way up through
three-Michelin-starred kitchens; becoming a
household name in the US with her own Food
Network series, *Korean Food Made Simple*; and
opening Jinjuu, the restaurant that launched
contemporary Korean cuisine in London. Yet in a
plot twist many still struggle to reconcile with the
chef's feminist credentials, it's a story that also
features Hugh Hefner, and the London-based
Playboy Club where Joo worked as executive chef.

'I thought long and hard about that post,'
she tells me – ten years, three restaurants and

Judy Joo

Judy at home in London making her ultimate KFC – Korean Fried Chicken (see recipe overleaf).

countless television appearances later – 'because I am a feminist. I am totally for women. But Playboy is one of the world's great super-brands, like Coca-Cola – so I thought I'd explore what this company was about.' For a woman raised in an environment in which academic success was prized above all, working in the Playboy Club was 'an eye opener. Everyone I had ever known wanted to go to university and have a professional career; then I was meeting girls from around the country who had no interest in that whatsoever.' A lot of these women just wanted to be a bunny more than anything in the world, she tells me. 'Bunny "graduation" was huge – parents, siblings, even grandparents attended, and all beaming with pride – and I thought, "Who am I to judge?" After all, people will be motivated by entirely different things; not everyone wants to pursue higher education.'

Indeed, it is possible Joo could see something of herself in these women's determination to pursue their dreams, despite societal expectations. 'Being a chef is not considered a prestigious career in Korean communities,' she says wryly. 'My parents were not too happy about my changing [from banking to cheffing], particularly having sacrificed so much for my education. But it's my life.' Besides, her degree – in Industrial Engineering and Operations Research – and her experience in banking were in many ways perfect preparation. 'Kitchens are like trading floors – full of male testosterone, and I was used to environments like that. In fact, I was used to even more pressure than I experienced in Michelin-star restaurants.' She laughs. 'But I have always been someone who, if I am going to do something, I'm going to do it to the best of my ability.'

The academic rigour that saw her sail from Columbia University straight into the City proved equally valuable when applied to her career in food. She graduated at the top of her class at culinary school before stages at The Fat Duck and The French Laundry. 'Cooking at three-star level is like being a professional athlete: you're constantly training, perfecting your technique'; worlds apart, she says, from cooking for loved ones at home.

'At home, food is the language of love. It's the way to show someone you care; to make them feel better.' Being Korean, a culture for which 'food is medicine, in every respect of the word' she is alive to the role food plays in human relationships. 'Eating together is the most bonding experience you can have with somebody, after sex. There is nothing else that engages all the senses; that creates such strong memories, and I think people have appreciated that all the more since the pandemic took it away from them.' Yet being a chef – and a chef, moreover who has starred in such alpha-competitions as *Iron Chef, Kitchen Inferno* and *Cooking with the Stars* – she has become accustomed to reconciling that sentiment with the demands of a professional environment, in which 'people are paying to eat your food, and you are running a brigade.'

Today, her Korean cookbooks and her latest restaurant, Seoul Bird, weave her identity as a chef inextricably together with the idea of food that has always driven her: as something 'full of memory and love that can transport people to another time or place.' At its heart, Seoul Bird is soul food: high-quality, Korean fried chicken served with a selection of homemade pickles, salads and sides. 'I am not striving for a Michelin star. My mission is not about perfection or accolades,' she continues. Were they her main aim, the strength of her skill and determination leaves me in no doubt she'd be star-spangled by now; instead her ambition has assumed a more altruistic quality: 'I want to spread the love for Korean flavours; create a nice, viable business that provides people with jobs that they enjoy – and have fun along the way.'

Judy Joo's Ultimate KFC (Korean Fried Chicken)

'I love fried chicken, and even though I grew up in America, for me, "KFC" stands for Korean fried chicken, not Kentucky! In Korea, there are many different versions, but what they all have in common is a very thin, crisp coating. It is such a crowd-pleaser and guaranteed to make everyone around your table happy – and isn't that what we are all trying to do? Food in my family is a language of love, which is what I believe my cooking represents. Something as delicious and pleasing as KFC can certainly help to provide that comfort. It is food that hugs you back.'

Serves 4

30g/1oz cornflour
2½ tsp sea salt
½ tsp baking powder
freshly ground black pepper, to taste
2 chicken drumsticks, 2 thighs and 4 wings
 (with tips)
vegetable oil, for frying

For the BBQ sauce
3 tbsp Korean chilli paste (gochujang)
3 tbsp ketchup
2 tbsp dark brown sugar
2 tbsp dark soy sauce
1 tbsp toasted sesame oil

2 tsp peeled and grated fresh ginger
2 garlic cloves, grated or finely chopped

For the batter
65g/2½oz cornflour
20g/¾oz fine matzo meal
30g/1oz plain flour
2 tbsp Korean chilli flakes
 (gochugaru)
1 tbsp sea salt
2½ tsp garlic powder
2½ tsp onion powder
¼ tsp baking powder
90ml/3fl oz vodka (or any neutral-tasting
 40% alcohol)
2 tbsp Korean chilli paste (gochujang)

Stir together the cornflour, salt, baking powder and a generous amount of pepper in a large bowl. Add the chicken and toss to coat. Transfer the chicken to a wire rack, shaking each piece to remove any excess coating. Leave, uncovered, at room temperature for around 1 hour.

Meanwhile, make the BBQ sauce. In a small saucepan, combine all the sauce ingredients and simmer for 3–5 minutes until slightly thickened. The sauce can be either served with the chicken or drizzled over

it. If you prefer the latter, remove it from the heat on the early side so it's a little thinner. Set aside; the sauce is best served warm or at room temperature.

Shortly before cooking, fill a large, wide, heavy-based pot (at least 13cm/5in deep) with 5cm/2in of vegetable oil and warm over a medium-high heat until it reaches 180°C/350°F.

While the oil is heating, prepare the batter. In a large bowl, whisk together the cornflour, matzo meal, flour, chilli flakes, salt, garlic powder, onion powder

and baking powder. In a small bowl, whisk together the vodka, chilli paste and 240ml/8fl oz water.

Right before you're ready to fry the chicken, whisk the vodka mixture into the cornflour mixture. (Don't do this in advance or the resulting batter may thicken too much as it sits. The consistency should be relatively thin and runny.)

Working in two batches, with the legs and thighs together as one batch and the wings as the other, dip each piece of chicken into the batter, letting any excess drip off. Suspend the chicken in the hot oil for a couple of seconds to set the crust before letting it slip completely into the oil; otherwise, it will stick to the base of the pot. Fry the chicken for 15–20 minutes, flipping halfway through, until golden and cooked through. Transfer to a wire rack or kitchen paper-lined plate to drain. Let the oil return to 180°C/350°F before cooking the second batch. Serve the chicken with the BBQ sauce either drizzled on top or on the side.

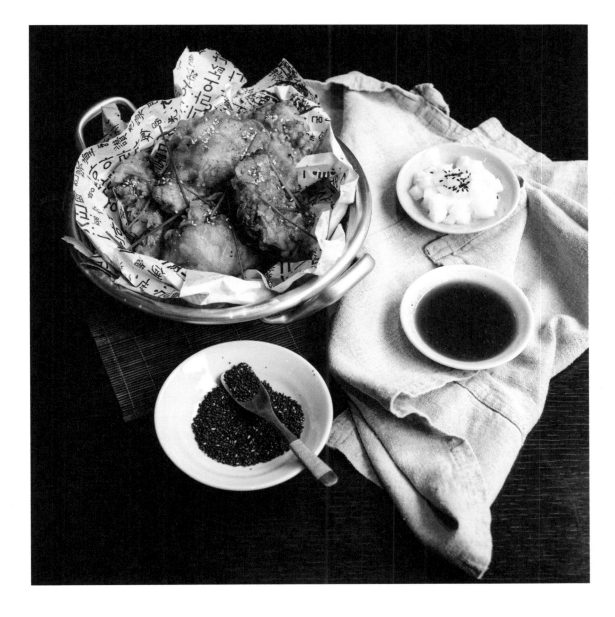

Nieves Barragán Mohacho

Spanish chef and co-founder of Michelin-starred
Sabor restaurant in central London

'I was seeing more women in kitchens and
starting to think, "This is possible."'

'I loved food. I loved cooking. But for me being a chef didn't feel like a possibility,' Nieves Barragán Mohacho says simply. Nor, until moving to London aged 20, was it her game plan. Born in Bilbao in Spain, Barragán grew up buying groceries and doing odd jobs in the kitchen to help her mother, who was her paralysed grandmother's chief carer. Though life at home revolved around mealtimes, cooking in a restaurant 'wasn't encouraged for women – especially in the Basque country' where cheffing was very much a man's world. At the behest of a friend, whose boyfriend was working at Simply Nico and who thought he could get her a kitchen porter job there, Barragán came to London. 'She said come over, learn a new language, see a new place – and I thought, "Why not? I'll go

for a year",' she laughs down the phone 20 years later: an acclaimed Mayfair restaurant, numerous awards and a Michelin star to her name.

In London, Barragán fell in love: 'with the city, with the people, with the cuisines – and that is how I started,' she recalls. 'There was so much energy.' In Michelin-starred chef Nico Ladenis' kitchen, her childhood love of food and cooking with her mother manifested itself in an insatiable appetite to learn. Within a month, she was one of the chefs, working 16-hour days, six days a week, 'going to sleep impatient to get up and get back to work the next morning, I was so enthusiastic. I wanted it so badly,' she laughs. At the same time, 'I was seeing more women in kitchens and starting to think, "This is possible." Thank God, the world was starting to change.'

Nieves Barragán Mohacho

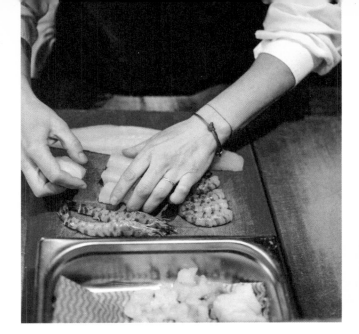

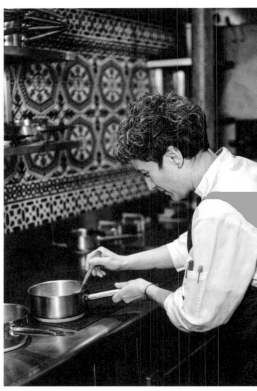

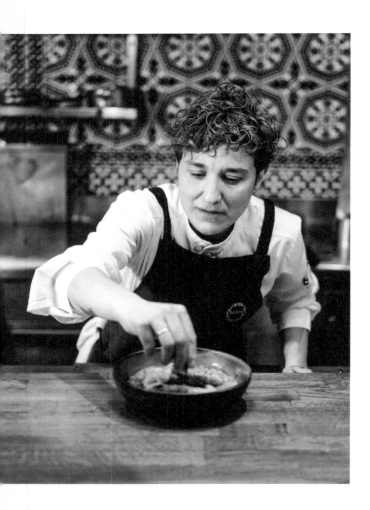

Barragán in the kitchen at Sabor, the restaurant she founded with José Etura in Mayfair, making seafood rice (see recipe overleaf).

Today Barragán is credited with upending preconceptions of Spanish cuisine by bringing authentic tapas to the masses and – perhaps most pivotal of all – introducing open kitchens to London. It's hard to believe now, but there was a time when 'open kitchen' wasn't part of a restaurant-lover's lexicon, and that was before Barrafina: the restaurant Barragán launched while executive chef at Harts restaurant group. 'I created the entire menu for every single Barrafina we opened, because it was really important not to be a chain,' she says – and besides, there was no shortage of dishes. 'Spanish cuisine is so varied. It is such a huge country.' By that point, she'd been a head chef for two years at Fino, the Harts' first Spanish restaurant, where 'what I'd learnt from my mum came together with everything I'd learnt in London, and I got the confidence to bring my own touch to traditional food.'

Nonetheless, she was overwhelmed by Barrafina's success. 'It was a surprise to everyone. [The first one] was so small – and yet the volume of food we sold!' She laughs, wonderingly. Much of this of course is down to 'amazing food and service' – but she suspects the open kitchen also had something to do with it. 'It is a show – but it is a real show. When you are in an open kitchen there is no other way to be than clean, smiling, tidy, and to interact with the customers who are watching and asking questions.' Where historically restaurant kitchens had been hidden in the basement, 'where it gets all sweaty and sweary', the open kitchen 'felt more natural – and more feminine, I guess, because it was 100 percent an easier atmosphere for women. It became a fun job,' she concludes – and when the staff are having fun, the customers will too.

Sabor is her restaurant: the three-storey realisation of a dream she had for decades of having a journey around Spain in one building. 'The bar is focused on the south of Spain; the fresh seafood counter is inspired by Galicia; and then the *asador*, the big wood fire, offers a taste of Castile.' Though her chef idols are Angela Hartnett (p.62) and Fergus Henderson, both now good friends of hers, it is her mother's philosophy that guides Barragán's cooking. Indeed, 2020 was the first year since Barragán's move to London that her mum hasn't come over and passed opinion on her dishes. 'Mum always says the food should look "shiny", meaning all the ingredients are dancing and shining together – and I try to follow that. I play around, but I don't mess around. It's all about fresh, quality ingredients.'

Barragán's biggest challenge is ensuring her team are happy and cared for. 'We are all humans. We all have different needs, difficult situations. Meeting those is a constant challenge, but to maintain a high-end successful restaurant, you need to be "on the same plate".' It's for this reason she regards herself not as a 'boss' or a 'chef', but as a 'leader'. 'If you want your team to follow you, to win their respect, you have to guide them, regardless of whether you're a man or a woman,' she says. 'So I am called leader. Nieves leads.'

'I got the confidence to bring my own touch to traditional food.'

Nieves Barragán Mohacho's Seafood Rice

'This is probably my favourite rice dish, it's always been served at home since I was little. It is a perfect dish to eat with family and friends – full of flavour and easy to share. This isn't like paella, it's more saucy, and has such an amazing richness.'

Serves 6

300g/10oz monkfish, cut into 2cm/¾in pieces
300g/10oz gurnard, cut into 2cm/¾in pieces
12 whole shell-on large raw prawns, peeled
 (keep the heads and shells)
250ml/8½fl oz arbequina extra virgin olive oil
 (or other extra virgin olive oil)
480g/1lb 1oz Calasparra rice
3 tbsp flat-leaf parsley,
 chopped
salt and pepper

For the bisque

12 whole shell-on large raw prawns
4 tbsp extra virgin olive oil
2 carrots, chopped
3 shallots, chopped
3 celery sticks, chopped
2 leeks, chopped
2 bay leaves
4 garlic cloves, crushed
4 tbsp tomato purée
200ml/6¾fl oz brandy
200ml/6¾fl oz manzanilla sherry

First, prepare the bisque. Remove the heads and shells from the prawns, reserving the meat for later. Heat the oil in a large saucepan over a medium-low heat and caramelise the prawn shells for a couple of minutes. Tip in the chopped vegetables, bay leaves and garlic and caramelise for 4–5 minutes. Add the tomato purée and cook for 2 minutes more, then add the brandy and sherry to bubble until the alcohol evaporates. Pour in 2 litres/3½ pints water and simmer for 20 minutes. Strain with a sieve, then measure out 1½ litres/2¾ pints of the bisque (any left over will keep in the fridge for a day or two).

Add half the monkfish, half the gurnard and the 12 peeled prawns to a pan set over a low heat and pour in 140ml/4¾fl oz of the arbequina oil. Cook very gently for just 2–3 minutes until tender (to confit).

In a separate pan set over a low heat, gently add 50ml/1¾fl oz of the arbequina olive oil and the heads and shells you removed from the prawns (not those used for the bisque). Cook gently for 10 minutes, then strain and reserve the prawn oil. Set aside.

Put the remaining 60ml/2fl oz of arbequina olive oil in a medium-sized saucepan over a medium heat. Add the rice and toss until the rice becomes clear and shiny. Add the bisque, the remaining monkfish and gurnard, and the prawn meat left over from the bisque. Cook slowly, stirring regularly, until the rice is al dente, this will take around 20 minutes. Add the confit fish and prawns (you can reserve some for decoration, if you like), the prawn oil and the parsley and mix well with the rice. Season to taste and serve.

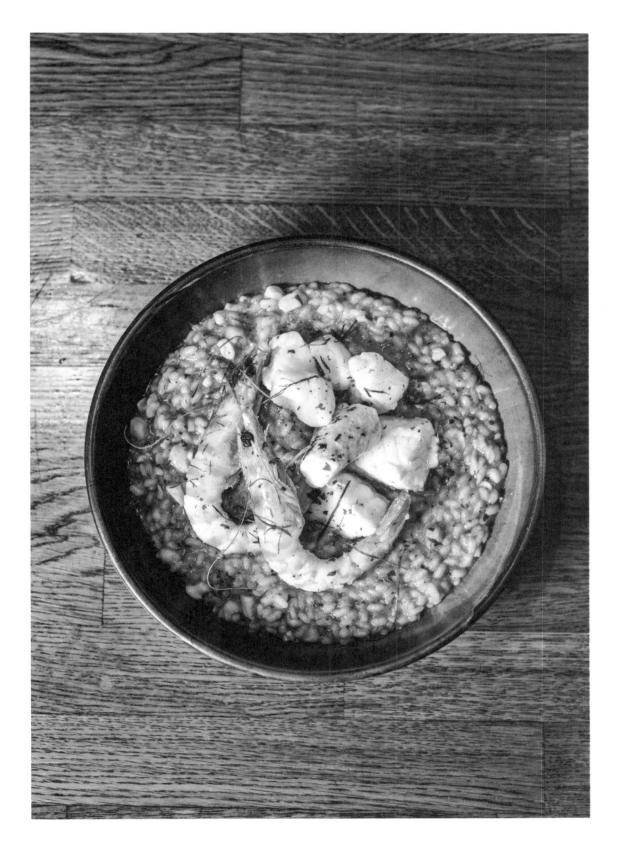

Sabrina Gidda

London-based chef, most recently the executive chef at AllBright, who started out in Fashion PR

'Cooking is what I do. And a chef is who I am – it is tremendously important to me that people get that right.'

With her long, tousled hair, eyes sparkling beneath cat-like curves of eyeliner and enviable dress sense, Sabrina Gidda makes for a striking presence – even before I've tasted her acclaimed spinach gnudi. Once the head chef of Italian restaurant Bernardi's, then executive chef at all-women's club AllBright, Gidda is now embarking on a freelance career – leaving myself and her many followers waiting with bated breath to see what she does next.

When I interview Gidda, I'm struck that I've never met anyone quite like her: a Fashion and Marketing graduate-slash-chef whose love of food is rivalled only by her love of fine art and fashion – and who has no problem at all reconciling these interests. 'It has always been really important to me to be who I am, and I am happiest being all of it: food, fashion, face. It is an old male idea that you have to be one or the other,' she reflects. Indeed, my having been so nonplussed by Gidda shows the extent to which I'd internalised this false dichotomy. 'Fuck that!' she laughs. 'You can be both. You can be neither. I'm no less of a chef for having a skincare regime.'

If anything, Gidda says, these seeming 'contradictions' have helped her. The only woman ever to reach the Roux Scholarship finals twice, it took her less than ten years to go from part-time shifts in a café to overseeing AllBright's entire culinary offering. Raised on a diet of her family's Punjabi food supplemented by 'every cookery show, every recipe book I could lay my hands on' she is as adept at a pub lunch as she is fresh pasta; at home with

Sabrina Gidda

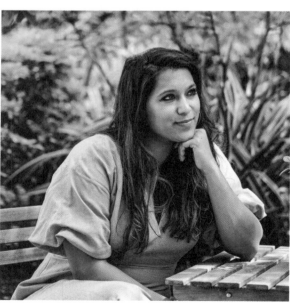

Gidda at home in London, having just prepared a bowl of her renowned spinach gnudi (see recipe overleaf).

both biryani and haute cuisine. 'I'm used to being an anomaly. I remember when I became head chef at The Draft House, and people loved that a 22-year-old woman was running the kitchen – and the food was great. I think it's been a novelty for restaurant associates,' she muses. 'I am super feminine – and it's never held me back. I haven't compromised on who I am in order to get to where I want to be.'

In part, she thinks this is down to her having 'always been very comfortable telling people to fuck off,' she laughs. But it is also luck; a feature of Gidda's unconventional route into restaurants. Growing up in a Punjabi family in the 90s, becoming a chef was not a career option: 'success meant earning a decent living in an esteemed job, and a chef was not that – so I found my calling a bit later.' It's shaped her approach to ingredients, 'which I think is more holistic than it might have been had I gone to culinary school. I cook with absolute freedom, which is very liberating,' she says – but it's also shaped her career, from the friends she has made in hospitality, to the critical acclaim she won at Bernardi's for her gnudi and her rabbit ragù.

'I have been so lucky in getting to pick and choose how I want to play the game. When doing classic French cooking, during the Roux Scholarship for example, then I am precise. Militantly so. A *sauce tomate* is an Escoffier *sauce tomate*, not a riff on it. But I can also wander over to the other side of the kitchen and work on some creative Indian mash-up thing.' Reaching the Scholarship finals – twice – led to her friendship with the late Albert Roux and his wife, Maria. 'They were amazing. Albert always celebrated what women bring to restaurant kitchens – which can be the same as men, but is often different,' she continues. 'I guess lots of people think of him as old guard now, but there are reasons the Roux brothers are known as pioneers. You aren't a pioneer because you're a dinosaur. You're a pioneer because you think in a more progressive way.' Reflecting on Gidda's career and character, her move to AllBright felt almost inevitable. 'It was about more than food. It was about empowering women; supporting and nourishing the wider picture, a wider conversation.'

Whether at Bernardi's, AllBright or now, as she embarks on her solo career of pop-ups, events and – hopefully one day soon – a restaurant of her own, her ethos remains the same: 'no matter what cuisine I cook, I feel like I am cooking with my entire heritage behind me, and a world of possibility in front. Cooking is what I do. And a chef is who I am – it is tremendously important to me that people get that right.' It's why, though she runs a tight ship, she needs her staff to be happy; to enjoy what they do. 'If you're a robot, we can't work together. Because when you give yourself, and you bring the influence of everyone you love to the kitchen, you can taste that. You can taste that magic.'

'I'm no less of a chef for having a skincare regime.'

Sabrina Gidda's Gnudi

'I absolutely love this dish – when I first created it and put it on the menu at Bernardi's it was a smash hit. It was loved and enjoyed as much when eaten as it was when it was made. I have cooked it on almost every menu since with various seasonal sauces, but the magic of datterini tomatoes, chilli, garlic and fresh basil will always be my favourite. There isn't a time of year when this dish wouldn't be the perfect thing to serve – it's timeless, forever deliciousness.'

Serves 4–6

For the gnudi
900g/2lb ricotta
2 medium Burford Brown eggs
1 Burford Brown egg yolk
90g/3oz Parmesan, finely grated, plus
 extra to serve
80g/2¾oz '00' flour
pinch of flaky sea salt
100g/3½oz fine semolina, plus extra for dusting
olive oil, for frying

For the sauce
100ml/3½fl oz extra virgin olive oil
600g/1lb 5oz fresh datterini tomatoes,
 halved
1 long red chilli, finely chopped
pinch of dried chilli
4 garlic cloves, finely sliced
1 lemon, zested (and ½ juiced)
around 14 leaves of fresh basil,
 roughly chopped, plus extra to serve
flaky sea salt
freshly milled black pepper

Before making the gnudi, hang your ricotta in a cheesecloth set over a bowl overnight to lose a little moisture. The next day, pop it into a mixing bowl. Carefully whisk your eggs and egg yolk, then add all the rest of the gnudi ingredients, except the oil, to the bowl and mix until thoroughly combined. Roll the dough into long sausages, then sprinkle with semolina and cut into 3–4cm/1–1½in pieces. Bring a saucepan of salted, oiled water to the boil and drop in the gnudi to blanch for 2 minutes, until they float. Carefully drain, then place the gnudi onto an oiled tray and set aside.

Now prepare the sauce. Pop your olive oil, tomatoes, red chilli, dried chilli and garlic in a saucepan over a low heat and season. Warm gently until the tomatoes start to soften and break down – gently encourage this with the back of your wooden spoon. This sauce isn't boiled, it's warmed, as you want the tomatoes to emulsify with the oil.

Meanwhile, fry the gnudi in a non-stick pan with a little olive oil over a medium heat until golden, around 2 minutes on each side.

Add the pan-fried gnudi to the sauce and stir carefully over the low heat for 3–4 minutes. Add the lemon zest and juice and the basil, stir and serve. Finish with additional Parmesan and basil leaves, if you like, and make sure you are drinking a crisp, cold white wine with it.

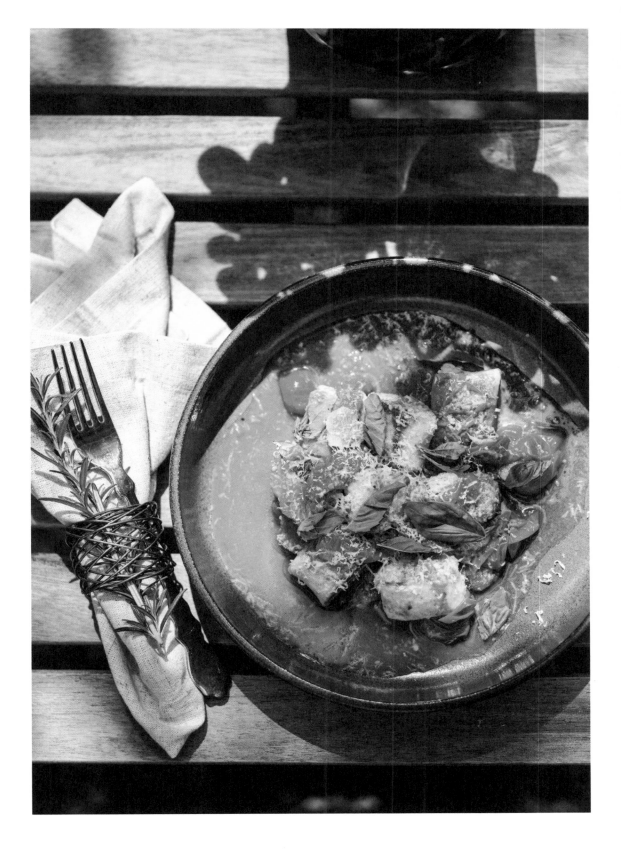

Sabrina Gidda

Julie Lin

*Glasgow-based chef and owner of Malaysian
street-food restaurant Julie's Kopitiam*

'There is a culture of machismo and fear that still exists in the industry – that is normalised. I want to talk about it.'

The week prior to our interview, Julie Lin tells me, she hailed a cab and was a picked up by a chatty 22-year-old who still lived with his Indian family. As he drove her across Glasgow, the young cabbie told her how, during the course of lockdown, he had learnt to cook with his mum. 'He said his mother had this amazing wealth of knowledge, and that it did his head in that his dad did nothing in the kitchen. He realised that, going forward, he needed to be the change.'

'It was like I'd got into a cab with an angel,' Lin continues, laughing delightedly; for this vignette of a Glaswegian cab driver in many ways sums up her feelings around cooking and gender. Though she owes her own culinary skills to her mother – a Malaysian woman who emigrated by herself to

Scotland to work as a nurse in the 1970s, and cooked to feel connected to her homeland – her ambition going forward is to 'get to the point where gender doesn't matter. I am very happy to celebrate the skills women have handed down over the centuries; the maternal cooking that runs through so many societies; but I think if we are going to get rid of the more negative ideas around cooking and restaurants and gender, we need to ultimately disentangle the two.'

For a woman who has made her name cooking the homely Malaysian food of her mum and grand-mother, and who has only ever worked under female chefs, this might seem surprising. Yet she is committed to ensuring anyone who wants to cook like she does, in the style of restaurant she

Julie Lin

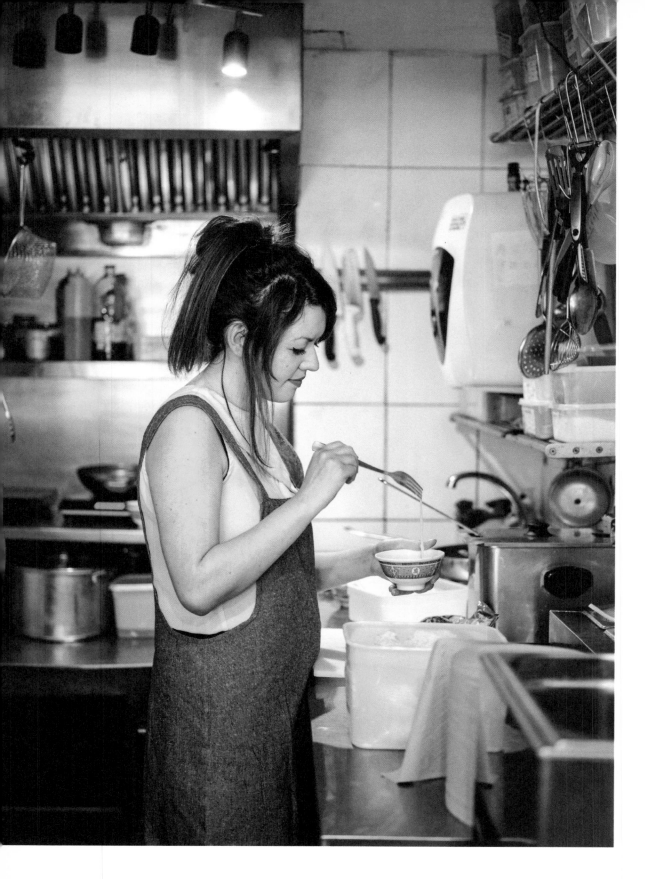

runs, can – a testament to her belief that no one group should have a monopoly over what restaurants and cooking should be.

Everyone who comes to work at her restaurant, Julie's Kopitiam, is taught the same way she was: through watching, following, tasting and feeling, rather than reading and writing down rules and recipes. It is a 'feminine' approach, she acknowledges – but as her mum always told her, 'it makes you more confident in the kitchen. You know you can do these things with these ingredients, and what you can substitute if you don't have them.' Besides, in a small, 'cupboard-sized' kitchen like that of Kopitiam – which occupies the ground floor of a townhouse – it's essential that everyone can do everything.

'In Asian restaurants you don't really have the same hierarchal model you do in restaurants in Europe,' Lin continues. 'Everyone can do the pass, the front of house and the back of house, the chopping and the washing up.' It's a model that makes for a healthier working environment – friendly, collaborative, with a sense of shared responsibility – but it is also inherently more inclusive, says Lin, enabling her to offer employment and experience to people new to the industry.

There's no denying that Britain's restaurant scene has a diversity problem. Though there are plenty of people from ethnic minority groups working as pot washers and kitchen porters, there are depressingly few in senior positions. By taking people on who might not have had the opportunity, time or money for formal chef's training, Lin hopes to 'encourage diversity, and create a new generation of chefs that can work in a different way'.

'It takes longer to train people like that, but I think the outcome is worth it – because that way you get independent cooks, who bounce ideas off each other. They can adapt a template,' she continues, 'but they don't have to be exact. They aren't chained to a recipe.' Though she had been encouraged to put on Malaysian specials in her first chef's job, at a top Glasgow restaurant, it was while working at an Indian street-food place that she realised what she calls 'estimation cooking' could have a serious economic value, outside of the domestic sphere.

Indeed, the approach is part and parcel of cuisines across Southeast Asia – because 'you can't regiment that style of cooking. The strength of each batch of curry paste is always different depending on where your ingredients come from – and you need to taste as you go because it's very difficult to fix once you've finished.' Emboldened by her experiences at the Indian restaurant, and by the popularity of the Malaysian street-food stall she ran part time, in 2017 she moved into bricks and mortar.

Today Lin counts herself lucky. Kopitiam is based in 'an extremely welcoming and multicultural area of Glasgow, and we have a nice, friendly kitchen. We do get a lot of people who haven't been chefs before.' Yet her passion for inclusivity and equality is by no means confined to her kitchen. 'There is a culture of machismo and fear that still exists in the industry – that is normalised. I want to talk about it.' Not content with simply ploughing her own path, she regularly champions the work of people in food 'who are fighting that culture', through interviews, collaborations, recommendations and events. 'Because if you have a group of chefs creating a different style of kitchen standing together and shouting about it, then you can create a movement. You can be the change.'

Julie Lin's Lap Cheong Fried Rice (腊肠炒饭)

'This is the first dish my mother ever taught me to make. I used to call it breakfast rice because we would have it in the mornings at the weekend. My mother doesn't enjoy the greasiness of lots of sausages in the kitchen so this was our alternative. The dish is so incredibly simple yet imperative when learning how to wok-fry rice. There's a subtle art to getting smokiness into the rice that comes from patience; she taught me so much of this when mastering *wok hei*.'

Serves 2

3 lap cheong (Chinese sausages)
1 tsp light soy sauce
1 tsp dark soy sauce
1 tbsp oyster sauce
2 eggs, whisked
2 spring onions
3 tbsp vegetable oil
400g/14oz cooked jasmine rice
100g/3½oz peas
salt and white pepper

Begin by thinly slicing the lap cheong on a diagonal. Then mix together the soy sauces and oyster sauce with a pinch of salt and white pepper (to taste) and 2 teaspoons of water.

In a non-stick pan set over a low–medium heat, scramble the eggs with a pinch of salt and white pepper then set aside. Chop the white sections of the spring onions into 3cm/1in chunks. Finely chop the green part and set both parts aside separately.

Add the vegetable oil to a wok over a medium heat and tip in the sliced lap cheong and the chunks of white spring onion. Fry for around 2 minutes until fragrant. Add in the rice and peas, then immediately pour over the soy sauce mixture. Turn the heat up to full and wok-fry until smoky and all of the sauce has been incorporated.

Add in the scrambled egg and the green part of the spring onions and mix through. Mould the rice into bowls, then flip out onto plates. Serve with fresh, sliced cucumber and chilli paste, if you like.

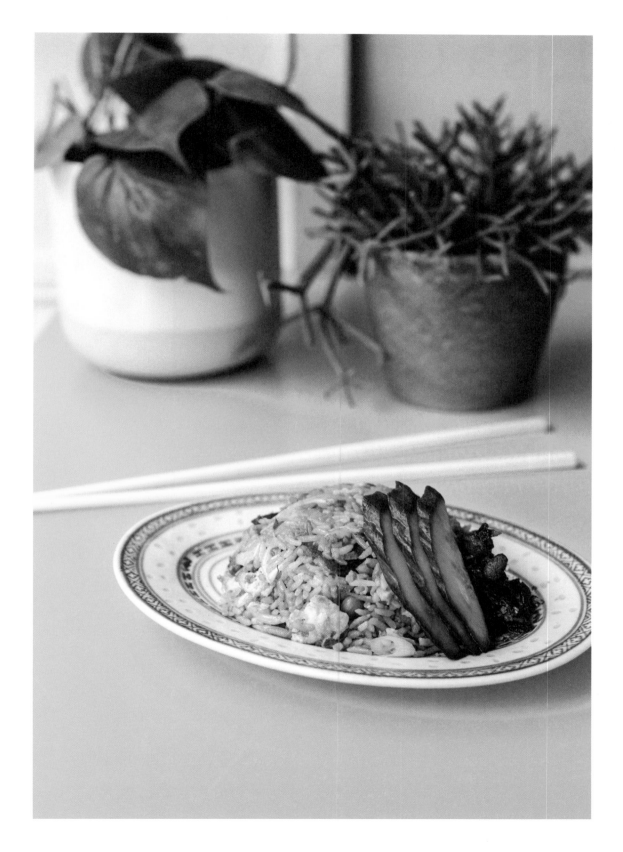

Lisa Goodwin-Allen

Executive chef at the Michelin-starred
Northcote restaurant in Lancashire

'All of a sudden I could express who I was.
I could communicate and develop and talk
through cooking.'

It is only 10am when I speak to Lisa Goodwin-Allen on an icy morning in May, but already the chef has been up for six hours – on a 100-mile round trip to take her team to a microgreens farm in Cheshire. 'Knowing where high quality produce comes from, who grows it and how it's produced is so important,' she explains. 'It helps us understand how to treat it, and why it tastes so good.'

It is this passion – for food, and for her team – that, coupled with her extraordinary talent, has propelled Goodwin-Allen into Michelin stardom and kept her there for 20-odd years. By just 23, she was the head chef of Northcote, the restaurant just above Blackburn that up until 2018 was run by Nigel Haworth, and she has retained their Michelin star ever since. 'I was hungry to learn, and to get stuck in,' she says of her early career, which took off at a time when female chefs were still something of a rarity. 'It was a struggle sometimes, but I just put my head down and got on with it. Because as I say to the lads and girls here, it doesn't matter who you are or where you're from: it's your passion for your craft and your willingness to learn and teach others that determines your destiny.'

The fact she grew up helping her dad in a car salvage yard every weekend may have contributed towards her ability to not see gender as a barrier. It certainly contributed towards her practical ability, which has manifested itself in and out of the kitchen. 'I am a very hands-on person. I enjoy getting my hands dirty, and I think in a way I've followed in my dad's footsteps through food.'

Lisa Goodwin-Allen

Though she struggled academically at school, she thrived when it came to Home Economics lessons: 'All of a sudden I could express who I was. I could communicate and develop and talk through cooking. Cooking is so versatile; it can show so many different expressions and emotions' – and she was good at it. 'I found I could turn out an apple turnover, for example, from start to finish, very quickly at a young age. I had finally found something I wanted to do.'

Though Goodwin-Allen is a chef, in every sense of the word, she sees cooking at home, for her husband and young son, and cooking in the restaurant as being on a continuum. 'At home it's more relaxed, more humble, and you're cooking the traditional things that kids love,' she says. 'But in the restaurant it's about taking that experience – the memories, the love – and taking it to another level by bringing your knowledge, research, skills and creativity. I am definitely a chef who brings influences from my life into the kitchen and puts a spin on it.' Indeed her playfully traditional dishes draw both on her own expertise, and on local, seasonal ingredients from Lancashire: her home county, to which she returned in 2001, bucking the trend of most aspiring young chefs to cut their teeth in London.

There is a continuum too between her strong family values and her brigade of chefs. 'It's really important that the guys and girls in my kitchen are happy and energised – and that means seeing their families and having lives.' It's a compassionate approach, but it's also good business sense: 'a chef who is loving their life and job will blossom and thrive and give you much more.' Often Goodwin-Allen will bring her young son into work. It's convenient for her, and fun for him – but it also sends an important message about being a chef and having a family. 'You can absolutely do both. It's hard work, but you will find a way if you want something that badly – and I wanted a family,' she says simply. 'Family keeps the world going round.'

'It doesn't matter who you are or where you're from: it's your passion that determines your destiny.'

Lisa Goodwin-Allen's Sundried Tomato and Goat's Cheese Quiche

'Quiche is a classic – everyone loves it. And it was the first thing I learnt to cook in Home Ec at school. I was very proud of it, I took it home to my family to eat together. It's a tasty base, but one of the best things about a quiche is you can add pretty much any flavour you want to it.'

Makes 1 quiche

For the pastry
260g/9¼oz plain flour
1 tsp salt
130g/4½oz cold butter, finely diced
5 large egg yolks (4 for the pastry,
 1 for the egg wash)
1 tbsp thyme leaves, finely chopped

For the filling
120g/4¼oz soft goat's cheese
20 sundried tomatoes

2 spring onions, finely chopped
200ml/6¾fl oz milk
100ml/3½fl oz double cream
100g/3½oz crème fraîche
3 large whole eggs
2 large egg yolks
1 tsp salt
pinch of black pepper

For the garnish
handful of fresh rocket
4 slices of salami,
 shredded

To make the pastry, sift the flour and salt into a large bowl. Rub in the butter with your hands until it forms a breadcrumb-like texture. Add 30ml/1fl oz cold water, the 4 egg yolks and the thyme leaves, then mix until a dough is formed. Wrap the dough in clingfilm and leave to rest in the fridge for 1 hour (or for best results, overnight).

Grease a 24cm/10in (3cm/1in deep) quiche tin. Remove the pastry from the fridge and place onto a lightly floured work surface, then roll out to about 1cm/½in thick. Line the tin with the pastry (don't cut off any overhanging edges) and place back in the fridge to chill.

Preheat the oven to 190°C/375°F (170°C/340°F fan). Take the pastry case out of the fridge and line it with baking parchment, then fill with baking beans. Place on a baking tray and blind-bake for 20 minutes, then remove the beans and paper.

Beat the last egg yolk then use it to evenly brush the base and sides of the pastry case. Return the case to the oven and bake for another 5 minutes, then reduce the oven temperature to 160°C/325°F (140°C/275°F fan).

Crumble the goat's cheese into the pastry base, then evenly place the sundried tomatoes and spring onion on top. Whisk the milk, double cream, crème fraîche, eggs and yolks together in a bowl until well combined, then season. Pour the mixture over the goat's cheese, tomatoes and spring onion. Bake the quiche in the oven for 30–40 minutes, until just set with a slight wobble. Allow to cool.

Trim the pastry edges with a small knife, remove the quiche from the tin and serve it in wedges with the rocket and shredded salami.

Lisa Goodwin-Allen

Ravinder Bhogal

Food writer and cookbook author, and chef-founder of Jikoni in Marylebone

'I do feel that the women who came before me have travelled with me, and are standing with me at the pass.'

With its gentle light, warm welcome and vividly embroidered fabrics, Ravinder Bhogal's 'immigrant kitchen', Jikoni, feels like a soothing ideal of home. But it's border-defying dishes – such as prawn-toast Scotch eggs – are as stimulating as they are comforting.

'The late, great A.A. Gill, in his review of us, wrote that while "religion and politics, relentlessly, endlessly, circularly, get everything wrong, cooks get it right",' Bhogal recalls. 'I feel great pride that Adrian was able to see that this was a restaurant with a kitchen at its heart, that celebrated the traditions of maternal cooks; and that we wanted to nurture our guests first and foremost.'

This sense of nurture applies to her team, whom Bhogal is dedicated to 'empowering, listening to, and learning from, from the kitchen porter to the head chef.' Some are mothers themselves – 'we lose such great talent by not supporting mothers in this industry' – and all are aligned with Jikoni's unwavering commitment to nurturing guests, colleagues and community. And it's true of her food, too: her vibrant, complex, storytelling dishes that weave her creativity and maternal instinct together with her rich culinary heritage. Bhogal was born to a Punjabi Indian family in Nairobi and raised in London where, from an early age, she cooked both to feel at home and to find it.

'I do feel that the women who came before me have travelled with me, and are standing with me at the pass,' says Bhogal. 'They cooked selflessly

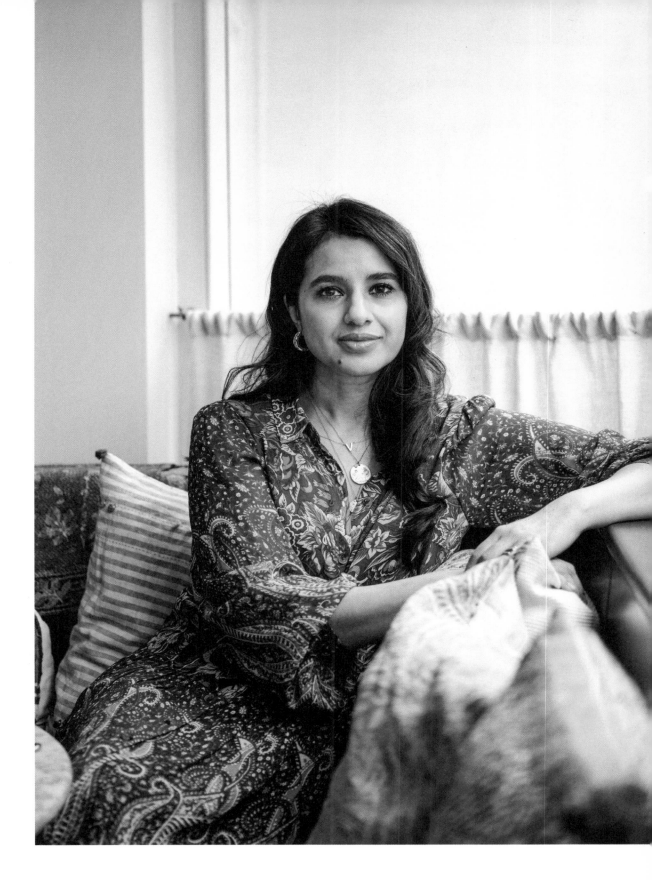

Ravinder Bhogal

The interiors of Bhogal's restaurant,
Jikoni, in west London, which is known
for 'cooking across borders'.

for their families and communities for centuries without payment, and it was thankless. But I would not be doing what I am without their sacrifice and teaching.' The techniques she uses are those she saw her mother and sisters using – 'We don't use a smoking gun here, for example. We pour ghee onto hot coals, letting it smoke gently' – so when she brings that style to the fore of her formidably successful restaurant, she feels she is 'bringing these ancestors, and representing them.'

Jikoni is, as the subtitle of Bhogal's book of the same name claims, 'proudly inauthentic'; a paean to the India of her family, the Nairobi of her early childhood, and the London she grew up in, criss-crossed as it is with the cuisines of multiple immigrant communities. It is also proudly femi-nine, in its décor as much as its dishes, and that, when it first opened, was an extraordinary thing. 'I wanted to create a space that reflected my nar-rative of being an immigrant, being a maternal cook; to create a pluralistic space in which we could talk about diversity, culture and politics,' Bhogal continues. For her, this meant what Jikoni now is: a place of tapestries and floral prints, of soft light and softer furnishings – yet when she was drawing up the designs for the restaurant,

this was met with opposition from 'some people saying it's not a good idea to make this wall pink; from people saying it's too feminine.

'I said, since when did feminine become a dirty word? Was your mother not a woman? Five years on, I have seen a lot more soft touches [in restau-rants],' she says, but Jikoni was a front runner. Bhogal's refusal to conform to a masculine, mod-ern idea of a restaurant – 'industrial surfaces, bare brick walls, chrome and so on' – mirrored an even more potent refusal to be 'assimilated into a ver-sion of Englishness that I don't fit into. From the fabrics and textiles, to hiring, to the events and discussions we have here, talking about cultural and political issues, I am proud to say I have been quite uncompromising.'

In Jikoni's décor, menu, team, events and – during the pandemic – home delivery boxes and delivery meals for hospitals, she has 'created a space where I finally belong. This is my narrative of Englishness. Restaurants are small microcosms of the worlds we want to exist; and Jikoni, being about diversity, plurality, femininity, the food of other cultures and how it fits so well together, is a microcosm of the world I want to be in.'

'Jikoni is a microcosm of the world I want to be in.'

Margot Henderson

*New Zealand-born chef, cookery writer and
co-owner of Rochelle Canteen in Shoreditch*

'Cooking is sensitive. People just want to hear that you love their food, whatever their gender.'

There is a last hurrah feeling in Rochelle Canteen when I visit in early December 2020. People are laughing and talking intensely; ordering bottles with far more abandon than you'd normally find at lunchtime on a Wednesday. At this point the worst of the pandemic is to come; yet here in this tranquil walled garden, the atmosphere of coming uncertainty somehow serves only to sharpen people's enjoyment of their meal.

It is against this backdrop that Margot Henderson meanders towards me from the kitchen with the kind smile and unflappable air that the Hendersons – Margot, and her husband Fergus, co-founder of St. JOHN – are famed for, almost as much as they are for their cooking. She remains philosophical. Her branch of Rochelle Canteen in the Institute of Contemporary Arts was one of the first high-profile closures of the pandemic when it shut up shop in September 2020 – but now the worst has happened, she's made the best of it by shifting her focus to the original east London site. 'I loved the ICA so much. It was a wonderful position, and I loved the gallery. But it was good to cut our losses and focus on Rochelle,' she muses – 'and we've had so much support from the wonderful folk returning to restaurants and giving us hope.'

In Rochelle, Henderson feels she has a 'proper' restaurant. 'A restaurant where the guests seem to really dine out in style: getting dressed up, eating three courses and drinking fine wines. I love it,' she says, smiling broadly. 'I should have done

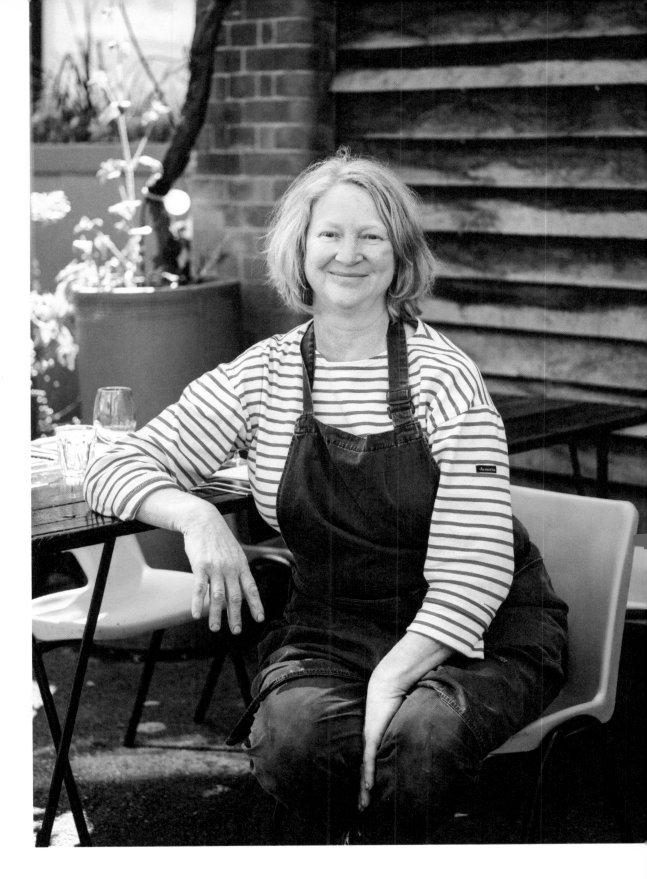

Margot Henderson

The garden at Henderson's restaurant, Rochelle Canteen, which is in the repurposed bike shed of a former school in east London.

this years ago.' What stopped her, she tells me, was confidence. 'I didn't want reviewers and so on. I felt very nervous about that sort of thing for a long time. Lack of confidence is so often the issue, I think, with women.' Now, her food is becoming more her food: 'more New Zealand', which is where she grew up, and less obsessed with the zealous simplicity that characterises The Eagle and The French House. 'At The French House, we were constantly trying not to be too racy, to keep it pared back. I am not so worried about that anymore. Again, it's about confidence,' she says. 'When you have children, you lose some of your confidence because you can't be in the kitchen as much as you were. Fergus went to work every day – as did I, but I was also bringing up children.'

Of course, this is not to say Fergus hasn't influenced her cooking – 'for the better,' she says in a stage whisper. 'I remember at The French House early on, I was boning out quails and Fergus said, "No, we're cooking them on the bone" – which is so much more flavourful, of course.' The irony, she continues, is that the 'earthy, peasant-style food Fergus cooks is the food hundreds of millions of women cook all over the world and have done for centuries. The Lebanese grandmother – she knows just a teaspoon of bicarb in the soaking water is all you need to take the bite out of chickpeas and transform them into clouds; that water is a gentle and lovely thing if used properly. Most chefs cannot leave well alone.'

Together with Peter Gordon at The Providores, the Hendersons pioneered a calmer, more humane approach to running a kitchen in their time at The French House. 'There was no swearing. We listened to Radio 4. It was all about caring and sharing.' It is not as obvious a revolution as the nose-to-tail, *cucina povera* (the Italian term for 'cooking of the poor', today used more generally to mean making the most of humble ingredients) movement they're normally associated with, but it has proved just as seismic – particularly for female chefs. 'I think that in those kinds of harsh environments, women can get marginalised or feel undermined; are more likely to get stuck on pastry than make their way into butchery, for example. But then' – she checks herself, laughing – 'men are sensitive, too. Cooking is sensitive. People just want to hear that you love their food, whatever their gender. To be up there at the pass takes a strong character.'

Reflecting on the course of her stellar career through some of London's most defining restaurants, Henderson is typically understated. 'I didn't have a plan. I just wanted to push myself forward – and to have a good time,' she adds pointedly. When she first came to London she wanted to work for Simon Hopkinson but opted for The Eagle under David Eyre. 'I'm too much of a laid-back New Zealander to do double shifts every day. I was too scared.' The reason she and her business partner Melanie Arnold started their catering company Arnold & Henderson was 'because we were able to multitask, pick the kids up from school and also have a business'; yet the reason that became Rochelle Canteen is because 'I'm ambitious. I needed to have another busy, successful restaurant and Rochelle Canteen is that' she says, looking around. 'It is rocking, we have a great team, and that is something I'm very proud of. I am ready for reviewers – I am ready for all of that now.'

'In those harsh kitchen environments, women can get marginalised, or feel undermined.'

Margot Henderson's Braised Squid, Parsley and Potatoes

'I discovered this recipe while reading Marcella Hazan, the brilliant Italian cookery writer who brought Italian food to Britain. (Well, along with Elizabeth David and a few others...) I love how she fries the parsley with the garlic and oil at the beginning, so cheeky. I have been cooking it many ways for years now. The potatoes can be replaced by chickpeas or beans – something that will absorb the wonderful squid flavours. Potatoes are definitely best; they love to absorb all the goodness around them.'

Serves 4–6

100ml/3½fl oz extra virgin olive oil
4 garlic cloves, finely chopped
bunch of flat parsley, finely chopped
 (stalks and all)
1kg/2lb 3oz medium-sized squid, cleaned and sliced
 into even, rectangular pieces (though you can
 also express yourself with the shapes)
70ml/2½fl oz white wine
200g/7oz winter tomatoes (or any variety),
 roughly chopped

pinch of saffron
1 chilli, split in half (and seeded, depending
 on if you want it hot or not)
700g/1lb 8oz waxy potatoes (e.g. Cyprus or
 Désirée), peeled and cut into happy chunks
 of about 2cm/¾in
lemon juice, to serve
1 tbsp marjoram, picked and finely chopped,
 to serve
sea salt and black pepper

In a heavy-bottomed pan, heat the olive oil over a low–medium heat then add the garlic and parsley. Gently cook for a couple of minutes. Turn the heat up and add the squid, giving it a good stir. Once the squid has turned white, add the wine and reduce for a moment then add the tomatoes and cook a little more. (The wonder of winter tomatoes is that not only do they taste fantastic, but they break down very quickly and give a brilliant texture to the dish.) Then add the saffron, chilli and potatoes. Pop the lid on, turn the temperature down and cook for about 20 minutes until the potatoes are cooked through but not collapsing. The squid should be tender.

Just before serving, season to taste and add a squeeze of lemon and some chopped marjoram to finish. Enjoy with lots of cold, white or rosé wine.

Margot Henderson 129

Pamela Yung

Ohio-born chef who previously co-owned Semilla in New York, now head chef at Flor in London

'It is a healthy thing to know what you don't know; to have humility and the desire to push yourself forwards and learn.'

My first feeling, upon reading that Pamela Yung grew up with working parents who rarely had time to cook proper meals, was not sympathy, but relieved recognition. Here was a woman working in food whose passion and talent stemmed not from her mother's apron strings, but from her own ambition; an ambition cultivated after, and even in spite of, her childhood.

'It's a good story,' she says of the tale told by so many chefs and food writers: of childhoods spent around the kitchen table, cooking and eating dishes handed down through generations. 'But it's not the only story. Not everyone has the privilege of growing up with parents who had time to cook from scratch. Not everyone has the privilege of growing up with both parents, with grand-

parents. And I don't think you need to have that to pursue a career in food.'

The proof is in Yung's CV: stints at Michelin-starred restaurants around Europe, training with the 'prince of pastry' Will Goldfarb and opening her own restaurant, Semilla, in Brooklyn in 2014, which won a Michelin star itself a year later. Today she's head chef of Flor, the acclaimed restaurant, bakery and wine bar in Borough Market – and all this despite growing up in 1980s America, where women were increasingly eschewing the kitchen in favour of careers.

'It's intimidating,' she says of the emphasis placed on 'origin' stories for those in food – not that she appears intimidated – 'but I think it can contribute a sense of imposter syndrome, and

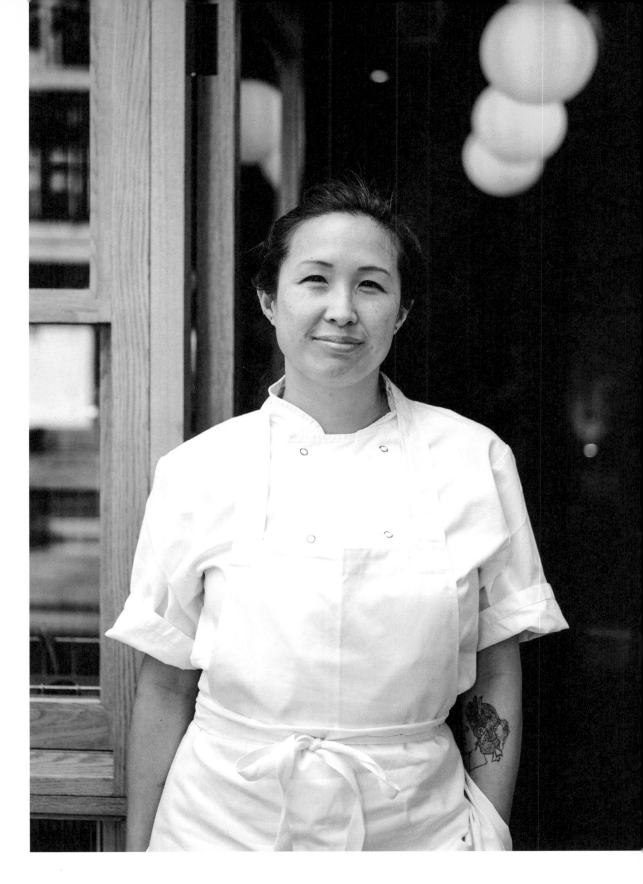

Pamela Yung

Yung making mozzarella in carrozza (see recipe on p.136) at Flor, in Borough Market, where she is head chef.

that's something many women suffer from.' Yet a background some might consider a barrier has served Yung well by ensuring she is always learning, always open-minded and never blinded by ideas of authenticity.

'It is a healthy thing to know what you don't know; to have humility and the desire to push yourself forwards and learn. There's always something new to explore,' she continues. Being free of the shackles of tradition has allowed her to take risks, 'which is really rewarding. It might be harder than doing something that you know works, and that people like – but when you're someone who likes to learn, it's interesting to try new ideas, even if they don't always work out.'

Today, Yung is rapidly establishing herself as a chef who puts environmental sustainability at the heart of her food, but in a way 'that is provocative. I'm not saying it should make you sit and scratch your head – food should first and foremost be delicious – but my motivation for menu development comes from working with and supporting producers who share a similar ethos around the environment and sustainability.' These are values she has nurtured throughout her career, but which are finding their fullest expression in Flor: a restaurant that, under the careful stewardship of founder and executive chef James Lowe, has been meticulous about sustainability from the start.

'As I've got older, I've felt the need to have more of an impact than "that was a really good dish" – not that that's not a great thing, but I want to be able to incorporate environmental and agricultural issues into what I do,' says Yung. Like Lyle's, its sister restaurant, Flor has sourced from organic and regenerative producers since it opened; now Yung wants to take this philosophy outside of the kitchen and into mainstream conversation. 'It's not just about sourcing well; it's about communicating to the customer what that means; how it supports the grower; the greater good in the world, and how they can take part.'

Being a baker as well as a chef, grain is the obvious starting point. 'It's an economy that is increasingly important in terms of how it is grown and how beneficial it is in feeding the world. Just saying we use "heritage grain" [slower-growing grain varieties that predate high-yielding, hybridised wheat; the mass cultivation of which has proved so damaging to soil health and biodiversity] is not enough anymore.' This doesn't mean she's looking to lecture someone over Flor's famed, chewy, cheesy flatbreads; more that she is looking to engage the media – and by extension the public – in a more meaningful way.

Our interview is on the phone – but I can almost hear her eyes rolling as we discuss the 'top 50 insert-adjective listicles' that dominate some parts of the food media. 'We can do better. We have to do better,' she exclaims. 'We have just lived through a pandemic that has been, if not brought on by, then exacerbated by many of the issues around agriculture and food production. These are the issues that are going to drastically affect our lives in the next 50 years. It's more important than anything else we can talk about.'

'Not everyone has the privilege of growing up with parents who had time to cook from scratch.'

Pamela Yung's Mozzarella in Carrozza

'A snack food for the masses in much of southern Italy, mozzarella in carrozza is traditionally made with leftovers – dried slices of bread; yesterday's mozzarella; the ever-present bowl of breadcrumbs that makes a cameo in nearly every dish in *cucina povera*, the food of Italy that speaks so dearly to me in its no-waste economy and elevation of simple ingredients. As a young cook in New York City, my post-shift, late-night appetite was often satiated at the (now-defunct) Lower East Side institution 'inoteca. My order would ALWAYS include their version of this southern Italian classic. I've decided to revisit that memory with our own version at Flor, with the cheeky addition of incredibly delicious 'nduja.'

Serves 2

250g/9oz ball of high-quality buffalo mozzarella
4 slices of stale bread (at Flor, we use a
 housemade milk bread)
'nduja (I suggest purchasing it from my friend
 Giuseppe at De Calabria in Borough Market)
drizzle of honey
sprinkle of dried Sicilian oregano

300g/10½oz plain flour
3 eggs
splash of milk, plus extra to brush
300g/10½oz fine breadcrumbs or
 panko breadcrumbs
vegetable or sunflower oil, to deep-fry
8 good-quality anchovies
sea salt and freshly ground
 black pepper

Slice your mozzarella into 1cm/½in planks and carefully dab them between sturdy paper towels to remove excess moisture.

Arrange 2 slices of the bread face up and, using a butter knife, spread a thin layer of 'nduja onto each slice. Follow with a generous drizzle of honey and a sprinkle of oregano on each. Trim your mozzarella to fit within ¾cm/¼in of the bread's perimeter and lay it flat onto the slices. Season with sea salt.

Carefully layer the second pieces of bread on top of each slice. Use a pastry brush dipped in milk to moisten the perimeter of the top slice of bread – this will help with adhesion. Using your palm, carefully and evenly apply pressure to try to create a 'seal' around the mozzarella. With a serrated knife, trim the crusts from the sandwich.

Apply pressure once more to ensure a closed edge.

Prepare to bread the sandwiches. In three separate bowls, place the plain flour (seasoned with salt and pepper); the eggs, lightly whisked with the splash of milk; and the breadcrumbs. Take a sandwich and coat it completely (both sides and four edges) with plain flour. Next, moisten entirely with the egg mixture – no dry spots should remain. Finally, coat it well in the breadcrumbs.

Fill a large, deep pot with a few inches of oil and heat to 180°C/350°C. Drop the sandwich into the oil and fry for 2–3 minutes on each side, until golden. Repeat the breading and frying process with the other sandwich, then plate up and drape over the anchovies. These sandwiches are best savoured hot, when the cheese pulls in the prized '*al telefono*' fashion.

Romy Gill

Food writer, cookbook author and previously chef-owner of Romy's Kitchen in Gloucestershire

'I wanted my own restaurant. I didn't want to own it with my husband.'

'I want to be known as a chef first. Then, as a female chef. I want my food to look pretty when it is going out over the pass not because I am a woman, but because you eat with your eyes. I am a feminist,' Romy Gill tells me, with the spirit of a woman who spent almost two years trying to get a bank loan for her restaurant, seven years running it, and has in the meantime written a cookbook and raised two now-teenage daughters. 'I want people to know that. I want my daughters to see.'

As it is, they'd struggle to miss her. Though Gill relinquished Romy's Kitchen in Thornbury, a market town between Bristol and Gloucester, in 2019, her public profile has gone from strength to strength, with an MBE, regular appearances on television, features in newspapers and residencies across the country. In 2020 it was announced she would be co-hosting BBC One's revival of hit 90s series *Ready Steady Cook*. 'I remember watching it when I moved to this country, thinking how amazing it would be to be Green Pepper or Red Pepper, never dreaming I could actually be on there,' she says wonderingly. It's a far cry from the Bengali steel plant she grew up in with her parents, surrounded by families who had travelled from all over India to work there; but then it's also unlikely she'd be where she is today if it wasn't for that unique childhood.

'If my dad hadn't worked in that steel plant; if he hadn't left North India to go over to West Bengal; then I wouldn't know and understand the flavours and cuisines of people from all over India.

Romy Gill

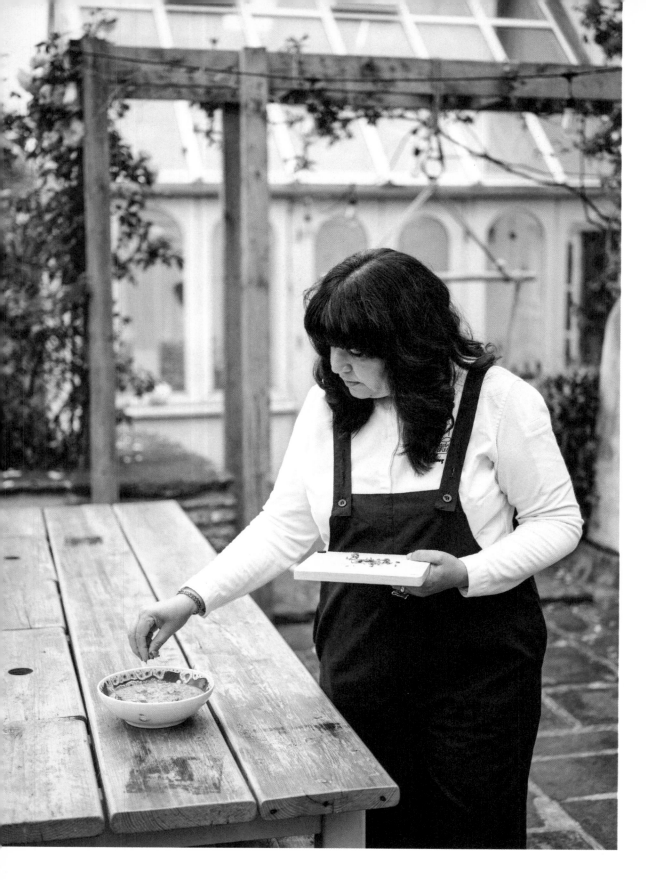

My best friends were from Bengal, Kerala, Kashmir, Nepal, and when people migrate, they take their identity with them, in their language, rituals and food.' Her turning point – the point at which she realised she could make money from her talent for cooking – came when she noticed how different she was from most Indian émigrés. 'Most Indian food writers and chefs in this country will only know the food of the region of India that their family is from; I can talk about the cuisines of many regions.' She is both indebted to her culinary heritage, and free to carve her own path through it.

Yet it is a long road from deciding to be a chef to becoming one; and it's even longer if you're a woman of colour with two children and no formal training. Though Gill had worked solidly for four years running cookery classes, catering for events and selling her sauces, samosas and chutneys at markets, the bank refused to stump up the cash for her to open a restaurant of her own. 'I wanted it to be my restaurant. I didn't want to own it with my husband,' she says – which would have been an easier way of securing a loan payment. One of the reasons the title of 'chef' matters so much to Gill is because she's fought so hard for it: selling her jewellery to raise the money for the restaurant, then, after it opened, working around the clock to build its reputation.

'I didn't see my kids for five years. But I knew that in order to establish my restaurant I needed to do that.' Owning a small restaurant in a small town, there was a limit to how much she could charge, and how many people she could employ. Her strong social media presence – her strong media presence – today belies the fact that for ten years she's been in a tiny kitchen 'actually cooking' for guests who flocked from around the country.

'I managed the reservations, the finances and cooked the food. I am a chef, and I want journalists to understand that.' Much as she respects the influencers of Instagram, 'they couldn't cook in a restaurant. It is a very different thing.'

Whether she will open another restaurant remains to be seen; for now, she is focused on her forthcoming book, *On the Himalayan Trail*, restaurant residencies and her TV slots and newspaper spreads. Having platforms like *Ready Steady Cook* and a regular recipe column in the *Independent* matters because 'women are great chefs. They are in restaurants. But they are not being noticed enough.' The newspaper supplements and prime-time TV series are 'men, men, men' – in part, she continues, 'because of the cliquishness of the industry.'

'Andi Oliver (p.18) is changing that. She's doing brilliant things,' says Gill – while for her own part, she hopes being the first female Indian chef to be awarded an MBE will 'shine a light for other women.' Ideologically, she knows how important it is that women, particularly women of colour, 'can see that I have done it'; yet Gill's reputation for running or collaborating in charity suppers (many of them led by all-female kitchens) shows that she thrives on being of practical use, whether that's for Action Against Hunger, young Indian entrepreneurs or BAME communities affected by Covid-19.

'I remember at the steel plant, women from all over India drying spices and pickling fruits and chopping together. They would help each other and share each other's food. That's how I grew up – so if any woman needs my help, I will help them,' Gill enthuses – 'not to follow in my footsteps, but to stand on their own feet and say, "This is what I do."'

Romy Gill's Urad Dal

'Every dal recipe tells a story; every Southeast Asian can tell you one. Dal can be a complete meal, but it is also an important part of a Thali. For me it is a warming, comforting dish that I cook all the time.'

Serves 4–5

250g/9oz urad dal (washed and drained)
1 tsp ground turmeric
1–2 tsp salt
½ lime, juiced
fresh coriander, chopped, to serve

For the tadka
3 tsp ghee (or 5 tsp sunflower oil)
1 tsp cumin seeds
6 garlic cloves,
 chopped
10g/⅓oz fresh ginger, peeled
 and chopped
5 spring onions, chopped
2 green chillies, chopped
100g/3½oz tomatoes, chopped
1 tsp ground cumin
1 tsp ground coriander

Add the urad dal to a medium-sized saucepan over a medium heat with 900ml–1 litre/1½–1¾ pints water (depending on the consistency you want for the dal), the turmeric and salt. Cook, stirring occasionally, for 30 minutes–1 hour, checking, until the urad dal are tender.

Meanwhile, make the tadka. Heat the ghee (or sunflower oil) in a frying pan over a medium heat, then add the cumin seeds, and when they start to sizzle, add the garlic and ginger and cook for 1 minute. Add the spring onions and green chillies and cook for another 3 minutes.

Then tip in the tomatoes and cook for a further 2 minutes. Add the ground cumin and coriander and mix it all together. Cook for another minute, then remove from the heat.

Check the urad dal and, once nearly cooked, add the tadka into the dal and stir thoroughly. Cook for 3–4 minutes, then stir in the lime juice and serve scattered with the fresh coriander.

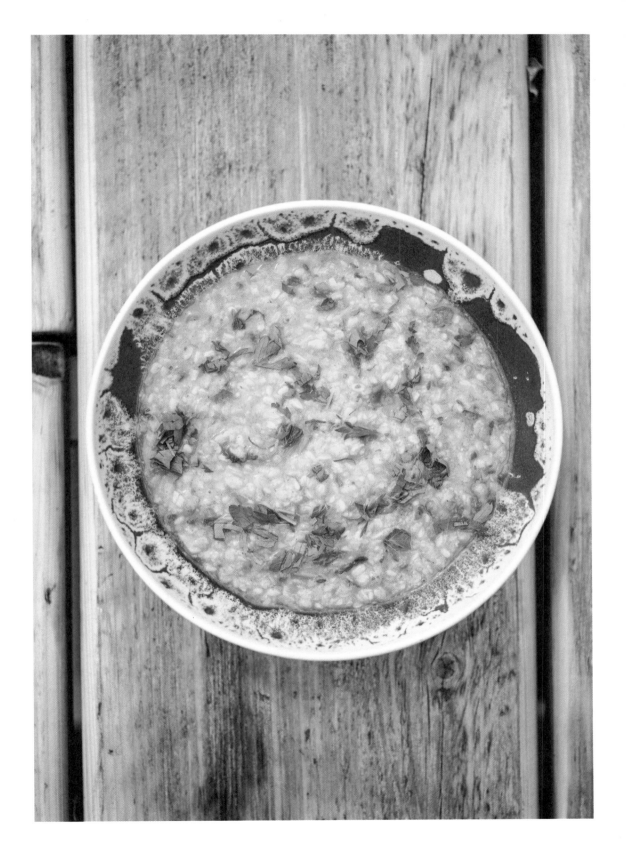

Zoe Adjonyoh

Founder of Zoe's Ghana Kitchen: a supper club,
pop-up, catering business and cookbook

'I have shown there is an appetite for
West African food: that people will pay for it,
that it is a viable business opportunity.'

The year is 2017, and I am sat with my friend Elizabeth: an elderly Ghanaian lady I met through Age UK. 'I don't believe it,' Elizabeth says sceptically. 'A Ghanaian cookbook? In English? Let me see.' I hand her Zoe Adjonyoh's cookbook, *Zoe's Ghana Kitchen*. 'She is half Ghanaian,' I stress, nervously. Elizabeth purses her lips; then, as she leafs through its pages, smiles in recognition. 'This is akara – and this is jollof rice! I've made you this before.'

'Some cultures in Britain don't get to see themselves,' Adjonyoh explains, when I recount this moment years later. 'When it came out, I had Ghanaians around the world mailing me to tell me how proud they were.' In the beautifully illustrated, perfectly bound pages of *Zoe's Ghana Kitchen*, British Ghanaians like Elizabeth saw their food recognised and represented as something aspirational and interesting.

'The cooking part of the book was less important than how it looked and felt overall; than it being a tool to inspire and be inspired by,' Adjonyoh continues. Many cookbook authors perish the thought of their creation being a coffee-table book, but that is exactly what Adjonyoh aimed for. 'It was about sharing the culture and giving it gravitas. I wasn't under any misconceptions that the book would have everyone cooking Ghanaian recipes twice a week.'

Her biggest accomplishment so far – and there will be plenty more during her lifetime – is to have 'kickstarted the West African food revolution over

Zoe Adjonyoh

*Adjonyoh at home in Hackney in the
live/work space where she hosts Zoe's
Ghana Kitchen supper clubs and
runs her catering business.*

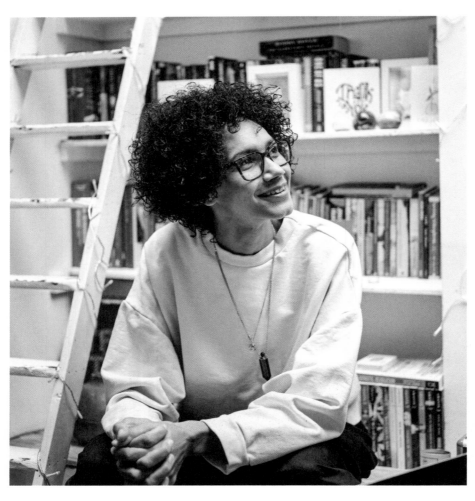

here; to show there is an appetite for this food, that people will pay for it, that it is a viable business opportunity.' It's an extraordinary feat for someone whose initiation into Ghanaian cooking came, not from growing up in Ghana, but from watching her dad cook for himself.

'It was a meditative, secretive act,' she explains, 'and it piqued my curiosity. We couldn't afford to visit Ghana when I was a kid, so my relationship with the country was rooted in watching my dad cooking.' As she grew older, she learnt the recipes herself – 'My dad was not a consistent figure in my childhood,' she points out – and cooked them for friends. The result (after a lengthy stint working in various industries) is Zoe's Ghana Kitchen, the moniker under which her stall, supper club, restaurant and cookbook all sit – but that's a well-known history. What's less talked about, she says, is the influence of the many women on her life, and of her own identity as a queer woman.

'My mum always gets left out of the story, but she is hugely influential. She raised me, and while I haven't eaten her food for a long time, because I normally cook when I visit, there is a maternal, feeder energy I bring to Zoe's Ghana Kitchen – or perhaps more a lesbian aunt energy,' Adjonyoh laughs. It frustrates her that no one asks about the relationship between her sexual orientation and her culinary identity. 'I think my queerness is responsible for part of my creative flair, and my rapport.'

There is a distinct and deliberate modernity to Adjonyoh's food, informed by her growing up in Woolwich, by her queerness and by her being the daughter 'of two immigrants: one Black and one Irish. 1970s England was not a welcoming place,' she says dryly. As a result, she feels very comfortable operating in the liminal space between London's contemporary food culture, and traditional Ghanaian cuisine. It's why the 'Zoe' part of Zoe's Ghana Kitchen is so important – because while the culture is hers to 'be in and experiment in, it isn't mine to appropriate or tell people what it is or isn't. When I started my business, I was mindful of that – so it is my relationship, my lens on Ghanaian food, informed by who I am and where I am in the world, and my hope to reach people of all races and backgrounds. People like me.'

Adjonyoh's confidence in that space stems from her background – but it has been sharpened by the women she spoke to and cooked with when she travelled around Ghana in 2013. 'I met all these aunties and grandmas, and what I took away was just how adaptable the cuisine was. Different women had different recipes, there are variations between tribes, and that enabled me to bring my own nuance' – a nuance which serves both to delineate and celebrate Ghanaian food, but also more broadly to bring today's Africa into Britain's cultural mainstream.

'The idea with the supper clubs and restaurant was that they were a gateway to a wider conversation about what Africa is now – about its art, music, literature,' she continues. 'I wanted to offer an alternative narrative to that I was bombarded by growing up: of Africa as a place of famine and poverty.' By decolonising people's diets, she hopes to decolonise people's minds, she says – or at least, to encourage them to investigate more. 'I can't do all the work for them. But I can, as a cook, a chef and a writer, unlock a key.'

'I think my queerness is responsible for part of my creative flair, and my rapport.'

Zoe Adjonyoh's Jamestown Grilled Prawns

'Grilling over charcoal is the favoured way to cook most fish and seafood in Ghana – especially along the Accra coastline, where there is an abundance of fresh seafood, and up into the region alongside Lake Volta. This recipe is inspired by my experience in Jamestown, Accra, where I watched the local fisherman hauling in their catches.'

Serves 6 (2–3 prawns each)

1kg/2lb 3oz uncooked shell-on king prawns
 or tiger prawns
4 tbsp coconut oil
1 onion, finely shredded or grated
zest and juice of 2 lemons

2 tbsp chopped thyme
1 heaped tsp ground ginger, or grated fresh ginger
1 tsp grated garlic
2 tsp ground hot pepper (or substitute
 cayenne pepper)
1 heaped tsp dried ground prawn powder
1 tsp sea salt

If you are using bamboo skewers rather than metal, put them in water to soak for 1 hour to prevent them burning on the barbecue.

Wash the prawns and remove the heads but leave the shells on for a more dramatic presentation. Butterfly the prawns so that you create a greater surface area for your seasoning: using a sharp knife, score down the belly and open out. This will also enable you to de-vein the prawns. Rinse thoroughly and pat dry. You can ask your fishmonger to prepare the prawns for you, if you prefer.

Put 2 tablespoons of the coconut oil in a bowl with all the remaining ingredients and mix well. Add the prepared prawns and gently turn to coat them all over with the marinade. Cover the bowl with clingfilm and leave in the fridge for 30 minutes to soak up the marinade while you light your charcoal barbecue and wait until the coals have burnt down and are covered in a grey ash. Alternatively, preheat a gas barbecue to medium-high.

Once the barbecue is ready for cooking, thread the prawns on to skewers. Brush the barbecue grill well with some of the reserved coconut oil and also drizzle the oil over the skewers, coating each side. Add the skewers to the grill and cook for 3–4 minutes on each side. Serve with a selection of dips and salsas, and plain boiled or coconut rice (see recipe opposite).

Zoe Adjonyoh's Coconut Rice

'Coconut features hugely in the West African diet and every street corner will have someone selling fresh coconuts with a hole and a straw to sip from. Using fresh coconut to cook with is a dream but not always entirely practical, so good-quality organic canned coconut milk will suffice.'

Serves 4

300–400g (10½–14oz) basmati or other long-grain white rice (75g/2¾oz per person is the norm but that's not enough in an African household, so I always go for at least 100g/3½oz per person, as you can always have seconds)

sea salt, to taste
400g (14oz) can organic coconut milk (you may not need it all)

Wash the rice thoroughly in cold water to remove as much starch as possible – I wash it in at least 3 changes of water until the water runs clear – then drain and place in a large, heavy-based saucepan. Pour in just enough water to cover the rice and add salt to taste – I use about ½ teaspoon sea salt, as I don't like over-salty rice. Cover and cook over a medium heat for about 5 minutes until it starts to boil – this allows the grains to open up.

Shake the can of coconut milk thoroughly before opening, then add about half the can to the rice and stir it through. Replace the lid and cook for a further 10 minutes over a medium-high heat.

Add another one-quarter of the can and stir it in, then reduce the heat and simmer for about 7 minutes until all the liquid has been absorbed and the rice is tender and fluffy.

Sam Evans
& Shauna Guinn

Cookbook authors and co-founders of
Hang Fire Southern Kitchen in Barry

'Never in a million years did those chefs think these two ladies would go back to Wales and set up a barbecue restaurant.'

'Fire is fire. It doesn't light or burn better just because you're a man,' laughs Sam Evans (pictured left). Together with her wife and business partner Shauna Guinn (right), Evans has been tending the flames at Hang Fire Southern Kitchen for five years now, slow-cooking and smoking large, hefty cuts of meat in the Deep South, not of America, but of post-industrial Wales. They might seem unlikely candidates for running a barbecue restaurant if, like me, you grew up in a home where 'barbecue' meant Dad charring chicken wings – but times are changing. When, in 2020, Guinn and Evans accidentally 'outed' themselves on TV to an 11-million-strong audience, the response was overwhelmingly one of support. And the couple's Barry-based barbecue kitchen has been slowly, steadily upending preconceptions we may have about who can barbecue meat, and where.

As *Financial Times* restaurant critic Tim Hayward pointed out in his glowing review of Hang Fire, Guinn and Evans didn't need to open in Wales and 'contribute to the regeneration of an area in sore need of help.' Nor did they need to be particularly adventurous with the menu, which comprises not just wings and brisket, but dill pickle chips, known as 'frickles', 'piggybacks' of puffed pork chicharrones, and gumbo, authentically made with tasso ham.

Were Hang Fire merely about proving a point – that women could master the art of smoking whole joints of meat over a flame – then they could have opened a bog-standard barbecue joint in Hackney

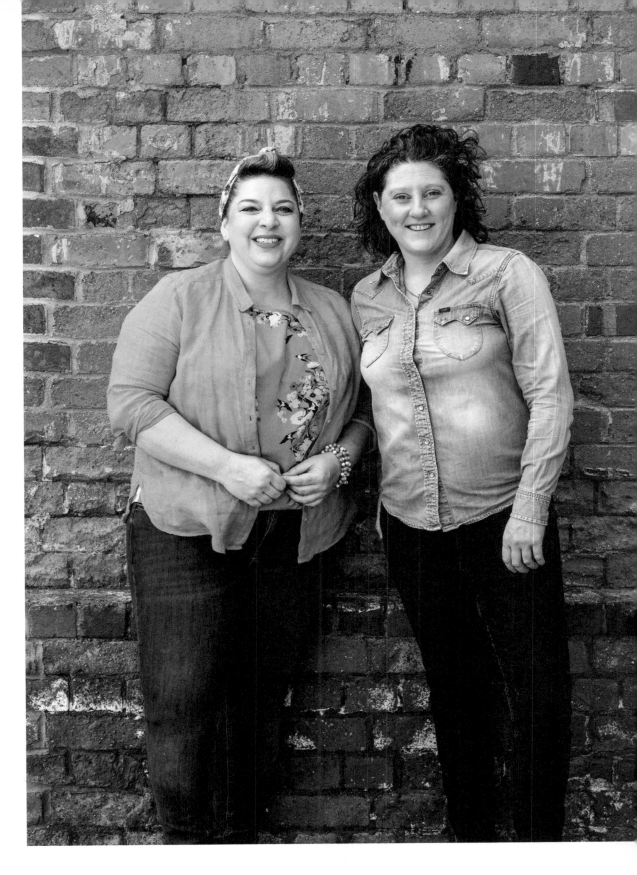

Sam Evans & Shauna Guinn 151

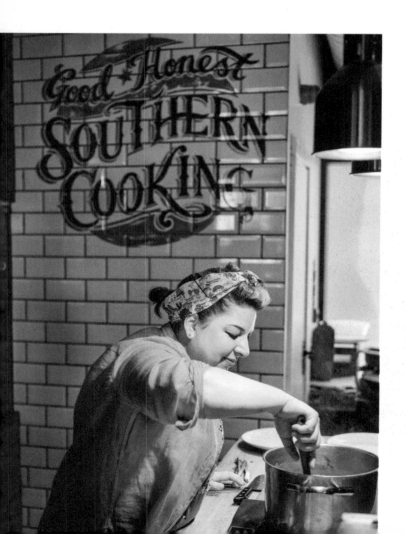

Evans cooking shrimp and tasso filé gumbo (see recipe on p.156) at Hang Fire Southern Kitchen, the barbecue restaurant she and Guinn own in South Wales.

and charged a small fortune. But the enthusiasm that drove Evans and Guinn to leave successful jobs in London was as blind to riches as it was to their being female. This same enthusiasm sent them on a quest across America learning about fire pits, then propelled them back to a pub in Cardiff, armed with a smoker and some locally sourced, 28-day-aged pork, and ultimately resulted in their winning the *Observer Food Monthly* Best Restaurant Award.

'We knew meat was male dominated, we knew barbecue was male dominated – we knew the restaurant industry was male dominated,' laughs Guinn. 'It didn't matter to us.' In part, that came 'off the back of our positions before – Sam in a high-level advertising industry, me in the world of policy and academia.' It didn't matter to them – and yet there's no denying the reason Guinn and Evans were so successful in gleaning advice from southern barbecue chefs was because they were women; because 'never in a million years did those chefs think these two ladies would go back to Wales and set up a barbecue restaurant. They took us out the back, encouraged us to take photos – and were happy to spill the beans because they never thought we were serious,' Guinn laughingly acknowledges; and when the pair established the pub-based pop-up that became Hang Fire Southern Kitchen, they drew as many female customers as male.

'Women love this style of food – they just don't want the bullshit of tattooed, lumberjack-shirted, top-knot masculinity that comes with it,' Evans observes. In Hayward's review, he went one step further, attributing the flavour of the food itself to the pair's femaleness: 'He claimed our food had a lightness of touch he had never tasted in barbecue before, and put it down to a sort of feminine sensibility,' Guinn recalls proudly. Their spicing is delicate; their touch is 'deft,' says Evans – whether because they are female or not, she couldn't say, 'but we don't cut corners. Our kitchen is not a place for anyone with an arrogant "that'll do" approach.' Yet while Hang Fire has thrived, with nearly every single evening booked out for five years, the barbecue bias towards men continues to linger.

'I think it's a hangover from dads barbecuing,' sighs Guinn – for while the gender politics of other foods are moving on, barbecue remains determinedly in the back garden, burning burgers. 'We had three BBC series, an *OFM* award and a BBC Food and Farming award. Yet I honestly don't think Sam is considered in the same light as the male barbecue chefs today.' At Meatopia, London's annual barbecue festival, they see a chance to deliciously redress this: 'I take an all-female team – and every year we go bigger and better,' Evans grins. 'It's my annual opportunity to put two fingers up at the male barbecue establishment.'

'Our kitchen is not a place for anyone with an arrogant "that'll do" approach.'

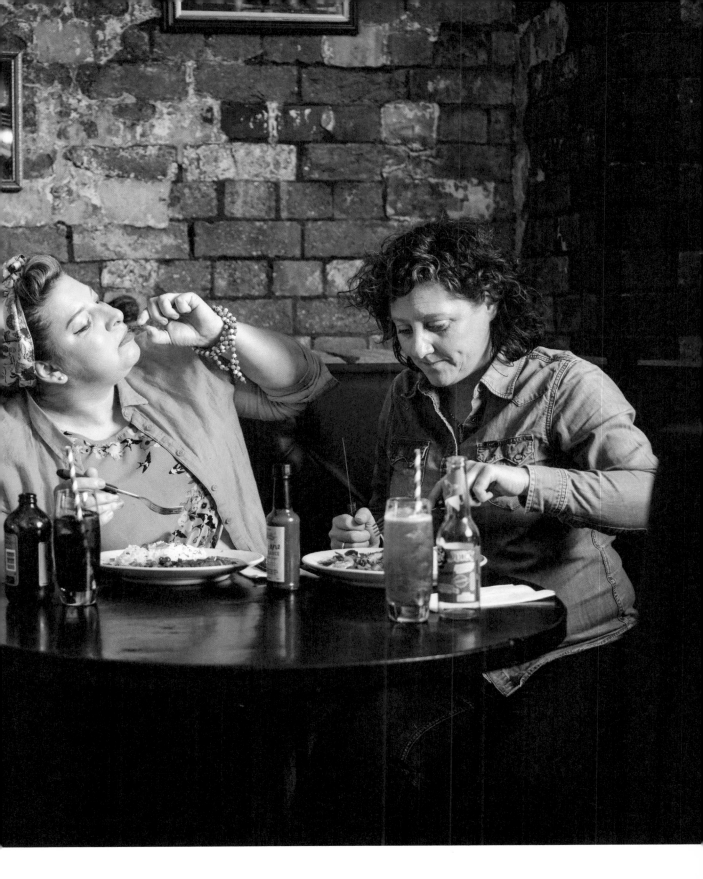

Sam Evans & Shauna Guinn

Sam Evans and Shauna Guinn's Shrimp and Tasso Filé Gumbo

'Gumbo really is so representative of who we are as chefs and people. The multiculturalism that came together to birth this dish – from the journey of the ingredients from West Africa, to the French-Creole preparation – is a perfect representation of food migration. Add to that a good helping of Deep South swagger, and for us, you have a perfect blend of history, people and produce in a bowl.'

Serves 4

130ml/4¼fl oz vegetable oil
120g/4¼oz plain flour
150g/5oz tasso ham, diced
1 medium onion, diced
1 green bell pepper, deseeded and diced
2 celery sticks, diced
3 tbsp Creole seasoning
2 garlic cloves, finely chopped

3 bay leaves
1½ litres/2¾ pints cold chicken stock
2 tsp dried thyme
350g/12¼oz shell-on jumbo prawns,
 rinsed and heads removed
2 tsp filé powder
2 tsp Worcestershire sauce
2 tbsp finely chopped flat-leaf parsley
3 spring onions, finely sliced
sea salt flakes and freshly cracked pepper

Heat the vegetable oil in a heavy-based pan, or cast-iron casserole dish, over a medium heat. Add the flour and use a wooden spoon to mix well. Cook, stirring the flour frequently, for 20–25 minutes, until you have a milk chocolate-coloured roux. Be super careful it doesn't splash you.

When your roux is ready, add your tasso ham, stir for 1 minute, then throw in your Louisiana 'holy trinity' of vegetables: the onion, bell pepper and celery. Mix through and add 1 tablespoon of the Creole seasoning, the garlic and bay leaves, stirring often for about 10 minutes, until the vegetables have softened. You'll notice the heat

of the roux will start cooking the vegetables and ham very quickly.

Next, gradually add the cold chicken stock, a ladle at a time, until fully combined. Stir in the remaining Creole seasoning and the thyme. Bring to a rolling boil over a high heat, then turn the heat down to medium-low and simmer, uncovered, for 1 hour. About 10 minutes before the end of the cook time, add your prawns, filé powder, Worcestershire sauce, parsley and spring onions and season to taste. Cook for 3–5 minutes, until the prawns are fully pink and cooked through. Serve immediately, with crusty bread or rice.

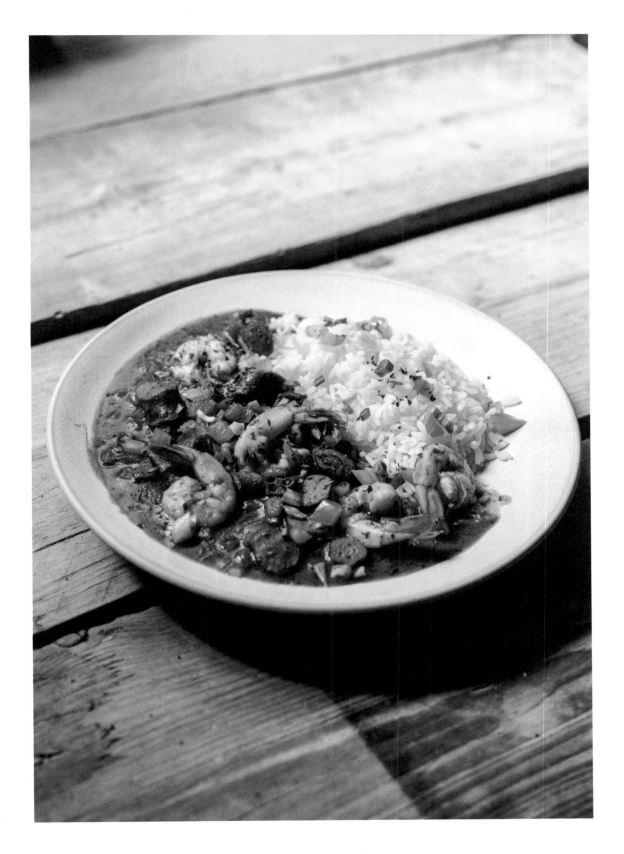

Saiphin Moore

Co-founder of Rosa's Thai Café, which started in London and now has branches across England

'I'd always wondered why my dad and brother never cooked. I didn't realise that in the outside world, men were chefs.'

'Even though I have over 20 restaurants, and have created everything on the menu, I still don't call myself "chef",' Saiphin Moore muses – 'which is funny.' Growing up in rural Thailand in the 1980s, Moore didn't think men could cook until she moved to Hong Kong and found restaurants were staffed almost exclusively by them. 'It was such a shock!' She laughs. 'I'd always wondered why my dad and brother never cooked. I didn't realise that in the outside world, men were chefs.'

Moore's childhood was as remote as it sounds. Born in the mountainous region of Khao Kho, she was raised on a farm and grew up helping her mum and aunt in the kitchen. 'Back then girls cooked from a young age. My parents were from Laos originally, so I learnt Thai dishes from my aunt – though she didn't teach me. She told me, "Make curry paste", and I learnt that way.' It didn't take much to encourage Moore's interest in cooking, however: 'I remember every time I went to water the vegetables by the river, I took my fishing rod. When I caught any, I'd set up a fire and barbecue them by myself.' She was just nine years old.

By age 14, Moore was running a noodle stall. 'I'd get up at 5am, ride my motorbike to the market and set up my shop. After school I'd rush out to cook noodles to sell to friends,' she recalls. By the time she left, she was making around 700 baht a day – 'a lot of money back then!' Fast forward three years and she's in Hong Kong, balancing her job as a nanny with making 200 spring rolls every day in a Thai restaurant, where she learnt everything

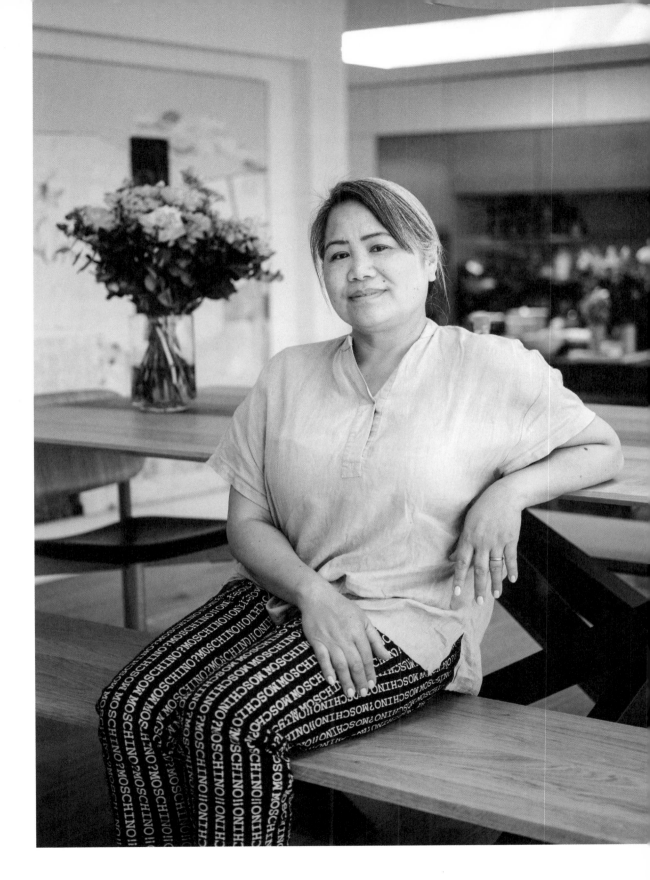

Saiphin Moore

she didn't know already. 'There were 50 dishes on the menu!' she exclaims. Then, in 1997, the year the British finally ceded Hong Kong to China, Moore's life took a dramatic turn.

'During the Handover we didn't know what was going to happen – so my ex-husband, a Jersey man, sent me and our two children to Jersey to be safe,' Moore says. 'It was a bad shock.' She'd never been anywhere so cold, isolated and utterly devoid of familiar ingredients. 'I had to substitute everything: Italian basil instead of Thai basil; swede instead of papaya.' Yet she learnt 'so much about adapting what you have to recreate recipes' – knowledge that, at the time, benefitted only the other homesick Thai émigrés she had befriended on the island, but which would stand her in good stead when, five years, a divorce and another marriage later, she set up the stall that would one day make Thai cuisine mainstream in the UK.

Moore moved to London in 2006, after returning to Hong Kong and establishing a successful chain of restaurants with her new husband, Alex. 'We sold up, arrived in London and I said, "I'm looking for a restaurant." Alex said, "Darling, you can't just set up a restaurant here, it's not like that."' Yet he had not – quite – counted on Moore's talent, and her determination to bring Thai food to Britain. One Sunday, on a stroll through east London, Moore and her husband stumbled across a street-food market – and after sampling one of Moore's signature spring rolls, the market manager was sold on the idea of her taking a stall.

Today, the path from street-food stall to fully fledged restaurant is well trodden. In 2006 it took

something exceptional; and that something was Moore's cooking. To her initial offering of fresh spring rolls, she added massaman curry, beef penang, pad thai and more: dishes that were unheard of back then, but are more or less household names today. Moore has moved on since her 5am starts and cooking her fare on camping stoves every Sunday – but her menu hasn't. 'Everything I sold at the stall is at Rosa's', she says – with the odd tweak to reflect what she has learnt about Brits' spice tolerance and culinary bewilderment. 'In Thailand, pad thai is like chips: everyone adds their own condiments, creates their own flavour. It's plain without. But people here didn't realise that,' she explains, 'so I mixed in the condiments – basil, chilli, lemon, sugar, vinegar – in a balanced way.'

It is just one example of the many ways in which Moore's recipes are both classically Thai, and entirely unique; the product of years spent cooking and adapting. It's why in 2008, when she had finally saved up enough to secure an old greasy spoon called 'Rosa's' she decided to incorporate the previous owner into her restaurant's name. 'Rosa had cooked there for 40 years. It was out of respect to her, and to all the women who have brought me here: to my mother, auntie, the women I've worked with,' Moore says simply. She might not yet be comfortable being called chef ('Though maybe I will now!' she jokes at the end of our call); but she's fine being Rosa. 'People call me that all the time, and I don't mind! Rosa visited us a year after we opened – and was so happy we'd remembered her in our Thai café.'

'I'd get up at 5am, ride my motorbike to the market and set up my shop.'

'I learnt Thai dishes from my aunt – though she didn't teach me. She told me, "Make curry paste", and I learnt that way.'

Saiphin Moore's Thai Noodle Soup

'This recipe is my favourite thing to eat; I eat it almost every day and there's always a pot of stock on my stove. It's also the dish that kickstarted my journey as a chef; I had a roadside noodle stall when I was just 14 and it helped to support my family.'

Serves 6–8

400g/14oz rice vermicelli noodles
6 tbsp vegetable oil
6 garlic cloves, crushed
1¼ litres/2 pints low-salt chicken stock
2 tbsp light soy sauce
2 tbsp palm sugar
1 bulb of pickled garlic
8 coriander roots
2 pandan leaves

1 tsp salt
400g/14oz boneless, skinless chicken breast
300g/10oz beansprouts

To serve
2 Chinese celery sticks, chopped
4 sprigs of coriander, finely chopped
4 spring onions, finely chopped
2 tsp dried turnip (available from
 Asian supermarkets)
pinch of white pepper

Soak the rice vermicelli noodles in warm water for 10 minutes until softened, then drain. Meanwhile, heat the oil in a small saucepan over a high heat, add the garlic and cook, stirring continuously, until it is golden. Remove the garlic from the pan and set aside.

Pour the chicken stock into a deep saucepan, add the soy sauce, palm sugar, pickled garlic, coriander roots, pandan leaves and salt and bring to a low boil. Add the chicken and poach for 20 minutes, then remove from the pan, slice and set aside. If the chicken is not yet cooked through, return the slices to the pot until they are done, then remove and set aside. Simmer the soup for 2 minutes more.

Bring a pan of water to a rolling boil, then add the noodles and cook for 30 seconds. Drain and place in a bowl with the beansprouts. Set aside.

Divide the noodles and beansprouts between two serving bowls, fish the pandan leaves out of the soup, then pour it over the noodles. The hot stock will cook the bean sprouts ever so slightly. Top with the sliced chicken and sprinkle over the Chinese celery, coriander, spring onions and dried turnip. Season with the white pepper, serve and enjoy!

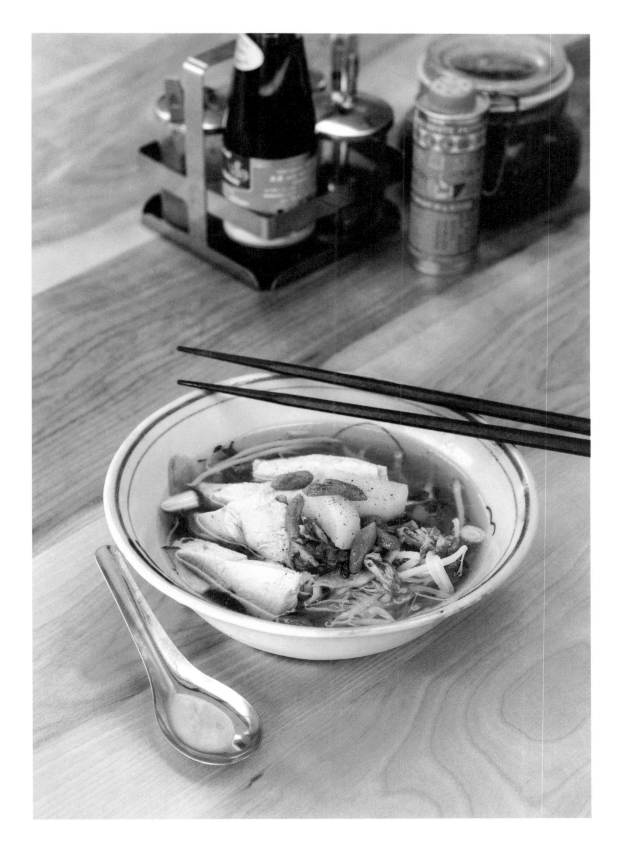

Selin Kiazim

Co-founder of Oklava in Shoreditch, whose recipes draw on her Turkish Cypriot heritage

'I am one of a number of chefs trying to pull away the industry's stigma and show how wonderful and fulfilling it can be.'

'The first thing I thought upon meeting Peter Gordon was, this is what it's like to be a great chef, running a successful restaurant, and still be nice to everyone,' says London-based chef Selin Kiazim. The experience of working with New Zealander chef Gordon – as famed for his kindness as he is for his fusion cooking – early in her career proved pivotal for Kiazim, who has gone on to recalibrate London's view of Turkish cuisine. 'If I hadn't met Peter, there is a question mark over whether I would ever have gone into restaurants,' she continues. 'Until then my experience of professional kitchens had been hotels and contract catering – and nothing felt right.' Though she experienced no overt bullying, 'there was a sense of aggression' – not helped by the way in which restaurant kitchens were being portrayed on TV at the time. 'These were the days of Gordon Ramsay shouting and screaming on screen.'

Kiazim's experience of working with Peter Gordon – for almost five years at his restaurants The Providores in Marylebone and Kopapa in Covent Garden – informed not just her decision to become a chef, but her way of being one. 'Some chefs like to try lots of different kitchens, but I learnt everything I needed working with Peter,' she reflects. 'Anyone who worked with him would say the same.'

Today Kiazim is 35. She has her own restaurant, Oklava; a cookbook of the same name; and with them, her own distinct brand of cooking. Though Gordon 'will always be a massive inspiration, I have

Selin Kiazim

Kiazim at Oklava, the restaurant in London she founded with business partner Laura Christie, making chilli roast cauliflower (see recipe overleaf).

changed with time. I have my own style.' In Oklava's signature dishes – medjool date butter slathered on sesame-seeded bharat bread and grilled *hellim* (halloumi), chewy and collapsing under streaks of London honey – one sees the influence not just of Gordon, but of her Cypriot grandmother. 'She's 92 now and cooking a lot less, but she's always made everything from scratch. I can see her now, elbow-deep in dough next to the bread-maker she refuses to use,' laughs the chef. But Kiazim's London upbringing also shapes the food she creates: 'I grew up in north London, so I am cooking food of my Turkish Cypriot heritage through the eyes of a Londoner.'

Oklava is a female-led operation, womanned by Kiazim and her business partner Laura Christie. When they opened in 2015, the trend for upending the clichés attached to regional cuisines was still in its infancy. Yet in the coming years, Kiazim would do for Turkish food what the Sethi family (founders of Gymkhana, Brigadiers and Trishna) have done for Indian cuisine, and Saiphin Moore (p.158) for Thai. 'In Oklava I was trying to do something specific,' Kiazim explains, 'and that was to show that, lovely as they are, there is more to Turkish food than mezzes and kebabs. I spent years fighting people who said, "I can get three times this amount of food for a tenner on Green Lanes" [north London's stretch of famously cheap mangal grills] – but I think I've conveyed that message.'

Her achievement has taken place against the backdrop of a more general shift, 'away from dainty, fancy plates and towards what gives people comfort; what they are craving,' Kiazim observes.

With the rise of programmes like *MasterChef*, which give talented home cooks a professional platform, 'people cooking food that is simple, but still delicious and wonderful, are getting a voice.' The line between home food and restaurant food is crumbling steadily – and it is into this space that Kiazim has stepped, with a menu that's high end, but homely. 'I don't really think about it until I'm asked, but those food memories of my grandma are part and parcel of Oklava.'

Kiazim is a chef: not a Turkish chef, not a female chef, but a chef who is female, of Turkish Cypriot descent, brought up and classically trained in London and schooled by Peter Gordon. 'I got boxed in very quickly. Most chefs I know are,' she says patiently, 'but I spent years with Peter, cooking food from all over the world.' Her next book, she says, will reflect that; her restaurant, meanwhile, will continue to create an environment that attracts more people like her.

'We pride ourselves on creating a happy, inclusive environment. We pay as much as we can. We have open conversations about hours, travel, childcare,' Kiazim says. She's not set out to solely hire women – 'it's hell to hire anyone at present, male or female' – but her philosophy is 'build it and they will come'. 'I am one of a number of chefs trying to pull away the industry's stigma and show how wonderful and fulfilling it can be; how it is possible to create almost a second family out of your colleagues. The more exposure we get, the more likely it is a mother will ring us for work,' she continues. 'The more likely it is that a young woman will look at me and say, "I want to be like her."'

'I was trying to show that, lovely as they are, there is more to Turkish food than mezzes and kebabs.'

Selin Kiazim's Chilli Roast Cauliflower

'On my first trip to Istanbul, I went to as many food markets as I could. I found myself at a small stall where a producer from a local village was selling only hot and mild sundried pepper paste, made by his fair hands. I was familiar with this product, but this one was so rich and unctuous I had to take some back to London. One evening at home I was a little short on supplies: I had a cauliflower and this delicious pepper paste, along with some pistachios I also picked up at the market. Right there and then, without particularly thinking about it, was the first time I cooked chilli roast cauliflower. On tasting, I realised it was quite special and it has been a favourite on the menu at Oklava since day one.'

Serves 4–6

For the chilli roast cauliflower
1 large cauliflower (leave some of the green
 leaves on if they're nice)
2 tbsp açi biber chilli paste (hot Turkish
 pepper paste)
4 tbsp tatli biber chilli paste (mild/sweet
 Turkish pepper paste)
50ml/1¾fl oz extra virgin olive oil
pinch of sea salt
drizzle of plain oil,
 for searing

For the sumac dressing
2 garlic cloves
2 lemons, juiced
300ml/10fl oz extra virgin olive oil
1 tbsp of sumac
fine salt, to taste

To garnish
large handful of flat-leaf parsley leaves
½ medium red onion, sliced as finely as possible
5 tbsp pistachio nuts, toasted and crushed
1 tsp sumac
flaky sea salt, to taste

Preheat the oven to 220°C/425°F (200°C/400°F fan).

Cut the cauliflower into 6 equal wedges – make sure you keep a little of the stalk on each piece to keep the wedges together. Rinse under cold water and pat dry.

Mix together the açi and tatli biber chilli pastes with the olive oil and salt. Rub the mix all over the cauliflower wedges (you might want to wear a pair of gloves while you do this), then place onto a baking tray lined with baking parchment. Roast the cauliflower wedges for 15–20 minutes – the cauliflower should be cooked but still have a good bite to it.

To make the sumac dressing, combine all the ingredients in a blender and blend until smooth. Set aside for later.

Take the cauliflower wedges out of the oven and leave to cool. In a hot, non-stick frying pan, drizzle in a little plain oil and fry each side of the cauliflower wedges for a minute or so to get a slight charring on the surface.

Place the cauliflower wedges onto large plates and top with the parsley, sliced red onion and pistachios. Drizzle with plenty of the sumac dressing, an extra sprinkling of sumac and some flaky sea salt.

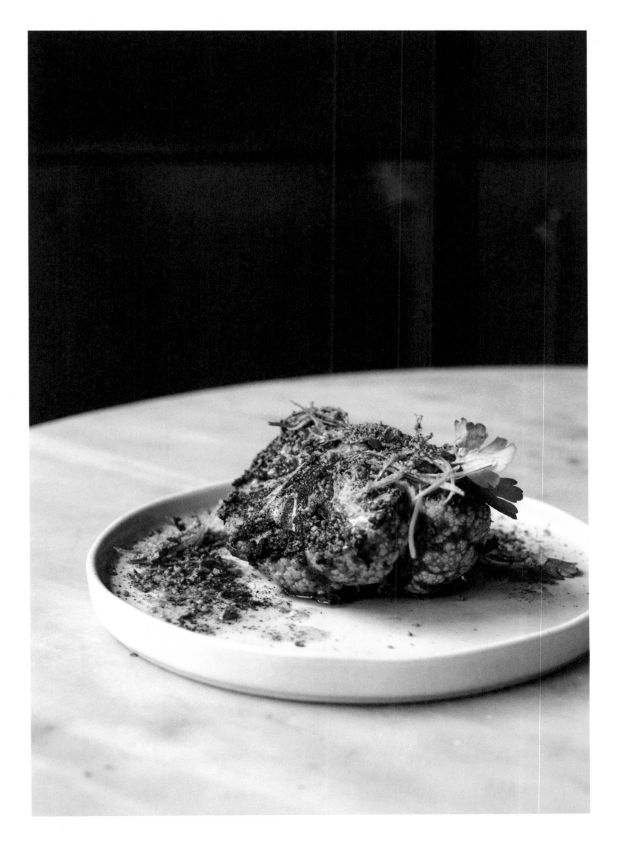

Selin Kiazim

Skye Gyngell

Australian-born chef and restaurateur,
and former food editor of Vogue

'What I want from running a restaurant is not the stuff that's naturally attached to it.'

Few restaurants embody the ethos and character of a chef quite so completely as Spring does Skye Gyngell. Everything from baking bread to breaking down a beef carcass takes place in its airy, sunlit kitchen; all vegetables come from Fern Verrow, a female-run, biodynamic farm in Herefordshire; and there's not been a piece of single-use plastic in sight since 2019. The elegance of its menu – a daily-changing homage to all that's fresh and in season – is rivalled only by that of its location within a restored 19th-century dining room in London's Somerset House.

'What I want from running a restaurant is not the stuff that's naturally attached to it,' says Gyngell. 'The big chef thing doesn't appeal to me.' Her unsought Michelin star was awarded for her work at Petersham Nurseries – then a garden centre – transforming a vegetable patch into simple, beautiful dishes for locals. Her food heroes are not star-studded chefs, but 'women who have raised their eyes above the stove, and addressed issues in our industry, women like Alice Waters' – the Californian food activist and organic-eating pioneer.

Gyngell came into the kitchen by accident, by way of a 'big-hearted' Lebanese woman called Layla Sorfie, who ran the deli-restaurant where she washed up while studying Law in Sydney. 'She'd say, "I'm just making a chicken stock. Come and watch me." I wasn't particularly confident, and her encouragement really altered the course of my life. Those opportunities are so important,' she

Skye Gyngell

Gyngell at her restaurant Spring in Somerset House, which is dedicated to sustainability and seasonality.

stresses. Even now, with a Michelin star behind her and her own acclaimed restaurant in front, her 'biggest hope is that I raise stronger, better cooks for the future.'

She needn't worry on that front. Wahaca's Thomasina Miers (p.192) is one of her protégés and her current team is led by two strong, talented women: head chef Rose Ashby, and general manager Georgie Stead. 'I have tried hard to create a restaurant in which people are happy working.' Gyngell's never sought an exclusively female environment – 'I think the harmony of both sexes is nice' – but she is proud of having a kitchen that is female-led and produce-driven. Nor does she look solely for experience: 'I would rather take a young person who is passionate and shares our ethos. The skills they can learn.'

This is not to say she's a soft touch: 'I'm not Nelson Mandela. We are cooking food for people who can afford to eat it,' she says dryly. Running 13 busy services a week in the West End 'demands military precision.' Timings are paramount and organisation is key. 'I am super exacting,' she continues. Whether you flail or thrive under that stress 'comes down to the type of person you are, rather than your gender. I love it, but some people find it bruising – not because my kitchen's atmosphere is stressful, but because the demands placed on us are.'

This distinction might sound like splitting hairs, but proof of Gyngell's commitment to a happy working environment is in her CV, which comprises some of the kindest kitchens in 90s London. 'After culinary training in Paris, I was at the Dorchester hotel, in a basement, surrounded by steel, and it was very intense – a far cry from what I'd learnt with Layla. So I left, and went to The French House with Fergus and Margot Henderson (p.124).' From there she joined The Sugar Club with the friendly godfather of fusion, Peter Gordon – and it was his and the Hendersons' legacy that she brought to Petersham Nurseries. 'These kitchens were different. There was more of an Australasian culture,' she continues. 'More creative freedom, less hierarchy.'

Though she has the utmost respect for the old-school kitchens of Hélène Darroze and Clare Smyth – the first women to be awarded three Michelin stars in the UK – she admits, 'I'd be terrified there. I wouldn't want that Gordon Ramsay style of working.' That Smyth and Darroze do simply goes to show that 'there are as many female chefs as there are cooks; as many tough women in the kitchen as there are men.' Today, Gyngell proudly describes her approach to cooking as 'female': 'I used to rebuff it, but I have accepted that mantel. Mine is the cooking of nostalgia, of the heart and soul, whereas I think "male" cooking is more cerebral.' These are broad brushstrokes, of course – but as she points out: 'You don't see many women engaging in molecular gastronomy. A "male" approach is to think, "How can I take a peach and turn it into something completely different?" Whereas I am more inclined to pull it back to a peach, and memories of eating peaches.'

These days, the phrase 'produce led' is bandied about with little justification; yet it's in the marrow of Spring. 'To source all your vegetables from one farm, to ban all single-use plastics – these are beautiful ideas, but what matters is that it's viable; that both farm and restaurant flourishes.' To be in a position, seven years after opening, to say that both indeed are flourishing, and that chefs and restaurateurs are coming to her for advice on scrapping plastic – 'that I am proud of,' she says. 'The cooking that counts is the cooking that nurtures; that stays in your heart, mouth and mind.'

Skye Gyngell's Leek, Potato and Parsley Soup

'I love working with herbs, and really fresh parsley straight from the ground is one of my very favourites. This soup is gentle in flavour and has a simple purity about it. I love food that feels good for you and focuses on the ingredient rather than the hands that have made it – I think this recipe is a good example of that.'

Serves 6

2 large bunches of really fresh curly parsley
50g/2oz unsalted butter
2 medium leeks (white parts only)
1 medium floury potato, peeled and cubed
2 garlic cloves
1 litre/1¾ pints chicken stock
150ml/5fl oz crème fraîche
sea salt and freshly ground black pepper

Wash the parsley really well under cool running water, especially the stems which can retain quite a lot of dirt but have plenty of flavour. Place a large pot of well-salted water on to boil and set aside one of the parsley bunches for blanching. Chop the other bunch very finely.

Melt the butter in a separate saucepan over a low heat, chop the leeks and add, then gently sweat for 5 minutes until they begin to soften. Add the chopped parsley along with the potato and garlic and continue to sweat for another 5 minutes. Season with a little salt and pepper and pour over the chicken stock. Bring to the boil then turn down the heat and simmer for 20 minutes or until the potato is cooked through.

Meanwhile blanch the second bunch of parsley: prepare a bowl of iced water, drop the parsley into the boiling water for 15 seconds, then remove and immediately refresh in the iced water. Allow the soup to cool slightly, then purée in batches in a blender, adding a little of the blanched parsley to each batch. Blitz until the soup is really smooth.

Finally, return the soup to the pan and place over a medium heat. Gently warm, then stir in the crème fraîche and taste for seasoning, adjusting if necessary. Serve.

Ravneet Gill

*Cookbook author, pastry chef and founder
of the hospitality platform Countertalk*

'Hospitality is a difficult world to know and penetrate if you didn't grow up eating fancy cheese.'

'Baking isn't about survival. It's an act of kindness,' says Ravneet Gill. 'You don't have to eat cakes, desserts and biscuits – but the world is nicer if you do.'

She is right: the world is nicer for her gloriously indulgent triple-chocolate cookies and deeply comforting steamed date sponge, recipes for which can be found in *The Pastry Chef's Guide*, Gill's debut book full of confidence tricks for even the most anxious baker. Yet the world is also nicer for Countertalk: an online platform that has been championing healthy working practices and connecting like-minded hospitality businesses since Gill founded it in 2018.

'I wanted to make the world of hospitality more accessible for everybody – including those who aren't well connected, who aren't male, or middle class,' she explains. As a woman of working-class origin and Indian parentage, Gill sits 'at the intersection' of those identities which 'create barriers. As a person of colour I found it hard to get into certain circles, and as a woman I often found it hard to run a team.'

Then there is 'the class thing. That cuts across everything,' she says, 'because you don't know the exhibitions or plays your colleagues are discussing. You don't know the restaurant "scene" or the people in it.' Though Gill's CV reads like a roll call of London's coolest, foodiest restaurants – St. JOHN, Llewelyn's, Black Axe Mangal, Wild by Tart – it owes less to design than it does happy accident. 'I just applied to jobs I saw on Gumtree.

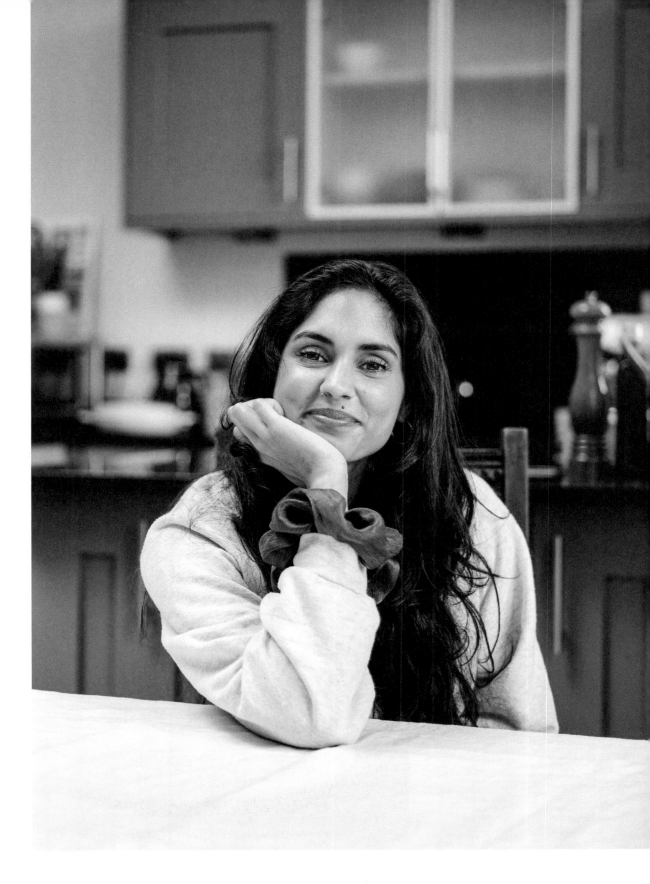

Ravneet Gill 179

Gill at home in London, making an apple pie she has been perfecting since she first started baking (see recipe overleaf).

I had no idea,' she says, when I ask her how she landed such sweet gigs. 'This is a difficult world to know and penetrate if you didn't grow up eating fancy cheese.'

Besides, Gill didn't start at St. JOHN. After the psychology degree she took to please her parents (and the Cordon Bleu course she took to please herself) she worked long hours for little pay in numerous restaurant kitchens. They varied hugely in the degree to which they accommodated her – 'one cookery teacher advised women wear a wedding ring "to keep you out of trouble". I wasn't sure what he meant at the time,' Gill recalls, dryly – but she ploughed on regardless, helped, somewhat surprisingly, by her psychology studies. 'I spent a long time thinking I'd wasted that degree – but actually, it helped me immeasurably when it came to understanding and relating to people. Even if I found a team hard, I would eventually manage to bend them around somehow,' she grins. Nevertheless, while the hostile nature of some of these environments didn't stop her progressing, they were exhausting, and by the time she finally reached St. JOHN she was ready to give up on baking.

Yet it was St. JOHN, a restaurant Gill initially saw as a stop gap while she explored other careers, that led to her staying in food and setting up Countertalk. Under chef Fergus Henderson – and then under Lee Tiernan at Black Axe Mangal – Gill discovered that kitchens could be kind. One of the aims of Countertalk is to spread the good word of St. JOHN (et al.) so that aspiring chefs or front of house staff who aren't well connected or familiar with the 'scene' can find likeminded employers. 'I wanted to change perceptions of people like me in this industry,' she continues, 'but I also really wanted to change the fact that I was so blind and naïve initially.'

At its 'best and most beautiful', hospitality is 'a meritocracy,' Gill continues. 'You can enter from nowhere and climb your way up through working hard.' Yet that takes strength of character and – if you're a newcomer – confidence. Like class, lack of confidence in the kitchen cuts across all identities, but Gill points out its particular prevalence in women. '99 percent of those I speak to say either, "I'm not a chef, I've just done a bit here and there"; or say, "I'm a chef", then immediately feel they have to justify it. It's just another instance of imposter syndrome.' She recalls her early days spent garnering support for Countertalk: a technology platform by definition, though for months she'd shy away from the term. 'Instead of walking in like a guy would and declaring "I'm building a tech start up", I'd say "I'm starting this website, that does this thing".'

In many ways, Gill's platform and book are cut from the same dough: designed to illuminate and provide an 'in' to those outside their respective worlds of restaurants and baking. Both instil confidence, but with a trademark sweetness: 'I wanted to create a conversation and a fun network – because ultimately, we got into food because we love food,' she says of Countertalk, and *A Pastry Chef's Guide* rests on the same principle: 'Pastry is an art,' she writes in the foreword '– but it is also food.'

'I wanted to change perceptions of people like me in this industry.'

Ravneet Gill's Apple Pie

'I grew up eating frozen apple pies from the supermarket – you know the ones that you just shove in the oven? And on rare occasions, my parents would buy me and my brother McDonald's apple pies, which always made it feel like Christmas. When I first started baking, getting an apple pie right was the dream: I tested it over and over again with my family until they were satisfied that it tasted better than the shop-bought ones of my childhood.'

Makes a 20cm/8in pie (5cm/2in height)

butter, for greasing
2 tbsp milk, for brushing
1 tbsp demerara sugar, for sprinkling
ice cream, custard or cream, to serve

For the pastry
225g/8oz strong white flour
5g/1 tsp fine salt

15g/½oz caster sugar
175g/6¼oz chilled, unsalted butter,
 cubed
70ml/2½fl oz ice-cold water

For the apple filling
375g/13oz peeled and cored Braeburn apples
90g/3oz golden caster sugar
¼ tsp ground cinnamon
2½ tbsp cornflour

First make the pastry. In a large bowl, or the bowl of a stand mixer, mix the flour, salt and sugar together. Add the butter and rub in or mix until the mixture is the texture of breadcrumbs: you still want to be able to see some chunks of butter. Add in the water in one go and mix quickly to form a dough. Tip the dough out onto a clean work surface and bring it together with your hands, then wrap the ball of dough tightly in clingfilm and place it in the fridge to firm up, about 4 hours.

Next, make the apple filling. Cut the peeled and cored apples into 1cm/½in cubes, then coat them in the sugar, cinnamon and cornflour. Set aside while you prepare the pie case.

Grease a 20cm/8in pie dish or closed-base cake tin with butter. Remove the cold pastry dough from the fridge and gently knead, then cut off a third of it and set aside for the pie lid. Roll the rest out to 4mm/¼in thick and use to line the dish or tin, leaving a bit of an overhang. Keep the scraps,

if you have any, and add to the portion set aside for the lid. Put the pastry case in the fridge while you prepare the lid.

Roll the pastry for the pie lid to 4mm/¼in thick and cut into a lattice (if you like, you can also leave it whole). Place in the fridge for 15 minutes.

Once the case and lid are chilled, tip the apple mixture into the case and top with the lid. If you left the lid whole, pierce a hole in the centre of it. Return the whole pie to the fridge while you pre-heat the oven.

Heat the oven to 220°C/425°F (200°C/400°F fan). Put a heavy baking tray in the oven to heat up: it works best on the bottom shelf.

When the oven is hot, remove the pie from the fridge and brush the top with the milk, then sprinkle the demerara sugar on top. Place the pie directly onto the hot baking tray and bake for 50 minutes–1 hour until golden. Allow to cool slightly before serving with ice cream, custard or cream.

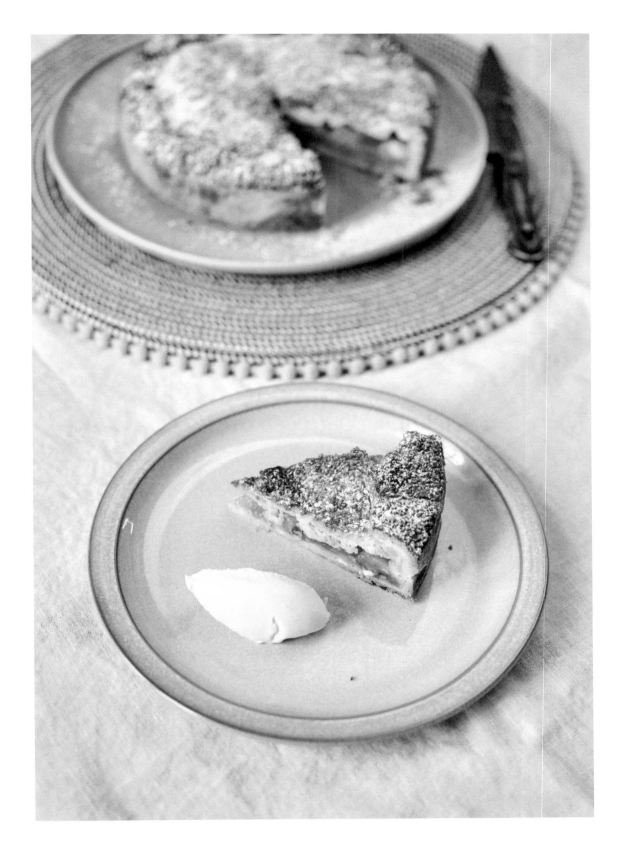

Sarit Packer

Co-founder of Honey & Co., which has three locations in Fitzrovia, and cookbook author

'There is a disconnect between these guys who could do service at a Michelin-star kitchen, but who I don't think could go home and cook a casserole.'

It is a rare treat to be interviewing Sarit Packer separately from her husband, Itamar Srulovich – not, you understand, because she's anything less than a formidably independent feminist. Packer can hold her own, as this interview and anyone that's met her will testify, but when it comes to the business of food, the pair come as a unit: Honey & Co., or 'the Honeys', to use the informal 'married name' that has been bestowed on them.

The Honeys are the duo behind the eponymous restaurant, Honey & Co., adjacent deli, Honey & Spice, a nearby grill house, Honey & Smoke, and four recipe books, as well as a weekend column in the *Financial Times* supplement. They also collaborate on *The Food Talks*, their immensely popular podcast which, in 2020, dedicated a season to women in food dubbed 'Who Run the World'. They are beloved not just for their food – a riot of slow-roasted meats, pickles, warm breads drizzled with tahini and crisp vegetable fritters, all inspired by their home in the Middle East – but for their views on employee welfare and equality within the restaurant industry. 'We are not shouty or angry. We are not hierarchal. Everyone has a space and a place,' Packer says of the Honeys' working environment. A few years ago, they made headlines for having an almost entirely female management team – but this was not deliberate. 'I recruit people who match our style.'

Today, Packer describes her main role as 'business manager: managing people, teaching people – and reinventing ourselves,' she says,

Sarit Packer

Packer at home in London making tahini and preserved lemon cookies with sesame seeds (see recipe on p.190).

referring to the endless closures imposed on them by coronavirus lockdowns. For Packer, the idea of quibbling over whether one is a chef or a cook seems ridiculous at a time when thousands of restaurants have been forced to close. 'For many years my husband introduced himself as a cook – which was interesting to me because my ambition was to be a chef,' she muses, 'but what are you, if you're a chef without a restaurant? All that is meaningless if you can't also look after your business and staff.'

Of course, having worked in a slew of Israeli and British restaurants, there's no doubting Packer's claim to chefdom. 'My parents wanted me to do a proper degree – but I was obstinate. My older brother and sister had been to university, so I said, you've already got your doctor and lawyer. Let me do what I want.' Since her chef's training, she's worked under Chris Galvin at Orrery and under Ottolenghi, as head of pastry and then executive chef at NOPI, and witnessed great change both in the food that restaurants serve and in their chefs' approach to cooking it.

On the one hand, 'there is often this anally retentive attitude that insists every dish must be meticulously accurate, and the same every single time, whereas with Chris, what mattered was that we knew the principles of say, a dressing, and it tasted good.' On the other, we've seen the rise of 'more honest, natural food, like that you'll find at the River Café or Skye [Gyngell, p.172]'s restaurant, or St. JOHN.'

There is more 'cooking' now, she continues – speaking for Honey & Co. as well as those she's just mentioned. 'Our kitchen is like a domestic kitchen. We cook there like we cook at home.' There is nothing wrong per se with 'measuring everything out to the last milligram', but there is a sad disconnect between 'these guys who could do service at a Michelin-star kitchen, but who I don't think could go home and cook a casserole.'

How much this incursion of 'homely' food into restaurants has to do with the incursion of female chefs, Packer isn't sure: 'I don't believe there is an inherent connection between women and nurture; I don't see that. But there are a lot of strong women who have brought their own style into the kitchen,' bringing something 'more honest than a formula. They aren't trying to impress with precision; they just care that it's delicious. They have this bravery most men don't have, to give you something real.'

Such quiet bravery suffuses Honey & Co. – from its menu to its resistance to rapid expansion ('the only reason we survived 2020,' says Packer) to its support for its employees. 'I remember early in my career insisting on picking up heavy stock pots, holding off going to the bathroom when on my period, cooking until I dropped – that is not what I want from my kitchens. I say to all my chefs, if you need to go, go. If you need to sit down, sit down. It's all connected,' she concludes simply.

'Our kitchen is like a domestic kitchen. We cook there like we cook at home.'

'There are a lot of strong women who have brought their own style into the kitchen. They have this bravery most men don't: to give you something real.'

Sarit Packer's Tahini and Preserved Lemon Cookies

'There is no better thing than the smell of freshly baked cookies. We start every day in our restaurant pastry kitchen by baking trays and trays of cookies, and these are some of the most popular cookies we sell, they have everything we love in just one little bite: lemon, in 3 guises, tahini and sesame, and these are paired with the magic of butter and sugar; truly nothing can go wrong here. They symbolise everything I enjoy about food and about creating recipes: thinking first of the ingredients you love and then pairing them together to make something greater than the sum of the parts.'

Makes 16 large cookies

140g/4¾oz butter, softened
200g/7oz light brown sugar
1 lemon, zested
1 egg
110g/4oz tahini paste
100g/3½oz strong white flour

150g/5oz light spelt flour
½ tsp baking powder
½ tsp bicarbonate of soda
2 tbsp lemon marmalade
2 tbsp chopped skins from a preserved lemon
 (discard the pulp)
5 tbsp sesame seeds
5 tbsp demerara sugar

Using a large wooden spoon or a stand mixer with the paddle attachment, cream the butter with the light brown sugar and lemon zest until it is soft, but not too white and fluffy (as you may lose the texture of the end cookie). Add the egg and beat until it is all combined.

Add the rest of the ingredients apart from the sesame seeds and demerara sugar and mix until evenly combined. Shape into large balls, each about 50–60g/2–2¼oz (you may have to chill the mixture in the fridge for 15 minutes to make shaping easier). Mix together the sesame seeds and

demerara sugar and roll the cookie balls in the mixture. (At this point, if you plan to bake the cookies at a later time, you can place them on a baking tray and freeze them.)

Heat the oven to 200°C/400°F (180°C/250°F fan). Place eight cookie balls on a baking tray with plenty of space in between each one, as they will spread while baking. Bake in the centre of the oven for 10 minutes, then rotate the tray and bake for another 4–5 minutes until the cookies have spread and are a light golden colour but still soft. Place on a rack to cool and firm up.

Thomasina Miers

Cookbook author and co-founder of Wahaca
who was the first winner of MasterChef *in 2005*

*'There are male chefs taking note of sustainability,
as well as women – but in my experience women
tend to get to the heart of things more quickly.'*

'I was modelling a Barbour bikini. Clarissa Dickson Wright was modelling a Barbour jacket. And she said, "If you love food so much, why don't you cook?"' recounts Thomasina Miers of the charity fashion show that changed the course of her life. At the time, Miers was a model, struggling to find her calling; Clarissa Dickson Wright was – well, Clarissa Dickson Wright, chef and one half of TV's *Two Fat Ladies*. Yet her advice was pertinent to the then-28-year-old Miers because Dickson Wright had had a number of jobs – most notably as a barrister – before she became a professional cook.

'At that point I'd spent ten years trying to find a career, failing at everything – and I'd been conditioned through influences at home and school into thinking I should be a lawyer or an accountant,'

Miers continues. That school was St Paul's, a private girl's school renowned for its academic success, where cooking wasn't even taught, let alone a career option – 'so I listened to Clarissa.' And, when Dickson Wright got her a place at the acclaimed Ballymaloe Cookery School in Cork, she went.

Thank goodness she did – for, a *MasterChef* win later, Miers went on to found Wahaca, and it's impossible to overstate the impact the chain has had on our culinary landscape. Today tostadas and chipotle mayo are so embedded in our lives, it's hard to remember life without them; yet in 2006, when Wahaca first opened, there wasn't even a supply chain for chipotle chillies in the UK. 'I had to open one up just to get them in.'

Thomasina Miers

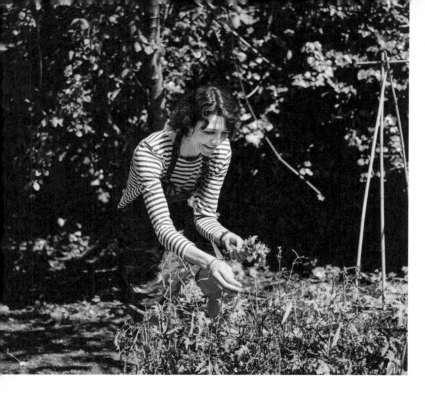

Miers picking fresh herbs in her garden in London and preparing her ricotta-stuffed courgette flowers (see recipe on p.198).

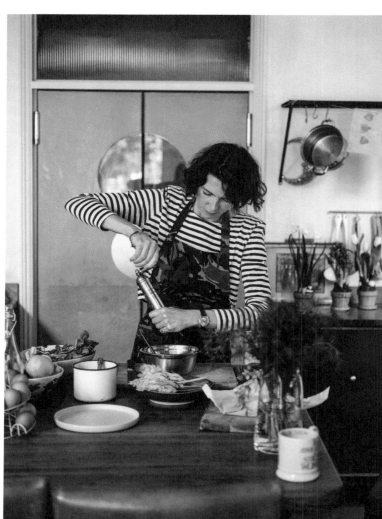

Mexican food in Britain in the early 2000s was considered 'naff' she laughs – reminding me of the Cheddar-slathered Tex-Mex I'd considered 'Mexican' in my twenties. Yet Mexico is 'one of the world's most biodiverse places – and the food reflects that. You can go from state to state and the topography, the soil, the people and the ingredients change radically.' On an intellectual level this fascinated Miers, who spent time there as a teenager and then again aged 28, running a cocktail bar: 'It thrilled me that this vast gastronomy, with hundreds of varieties of chilli, corn and tomatoes, was completely unknown in Europe.' Yet it was also their culture of food that inspired her and which, when brought to England in the form of Wahaca, would prove so pioneering.

'It's a culture based on the pleasures of eating, and the democracy of eating,' Miers continues. 'Everyone eats well in Mexico.' There is poverty of course, but there is not food poverty. 'There is not this perception that if you're poor, you eat badly.' Having grown up with a father whose income was unreliable and a mother who was 'a brilliant cook', Miers knew how to turn inexpensive ingredients into something flavoursome. Yet she was also, thanks to Ballymaloe, aware of the environmental cost of cheap grain, out-of-season produce and factory-farmed meat.

'I believe in the right of every person to food. And of course, how we eat has a massive impact on the planet.' In establishing Wahaca, Miers succeeded in squaring that circle of accessibility, sustainability and pleasure with a restaurant that is a chain, but is also a model of sustainable business. 'My business partner Mark Selby wanted to open more than one site; I was adamant that if we were going to do that, sustainability had to be at the heart of it.'

At first the sustainability side was powered by Miers, who found organic farmers and organised compost and recycling – 'but then Mark caught on and got really into it, especially with the restaurant build.' That Wahaca is a fun, affordable Mexican restaurant group with sites across the UK is public knowledge. What's less well known is that Wahaca recycles as much as it can of pre-existing building materials, installs eco walls for insulation, recycles the hot air from the fridges to provide heating, has been carbon neutral since 2015 – and still turns a profit.

'I wonder if, in fear of shouting about sustainability too much, we've not shouted about it enough,' Miers ponders – which is ironic given her suspicions that it's a 'more male, ego-driven approach to restaurants' that has prevented the industry from cleaning its act up sooner. 'There are male chefs taking note, as well as women – but in my experience women tend to get to the heart of things more quickly, which is why you need a balance of the two.'

It's a word which sums up Wahaca; not only its gender parity, but its flavours, its sense of fun, its healthy and affordable menu and its consideration for the environment. Wahaca might not scream green – but how refreshing to have a company that strives for sustainability, not for publicity, but because it's the right thing to do.

'Mexico is one of the world's most biodiverse places – and the food reflects that.'

Thomasina Miers

'It thrilled me that this vast gastronomy, with hundreds of varieties of chilli, corn and tomatoes, was completely unknown in Europe.'

Thomasina Miers' Ricotta-stuffed Courgette Flowers

'I grew some courgettes in my small patch of earth for the first time this year. They are grown everywhere in Mexico and the flowers are used extensively in Mexican cookery. I love the seasonal side of cooking with the flowers, and that, thanks to a renewed interest in growing, they are more available in the UK than ever before. They are astoundingly delicious with this creamy filling, freshened by grassy spiky flavours from the herbs and sweet, smoky, lightly chillied notes from the chipotle honey.'

Serves 4

250g/9oz ricotta
12 courgette flowers, with baby courgettes
 attached
4 tbsp extra virgin olive oil
2 shallots, finely chopped
3 garlic cloves (1 crushed, 2 sliced)
1 lemon, zested

2 tbsp tarragon leaves, finely chopped
½ tsp local honey
sea salt and black pepper

To serve
small bag of rocket leaves
drizzle of extra virgin olive oil
grating of Pecorino cheese (or Parmesan)
½ lemon, juiced

These are a real treat and very easy to make. Put the ricotta in a piece of muslin or fine cloth and squeeze into a tight ball to wring out any excess liquid. Leave to drip over a bowl.

Meanwhile, wipe the courgette flowers clean with a slightly damp, clean kitchen cloth and break off the baby courgettes. Slice the courgettes in half lengthways. Carefully make a slit down one side of each flower by peeling apart two petals. Pinch out the stamen from inside the flower.

Heat 2 tablespoons of the olive oil very gently in a pan and add the shallots and crushed garlic clove. Cook gently until soft, then add the ricotta, lemon zest, tarragon and honey. Season well with salt and pepper and stir over the low heat for 5 minutes.

Stuff each ricotta flower with a little teaspoon of the ricotta mixture. It is very tempting to overstuff them, but they will only burst open when you cook them later. Press the petals together and twist around slightly to close up the ends.

Heat another tablespoon of oil in a frying pan until gently bubbling and add half the courgette flowers, sautéing on all sides until slightly coloured. Drain on kitchen paper and repeat with the remaining flowers. Set aside in a warm place.

Heat the remaining tablespoon of oil in the pan and, when very hot, add the courgette halves and sliced garlic and sauté over a high heat for a few minutes until all starting to colour.

Toss the rocket with the olive oil, Pecorino and lemon juice and season with salt and pepper. Top with the courgettes and serve, with three courgette flowers to a plate.

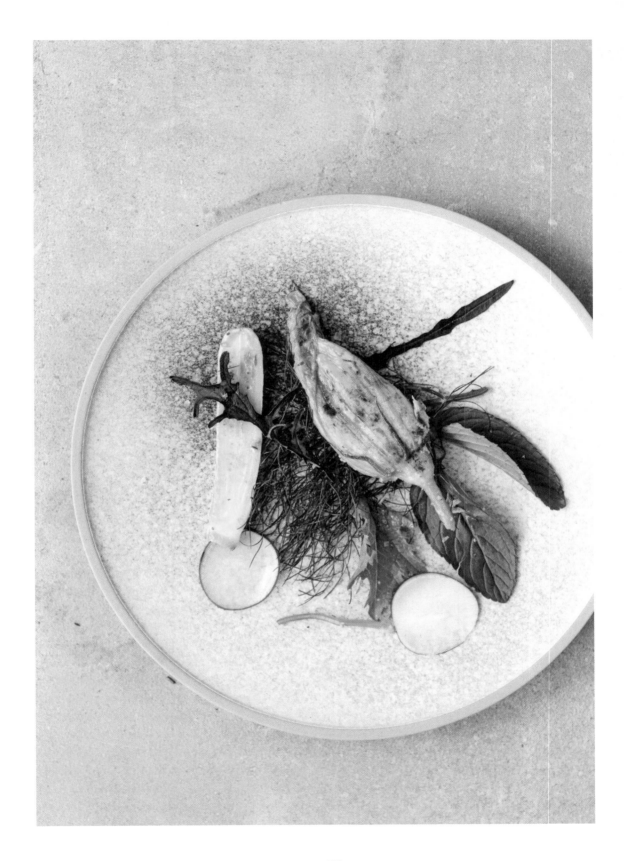

199

Olia Hercules

Ukrainian cookbook author and food writer,
previously a chef at Ottolenghi in London

'I want to bring the knowledge and wisdom of Ukrainian mothers and grandmothers to the fore.'

I first came across Olia Hercules in 2016, following the publication of her first cookbook, *Mamushka*. The book – a sumptuously written and illustrated collection of her Ukrainian family recipes – had inspired me to pitch a piece to a food magazine about the revitalisation of Eastern European cuisine. The editor at the time was sceptical: 'Isn't it just cabbages and potatoes? You're going to have to work to convince me of that one.' Five years on, with three bestselling cookbooks and a host of supper clubs, television appearances and recipe spreads behind her, there can be no doubt in anyone's mind that Eastern European food is having a renaissance, and that Hercules is leading the way.

'There have been books on Central and Eastern European food before – but I think *Mamushka* made it more of a thing, and paved the way for other new books from that region. It proved it was something that could be appreciated outside of those cultures,' says Hercules. When *Mamushka* came out, Hercules was already becoming a familiar name among food editors, having worked as a chef in Yotam Ottolenghi's restaurants and as a freelance recipe contributor at *Guardian Cook*. It was there her career took off. 'One week the theme for the "10 best" feature was courgettes – and for some reason, I put forward one of my mum's dishes,' she remembers. It was a defining moment. 'From then on, my editors kept asking for more Eastern European recipes. I'd do other things and they'd say, this is great – but what would your mum do?'

Olia Hercules

Hercules picking fresh dill from her garden in London and preparing 'sous' – a family recipe for courgette and potato ragout (see p.206*).*

The funny thing is that for years Hercules had studiously avoided the cuisine she grew up with. 'I had this weird complex about it. Even though I knew it was delicious, and that my mum and grandma were highly skilled, I thought it was too esoteric; that other people wouldn't get it.' Yet when the enthusiasm of her *Guardian* readers and editors – Mina Holland and Nell Card, 'two young, brilliant women who found everything interesting' – was followed by a book contract, Hercules' calling began 'clicking into place.'

Though her historic insecurity around Ukrainian food now seems bizarre to her, it makes sense within the context of the country she grew up in. 'For decades we were stuck in this cultural vacuum – then as soon as the Soviet Union broke up we were so excited by having access to other cuisines, we lost sight of our own.' Ukrainian sunflower oil was replaced with Italian olive oil, their own dumplings were dismissed in favour of ravioli, and sushi was 'massive – we wanted sushi all the time because it was something so different.' Writing *Mamushka* and her latest book, *Summer Kitchens* – inspired by the small outdoor cooking spaces common in Ukraine – was as much about reconnecting her fellow countrymen with their culinary culture as it was bringing it to new audiences in Britain. 'I want to bring the knowledge and wisdom of Ukrainian mothers and grandmothers to the fore; seek out those recipes that may have been forgotten or no longer have much of a following even at home.'

Hercules' own return to Ukrainian cooking coincided with the birth of her first son, Sasha. 'Having him reinforced that impulse, because I wanted him to be familiar with those dishes; to have those same food reference points that I have from childhood.' In fact it was having Sasha that made Hercules quit restaurants. 'I think I would have continued had I not got pregnant, but at that time, being a single parent and having a job in a restaurant was just not possible.' In a way, Sasha saved her, she says, 'because even though I loved service – and still do when I do pop-ups and so on – it was mentally extremely harsh.'

In 2016, when I first interviewed her, Hercules was very much a chef. Today, however, she is not so sure. 'It's a difficult one,' she muses. 'I still use "chef" a bit – but I think "cook" is warmer.' After all, one of the reasons she's insisted on 'chef' is 'because there's been a bit of a complex there in that I wanted men to take me seriously, and not dismiss me as a domestic cook.' Now she's more confident – both in her cooking, and in the cuisine of her country – but is torn between keeping the label (she is after all a graduate of Leiths School of Food and Wine, and still a familiar guest chef in restaurant kitchens) and 'putting two fingers up at the whole macho chef situation – because cooking is serious, too.'

For me the greatest marker of how far not just Hercules, but also Britain's understanding of Ukrainian food has come since I first pitched that article, is our appreciation of cabbages and potatoes – two brilliant and broad foodstuffs. 'For ages I feared them – but in *Summer Kitchens* I thought, "You know what? I've taught the world about our herbs, watermelons and aubergines. Now I'm going to embrace a beautifully braised cabbage." I've matured with age.' And the world has, too.

'At that time, being a single parent and having a job in a restaurant was just not possible.'

'I wanted men to take me seriously, and not
dismiss me as a domestic cook – but cooking
is serious, too.'

Olia Hercules' Summer Courgette and Potato Ragout

'This is definitely a "cook's" recipe, not a chef's recipe. It's called simply *sous* in our family (pronounced "saw-oose", which literally means "sauce") and it's one of my favourite things to eat. My late grandmother Lusia used to make it – with her outstanding home-grown potatoes, courgettes and tomatoes – and also my mum. In the summer she would make a big pot of it and leave it on the hob before going to work. My brother and I would wake up and help ourselves, scooping the *sous* straight out of the pan with big chunks of bread.'

Serves 4

3 medium potatoes
50g/2oz plain flour
4 tbsp rapeseed oil (or any vegetable oil),
* plus extra if needed*
2–3 medium courgettes (or 1 marrow),
* sliced into ½cm/¼in rounds*
3 banana shallots or onions, peeled and
* thinly sliced*

2 tbsp tomato purée
800g/1lb 12oz ripe tomatoes, skins removed
* and flesh grated (or 2 x 400g/14oz tins*
* of chopped tomatoes)*
2–4 tbsp full fat crème fraîche
1 large garlic clove, peeled and
* finely grated*
salt and freshly ground black pepper
fresh dill, to serve
bread and butter, to serve (optional)

My mum peels the potatoes, but I don't bother. Slice them into thinnish circles, or semicircles if they are quite big. Season the flour with salt and pepper in a bowl. Heat the oil in a large cast-iron pan or a deep frying pan over a medium heat, and dust the potato slices in the seasoned flour.

Fry the potatoes in the hot oil in batches until all are brown on at least one side. You want to get some colour on them here and there but they don't have to be completely cooked through. Add some more oil if the pan becomes dry. Remove the fried potatoes to a plate and set aside.

Scrape the bottom of the pan to remove any potato or flour that got stuck to it, add some more oil if needed, then fry the courgette in batches until it is browned here and there. Remove to the plate with the potatoes.

Add more oil once again, if needed, and tip in the shallots (or onions). Cook over a medium-low heat for 10 minutes, adding a splash of water every now and then to deglaze the shallots and scraping at the bottom of the pan. You want them to soften and colour nicely – we are not making French onion soup here, so no need for deep caramelisation. Then add the tomato purée and cook off for a couple of minutes.

Add the fresh or tinned tomatoes and give it all a stir. Then add the crème fraîche and mix again. The sauce will be a dusty rose pink and smell delicious.

Add the potatoes and courgettes to the sauce, in layers if you can. Cook over a low heat with the lid half on, for about 20–30 minutes or until the potatoes are cooked through.

Add the garlic to the pot, gently swirling it into the sauce, for the last 5 minutes of cooking.

You can absolutely eat this dish hot with lots of dill thrown on top, but it is so delicious when eaten only warm or at room temperature with a big chunk of crusty bread.

Nokx Majozi

*South African sous chef and head pie maker
at Holborn Dining Room in central London*

'It is so different compared with when I first
arrived in this country in 2004. Women can
see each other; are helping each other.'

'When people ask me what I do, I say I'm a pie maker,' Nokx Majozi laughs. 'They look at me like, "What?" And I start to explain to them.' It's an explanation that tells how, in the grand dining rooms of the Rosewood London hotel, there is a tall, marble antechamber devoted to pies; how copper pie moulds wink from wooden shelves, and a cavalry of Kitchen Aids span the surface; and how she came from a small village in rural South Africa to be presiding over it all – weaving flour and butter into intricate lattices of pastry enveloping tender roast beef or dauphinoise potatoes, caramelised onion and Comté cheese.

From the moment she arrived at the Rosewood's brasserie, Holborn Dining Room, in 2014, she felt she'd come home. 'It felt like such a relief;

like a place where I could be myself, and there was respect between people. It felt like a family kitchen,' she recalls. At its head was Calum Franklin, a man for whom the true measure of success was not just shining himself, but polishing others so they could shine too. 'To have someone who had been in tough kitchens, and didn't want that; who wants to change kitchen culture – that is inspiring. But then as well, to have someone who wants you to progress, to do more and better...' Majozi pauses, momentarily lost for words. 'Calum gave me the stage and said, you can do it. Just dance.'

And dance she has. In 2018, when The Pie Room opened at Holborn Dining Room, Franklin put Majozi in charge of running it alongside her work as sous chef. In 2020 and again in 2021

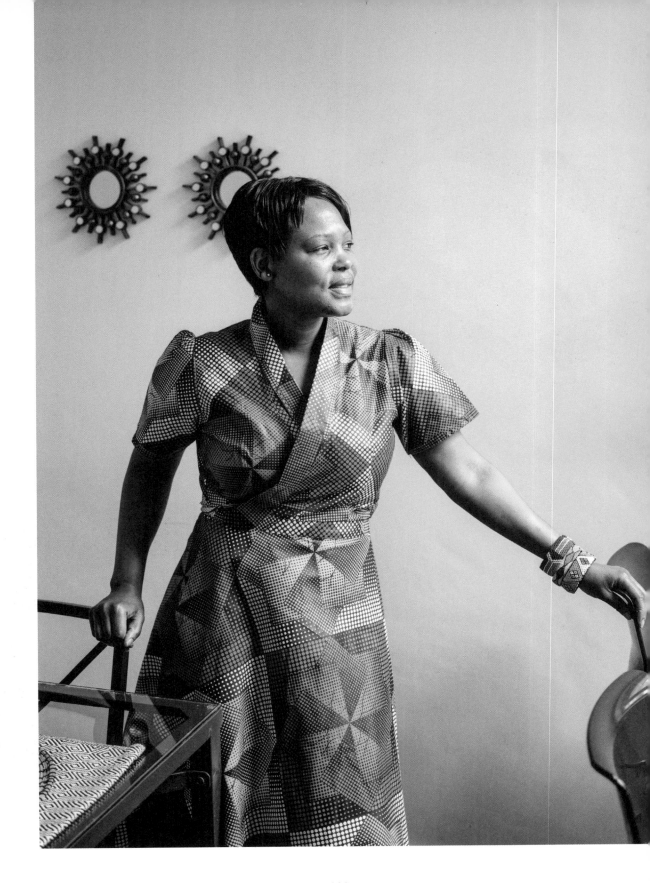

Nokx Majozi

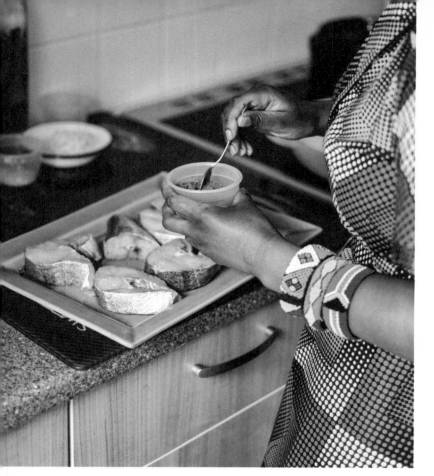

Majozi at home in London, preparing fish steaks for a South African curry (see recipe overleaf).

she was named one of CODE's 100 most influential women in hospitality. 'Before I entered, I thought – I want to be among those women. I wanted to be there not only for me, but for others – because if I am there, women like me will believe they can do it.' Majozi wants to pass on the confidence and skills instilled in her by Franklin: 'He showed me, and he showed me to show others. Because it is not just work, it is recognition that builds you. When I tell my girls they're doing good, I can see their confidence building.'

Of course, Majozi mentors her male juniors, too – but it is the representation and elevation of women she finds so exciting about the present moment in hospitality. 'It is so different compared with when I first arrived in this country in 2004. Women can see each other; are helping each other. On the day The Pie Room and the restaurant reopened after the lockdowns, the shift patterns meant it happened to be all girls in the kitchen. I spoke to Asma Khan [who runs a female brigade, (p.32) later and said, "Is this what you feel every day? This joy of women working together?"'

Today, Majozi regards Khan 'like an auntie. If I need help, she is here for me.' Yet for the majority of Majozi's professional life she has been on her own. She was the only Black woman in her class at catering college in South Africa, and before that had felt just as anomalous among her family, who could not understand her desire to pursue cater-ing in the first place. 'Even my dad, who, unusually, loved cooking, told me it was not a career. In South Africa every woman cooks; for me to say I was going to study it was unbelievable.' Yet when Majozi's profession saw her become the first person in her village to leave the country, and then go on to hold a senior position in one of the best restaurants in London, 'they were proud of me'.

It's why, since she's been running The Pie Room, Majozi has made a point of incorporating her homeland into her pies, weaving South African motifs into the pastry and the flavours into the fillings. Being South African, she's no stranger to pies, which are a culinary hangover of the British Empire – 'we eat them like you eat sandwiches,' she laughs – so there is a poetic justice in her coming to Britain to make them and, in the pie masterclasses she runs with Franklin, showing Brits how it's done.

'English people showed us; now I show them,' she grins – but it is not this that drew her to The Pie Room. Proud South African though she is, it is not her country she feels she represents when she's working, but her own creativity and resilience. 'I remember the first pie I made, when I asked Calum if I could help. It was a French pie called a *pithivier*, and I remember thinking – this is me. I have worked so hard to get here, and I was on my own for so much of it. So in The Pie Room, I represent Nokx Majozi.'

'In South Africa every woman cooks; for me to say I was going to study it was unbelievable.'

Nokx Majozi's Fish Curry and Pumpkin Maize Meal

'This is a recipe my late father used to make. He worked in the harbour and right beside it there were fishmongers. He often used to come home with fresh fish for dinner, so it's a fond memory and one of the first recipes I ever learnt. I'm from Durban in South Africa; a city that is huge on curries.'

Serves 4–6 people

For the fish curry
15g/½oz curry powder
10g/¼oz ground cumin
30g/1oz fish masala spice mix
1kg/2lb 3oz fish steaks (you can use a fish of your choice)
50ml/1¾fl oz vegetable oil
1 large onion, finely chopped
15g/½oz garlic (around 2–3 average-sized cloves), grated
15g/½oz fresh ginger, peeled and grated
sprig of curry leaves
200g/7oz tomato purée
10g/⅓oz sugar
150ml/5fl oz coconut milk
15g/½oz fresh coriander leaves

For the pumpkin maize meal
1 tsp salt
1kg/2lb 3oz peeled pumpkin (or butternut squash), cooked and mashed
250g/9oz maize meal (or polenta)

For the salsa
1 carrot, grated
1 small onion, chopped
1 tomato, chopped
¼ cucumber, chopped
½ lemon, juiced
salt and freshly ground black pepper

To make the fish curry, first mix together the spices and divide in half, then rub the fish steaks with half of the mixture until well coated. Heat the oil in a saucepan over a medium heat and add the fish, frying on both sides until browned. Remove the fish from the pan and set aside.

In the same pan and oil, cook the onion, garlic, ginger and curry leaves until the onion and garlic are translucent and the rest are browned. Lower the heat, add the other half of the spices and stir well. Add the tomato purée, sugar and coconut milk and bring to a boil, then add the fish back in, lower the heat and simmer for 10 minutes.

Meanwhile, make the pumpkin maize meal. Place 1 litre/1¾ pints water in a pot (that has a lid) over a medium–high heat, add the salt and bring to a boil. Add the pumpkin (or butternut squash), maize meal (or polenta) and stir until all is combined and smooth. Reduce the heat, put on the lid and simmer for 10–15 minutes, stirring every 5 minutes.

To make the salsa, mix together all of the ingredients and season to taste.

When ready to serve, scatter the coriander leaves over the fish curry and enjoy with the maize meal and salsa.

Clare Finney's initiation into the world of female cheffing was in the vast kitchen of her grandma's hotel: a remarkable woman who to this day rejects the 'chef' label. Now, Clare writes about food, cooks, chefs and producers for a variety of national and regional magazines and newspapers, and in 2019 was pronounced Food Writer of the Year in Fortnum and Mason's Food and Drink Awards. This is her first book.

Liz Seabrook is a portrait and lifestyle photographer. Celebrating women through warm, honest portraiture has always been at the core of Liz's work; in 2020, she was selected for 1854's Portrait of Britain award. From foraging greens on the coast of Loch Fyne to extra spoonfuls of dhal over a long lunch in London, shooting this book has kept her well fed and well travelled.

Hoxton Mini Press is a small, east London publisher, run by a handful of book-mad people and two dogs, Bug and Moose. We are dedicated to making books that tell personal stories through good photography and passionate writing. As the world goes ever more online, we believe that beautiful books should be cherished: kept for future generations on neatly stacked shelves.

The Female Chef
First Edition

Published in 2021 by Hoxton Mini Press, London
Copyright © Hoxton Mini Press 2021. All rights reserved.

Text © Clare Finney 2021*
Photography © Liz Seabrook 2021**
Edited by Florence Filose, design by Daniele Roa, production by Anna De Pascale,
image editing and editorial support by Becca Jones

*Heartfelt thanks to the chefs featured in these pages, who generously spared their time and
work during an extraordinarily challenging year. This book was inspired by a brilliant idea from
Faith McAllister, a true HMP-er. Thank you Faith, from all of us.*

*Except for recipes © their attributed chefs, and with thanks to those publishers
who gave permission for recipes to be reproduced: Asma Khan's Beef Kofta (p.36), first published
in *Asma's Indian Kitchen* (Pavilion Books, 2018); Angela Hartnett's Anolini (p.68), adapted recipe
from *Angela Hartnett's Cucina* by Angela Hartnett, published by Ebury Press. Copyright © Angela Hartnett,
2007. Reprinted by permission of The Random House Group Limited; Emily Scott's Vanilla-Seeded
Panna Cotta (p.82), adapted recipe first published in *Sea & Shore* (Hardie Grant, 2021); Gizzi Erskine's
Greenhouse Romesco Sauce (p.88), first published in *Restore* (HQ, 2020); Zoe Adjonyoh's Jamestown Grilled
Prawns and Coconut Rice (p.148–9), first published in *Zoe's Ghana Kitchen* (Mitchell Beazley, 2017,
reproduced by permission of Octopus Publishing Group Limited); Sam Evans and Shauna Guinn's Shrimp
and Tasso Filé Gumbo (p.156), first published in *The Hang Fire Cookbook* (Quadrille, 2016); Selin Kiazim's
Chilli Roast Cauliflower (p.170), first published in *Oklava* (Mitchell Beazley, 2017, reproduced by
permission of Octopus Publishing Group Limited); Thomasina Miers' Ricotta-stuffed Courgette
Flowers (p.198), first published in *Mexican Food Made Simple* (Hodder & Stoughton, 2010).

**Except for portrait of Clare Finney © Orlando Gili;
and portrait of Sheila Dillon © Sheila Dillon

A CIP catalogue record for this book is available from the British Library
ISBN: 978-1-914314-01-8

Printed and bound by OZGraf, Poland

Hoxton Mini Press is an environmentally conscious publisher, committed to offsetting
our carbon footprint. The offset for this book was purchased from Stand For Trees.

For every book you buy from our website, we plant a tree:
www.hoxtonminipress.com

MIX
Paper from
responsible sources
FSC® C163799